BIBLIOPHILE

BIBLIOPHILE

AN ILLUSTRATED MISCELLANY

by Jane Mount

CHRONICLE BOOKS
SAN FRANCISCO

Library of Congress Cataloging-in-Publication Data:
Names: Mount, Jane, author.
Title: Bibliophile : an illustrated miscellany / by Jane Mount.
Description: San Francisco : Chronicle Books, [2018] | Includes
 bibliographical references.
Identifiers: LCCN 2017060431 | ISBN 9781452167237 (hardcover : alk. paper)
Subjects: LCSH: Books and reading—Miscellanea. | Book industries and
 trade—Miscellanea. | Publishers and publishing—Miscellanea. |
 Libraries—Miscellanea.
Classification: LCC Z1003 .M94 2018 | DDC 028.9—dc23 LC record available
at https://lccn.loc.gov/2017060431

Manufactured in China.

Design by Kristen Hewitt and Jane Mount.

10 9 8 7 6 5 4

Chronicle books and gifts are available at special quantity discounts
to corporations, professional associations, literacy programs, and other
organizations. For details and discount information, please contact our
premiums department at corporatesales@chroniclebooks.com or at
1-800-759-0190.

Chronicle Books LLC
680 Second Street
San Francisco, California 94107
www.chroniclebooks.com

"A book, too, can be a star,
a living fire to lighten the darkness,
leading out into the expanding universe."
—Madeleine L'Engle

For Kepler & Phoenix:
May you never run out of books, or stars.

CONTENTS

INTRODUCTION

The goal of this book is to triple the size of your To Be Read pile. It's a literary *Wunderkammer*, connecting you with books you might love for all kinds of reasons—because the subject speaks to you, because you found it through a great local library, or because there is a cute cat on the cover. Like a portable, beloved bookstore with aisles full of passionate shelftalkers, this volume contains something for everyone who enters. Each time you open it, you'll find another jewel you didn't know you needed to find until that moment.

I was a shy, dorky kid with few friends and, like many others, turned to books for better worlds. I spent many happy latchkey afternoons reading and drawing. After a degree in anthropology, a short-lived stint in art school, and many years as an internet entrepreneur, I focused on drawing in earnest again. In the small Manhattan apartment my husband and I shared, I set up at our red dining-room table, right next to our packed bookshelves. Overwhelmed by the blankness of the paper before me, I thought, I'll just draw these books right here to get going. A friend stopped by, saw the pictures, and said, "I want to buy all of those right now." I'd never had anyone react so immediately and viscerally to anything I'd made, so I knew there was something to it, to making books look as loved as they are.

Me, after the glasses and braces

At first I painted books like a dinner-party voyeur, documenting them exactly as they sat on friends' shelves. Eventually I realized it was

← This is *my* favorite book! (Bullseye Books 1996 paperback)

more interesting to ask people which books they'd pick to represent themselves, which books they love the most, which books would live on their Ideal Bookshelves. Everyone has a favorite, maybe the first book they hugged to their chest and told someone else about, or the one that changed the way they saw the world forever after. Many of us have several. Painted together on a shelf, these books tell a story of what we've experienced, what we believe, and who we are.

Soon I began to receive commissions, from bibliophiles wanting to document their true loves, and from others wanting to give a heartfelt gift to their bibliophile true loves. Often, after someone commissions an Ideal Bookshelf as a gift, they write to tell me that the recipient loved it so much—both the picture and the giver's effort to learn the recipient's favorite books— that they cried happy tears. There is no better job in the world than one that inspires happy tears.

happy tears!

Since 2008, I've painted well over a thousand Ideal Bookshelves. That's 15,000 or so book spines, many of them painted multiple times. On the next page, you can see the books I paint most often, in order of frequency from the top down. (*To Kill a Mockingbird* far outstrips the rest, but if you counted all seven books from the Harry Potter series as one, including both US and UK versions, they would be a very close second.) These are true classics, books that change and inspire many people and answer life's questions.

But all sorts of books can do that, and I don't judge. I know that any book, when read at the right moment, might make my life better, might give me a greater understanding of the universe and all the other people in it. I have painted the favorite books of writers, teachers, biologists,

chefs, architects, musicians, kindergartners, retirees, atheists, Buddhists, tattoo artists, grandfathers, and lawyers. People ask me to paint both literary fiction and popular fiction from all genres, plus poetry, essays, memoirs, comics, short stories, travel guides, history books, science books, self-help books, cookbooks, art books, and children's and young adult books (even if the reader is not a child or a young adult). People love what they love.

In this job I have, of course, learned a lot about books. I've read many I would never have otherwise come across, and I've added hundreds to my own proverbial bedside table. With this book I hope to pass some of that knowledge along to you, in many different forms, including tidbits of trivia, fun quizzes, profiles of bookish folks, tours of lovely bookstores, and, of course, many stacks of excellent, highly recommended books, organized by topic. Feel free to step out of your favorite genres; there are stunning surprises everywhere. Any one (or many!) of these small magical doorways might lead you to love a new book, and to love the new world inside it.

And if you love a book, no doubt many other people love it, too. That shared love connects us and sparks that miraculous feeling of not being alone in the world. Which is exactly the whole point of books, showing us the world as others see it, helping us understand each other, reminding us we're all human.

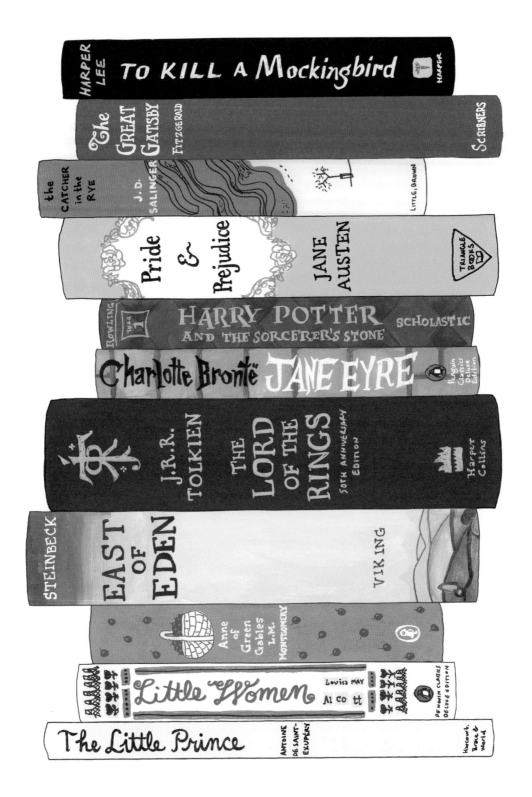

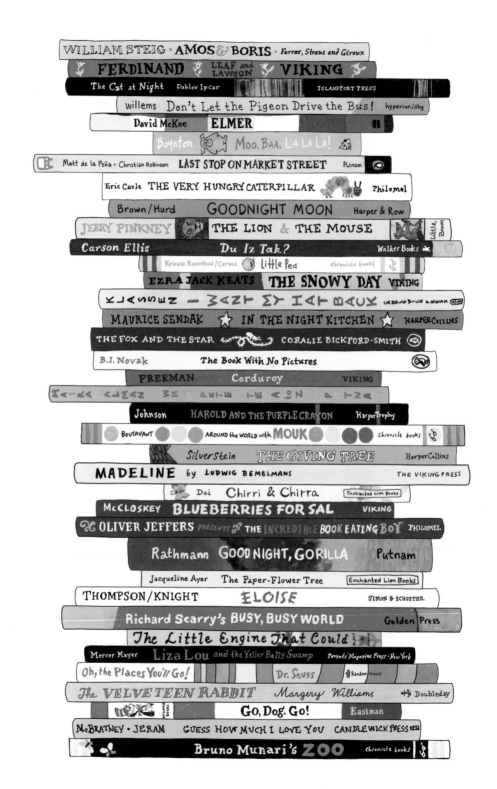

KIDS' PICTURE BOOKS

The very first illustrated book for kids was *Orbis Sensualium Pictus*, or *The World of Things Obvious to the Senses Drawn in Pictures*, a textbook created by John Amos Comenius in 1658 to "entice witty children." Picture books more akin to what we read now appeared in the late 1800s, when English illustrator Randolph Caldecott (for whom the Caldecott Medal is named) created an "ingenious juxtaposition of picture and word," as Maurice Sendak explained, in which either can continue the narrative. They really took off in the late 1930s and early 1940s when Simon & Schuster began publishing its good-quality but affordable Little Golden Book series and Theodore Geisel started writing as Dr. Seuss.

Margaret Wise Brown wrote over a hundred books (including *Goodnight Moon*, *The Runaway Bunny*, and *Little Fur Family*) and lived a short but fascinating life. She spent her entire first royalty check on a cart of flowers; had intense affairs with both men and women; got engaged to a (much younger) Rockefeller; and was a lifelong beagler, keeping up (on foot) with the hounds as they chased down rabbits (yes, runaway bunnies!). She died at age 42 of an embolism, the clot released when she kicked up her leg to show a nurse how great she felt after an appendectomy.

Christian Robinson illustrated *Last Stop on Market Street*, and also a 2016 edition of Margaret Wise Brown's *The Dead Bird*. He has said that P. D. Eastman's *Are You My Mother?* is a book that has really stuck with him since childhood.

← HarperCollins 2016 hardcover

I Want My Hat Back was the first book Jon Klassen both wrote and illustrated.

Candlewick Press 2011 hardcover

In 2016, Matt de la Peña won the Newbery Medal for *Last Stop on Market Street*, a book about a boy riding the bus with his grandmother (since they don't have a car) and learning to appreciate the world along the way.

Putnam 2015 → hardcover

MORE

- *The Little House* by Virginia Lee Burton
- *Miss Rumphius* by Barbara Cooney
- *Click, Clack, Moo* by Doreen Cronin
- *Kitten's First Full Moon* by Kevin Henkes
- *The Poky Little Puppy* by Janette Sebring Lowrey
- *Zen Shorts* by John J. Muth
- *Not a Box* by Antoinette Portis
- *Dragons Love Tacos* by Adam Rubin
- *The Polar Express* by Chris Van Allsburg
- *Owl Moon* by Jane Yolen

BELOVED BOOKSTORES

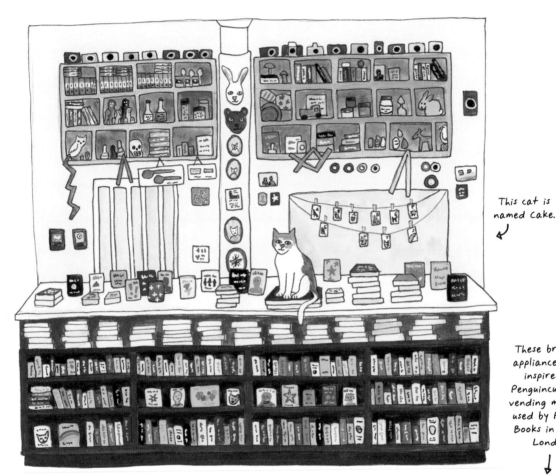

This cat is named Cake.

These brilliant appliances were inspired by Penguincubators, vending machines used by Penguin Books in 1930s London.

BOOKSACTUALLY

Singapore, Singapore

For a single store, BooksActually has a significant presence in Singapore and beyond, presenting books by Singaporean authors in vending machines throughout the city and shipping books across the globe. The store started online and opened its storefront in 2005, with a global and local, new and rare selection. Its vending machines are installed at the National Museum of Singapore, the Singapore Visitor Centre, and the Goodman Arts Centre, headquarters for the National Arts Council. The hope is that even if people don't buy a book right away, they'll start to become familiar with the names of local authors.

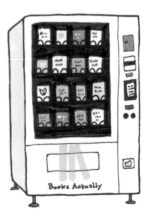

CHARIS BOOKS & MORE

Atlanta, Georgia, USA

Charis Books & More is one of few feminist book-stores founded in the 1970s that is still open. The stalwart Charis has so far outlasted other iconic shops that opened in an energetic wave during that era, including Old Wives' Tales in San Francisco, New Words in Boston, and Lammas in Washington, DC.

Charis means "grace" or "gift." Founder Linda Bryant chose the name in honor of the friend who gave her the funds to open the store.

Charis Books formalized its educational and social justice programming in 1996 with Charis Circle. This nonprofit arm works with artists,

authors, and activists to bring over 250 events a year—writing groups, poetry open mics, chil-dren's story hours, yoga classes, and intersectional meetings—to Atlanta's feminist communities.

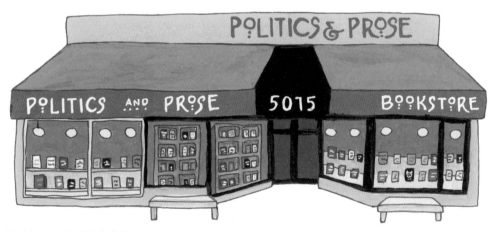

POLITICS AND PROSE

Washington, DC, USA

Politics and Prose does have roots in politics: Carla Cohen opened the store after losing her job with the Carter administration, and one of the current owners, Lissa Muscatine, was an adviser to Hillary Clinton. But it doesn't specialize in politics, as some early would-be customers assumed. The store offers books about pretty much everything. Its name was just supposed to sound unpretentious while honoring its DC home.

Politics and Prose is known for its author talks, hosting writers ranging from Trevor Noah to Drew Barrymore, Neil Gaiman to Celeste Ng. Thankfully, readers everywhere can watch them on the Politics and Prose YouTube channel (and thousands do!).

BOOKSTORE CATS

The ancient Egyptians trained cats to attack papyrus-loving pests, thereby establishing the world's first book-attending felines. Since then, cats have kept mice and rats out of bookstores. They seem especially good at protecting the comfortable chairs so often found in great independent shops.

NIETZSCHE

The Book Man

Chilliwack, British Columbia, Canada

Nietzsche was adopted from Safe Haven animal shelter in 2008. He loves kids! And going for rides in their strollers.

Emma

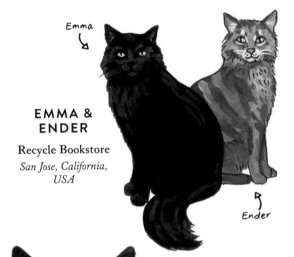

Ender

EMMA & ENDER

Recycle Bookstore

San Jose, California, USA

TILSA

Librería El Virrey

Lima, Peru

STERLING

Abraxas Books

Daytona Beach, Florida, USA

When just a tiny stray kitten, Sterling ran out in front of Abraxas owner James D. Sass's car, and he's lived in the store ever since.

TINY THE USURPER

Community Bookstore

Brooklyn, New York, USA

He got his name by ousting another cat, Margery, from bookstore management. He even has his own Instagram feed, @tinytheusurper!

SADLEIR

David Mason Books

Toronto, Ontario, Canada

AMELIA

The Spiral Bookcase

Philadelphia, Pennsylvania, USA

She is named after both children's book star Amelia Bedelia and Amelia Pond from *Doctor Who*.

HERBERT

King's Books

Tacoma, Washington, USA

King's Books had a contest to name their new adopted friend in 2015 and ultimately paid homage to local literary hero Frank Herbert.

Zeus

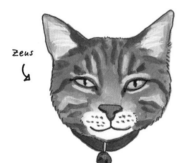

ZEUS & APOLLO

The Iliad Bookshop

North Hollywood, California, USA
They are brothers, born in 2014.

Apollo

JACK

Copperfield's

Healdsburg, California, USA

PIERRE, HEAD OF SECURITY & UPTON SINCLAIR, APPRENTICE SECURITY

The Kelmscott Bookshop

Baltimore, Maryland, USA

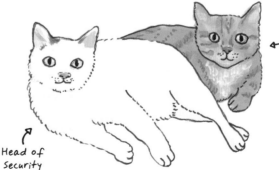

← Apprentice Security

Head of Security ↗

FORMATIVE FAVES

The first books we read all on our own often stick with us more than any others, especially those written for young (impressionable) readers about young (wise, powerful, or adventurous) protagonists.

Meg Murry was one of science fiction's first female protagonists. Madeleine L'Engle felt that was one reason many publishers rejected *A Wrinkle in Time* before Farrar, Straus & Giroux acquired and published it in 1963. Meg and her braces, glasses, mousy hair, and ability to do complex math problems in her head have since inspired legions of girls (and boys!), especially ones who feel like they don't quite fit in.

This is the Farrar, Straus & Giroux 1963 hardcover, designed by Ellen Raskin. She designed more than 1,000 book covers, wrote 16 books, including "The Westing Game," and illustrated more than 30.

Smile is Raina Telgemeier's graphic novel memoir of her experience in middle school after she tripped and fell on her face, really screwing up her teeth. She has a long dental history and some very poignant memories about growing up, friendship, and trying to be normal.

The pint-size front door of Wild Rumpus Books, in Minneapolis, was built especially for kids, so adults must shrink like Alice to enter. One of several bookstores around the US that carries books just for young readers, it also boasts pet cats, chickens, chinchillas, and a cockatiel.

In 1949, E. B. White saw a spider spinning an egg sac in the barn at his Maine farm (where there were also pigs). When she disappeared, he cut the sac loose and took it back to his New York City apartment. A couple of weeks later, hundreds of baby spiders crawled out, and White let them spin webs all over his dresser and mirror until, eventually, his cleaning lady had had enough. Three years later, *Charlotte's Web* was published, becoming what many consider the greatest children's book of all time.

Jules Feiffer

As a young architect in Brooklyn, Norton Juster won a grant to write a book about cities. But he got bored. Instead, he wrote about a bored boy who discovers the world. Juster asked his neighbor, Jules Feiffer, to draw the pictures, and *The Phantom Tollbooth* was born, to the delight of smart kids everywhere and everywhen since.

Norton Juster

MORE

- *Tuck Everlasting* by Natalie Babbitt
- *The House with a Clock in Its Walls* by John Bellairs
- *The Penderwicks* by Jeanne Birdsall
- *Awkward* by Svetlana Chmakova
- *Half Magic* by Edward Eager
- *The Wind in the Willows* by Kenneth Grahame
- *Sunny Side Up* by Jennifer L. Holm
- *Bridge to Terabithia* by Katherine Paterson
- *Hatchet* by Gary Paulsen

BELOVED BOOKSTORES

STRAND BOOKSTORE

New York City, New York, USA

Located in the East Village of Manhattan, Strand Bookstore has the slogan "18 Miles of Books," which equates to over 2.5 million of them organized on three floors. All the newest titles are there at great prices, of course, and it buys and sells used and rare books, too. But the art book section on the second floor might be the best part.

If you want to work at Strand, no matter what the job, you have to take a quiz to prove your book knowledge. It's only 10 questions but makes applicants very nervous. Fred Bass (one of the owners) called it "a very good way to find good employees."

Strand is also known for its tote bags, designed by lots of different people. And it sells bookish socks, enamel pins, patches, and pretty much anything else a booklover could want.

WANT TO TAKE THE QUIZ?

Here's an old version of it (the current one is secret, of course!). Match the book with the author.

1) *The Histories*
2) *Brave New World*
3) *The Poisonwood Bible*
4) *A Wrinkle in Time*
5) *Wise Blood*
6) *Infinite Jest*
7) *White Teeth*
8) *What We Talk About When We Talk About Love*
9) *The Sound and the Fury*
10) *The Wind-Up Bird Chronicle*

A) David Foster Wallace
B) Walker Percy
C) Flannery O'Connor
D) William Faulkner
E) Zadie Smith
F) Herodotus
G) Barbara Kingsolver
H) Haruki Murakami
I) Aldous Huxley
J) Madeleine L'Engle
K) None of the above

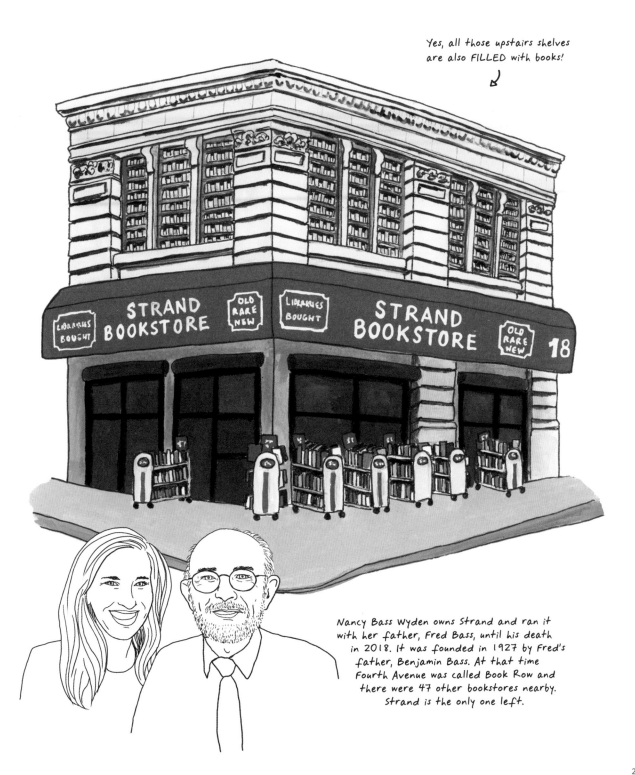

Yes, all those upstairs shelves are also FILLED with books!

STRAND BOOKSTORE

LIBRARIES BOUGHT

OLD RARE NEW

STRAND BOOKSTORE

LIBRARIES BOUGHT

STRAND BOOKSTORE

OLD RARE NEW

18

Nancy Bass Wyden owns Strand and ran it with her father, Fred Bass, until his death in 2018. It was founded in 1927 by Fred's father, Benjamin Bass. At that time Fourth Avenue was called Book Row and there were 47 other bookstores nearby. Strand is the only one left.

GIRL STARS

A 2011 study of almost 6,000 children's books published in the US in the 20th century found that only 31% had female lead characters, while 57% had male ones. Since the 1990s, this has started to change, thanks in part to the books in this stack and others like them. The strength of these female characters speaks to their audience, and a couple are also real-life heroines, battling against Goliaths of fear, hatred, and inequality.

Astrid Lindgren's nine-year-old daughter, Karin, sick in bed, demanded to be told a story. When Lindgren asked what it should be about, Karin pulled a name from the air, and that's how *Pippi Longstocking* (or *Långstrump*, in her native Swedish), the strongest girl in the world, came to be. Lindgren recorded the stories she told Karin and gave her a copy of the published book on her tenth birthday.

Rabén & Sjögren 1945 hardcover, art by Ingrid Vang Nyman

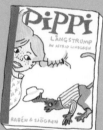

In Pakistan, in 2012, a Taliban gunman shot 15-year-old Malala Yousafzai in the head for speaking out about girls having the right to attend school. Since recovering, she has continued to advocate for education rights and in 2014 won the Nobel Peace Prize.

Most of Beverly Cleary's books—including all the ones about Ramona, Beezus, Henry Huggins, and Henry's dog, Ribsy—are set in Portland, Oregon, where she grew up. Visitors can walk a self-guided tour of her old Northeast neighborhood and see the real-life Klickitat Street, the inspiration for Glenwood School, and the place where Ramona's boot got stuck in the mud. There's even a guidebook called *Walking with Ramona,* by Laura O. Foster.

With her notebook always under her arm, Harriet M. Welsch of *Harriet the Spy* has been the patron saint of city kids, writers, New Yorkers, and gender-norm defiers for decades. Confident and always true to herself, Harriet was one of the very first female rebels in children's literature.

Scott O'Dell's *Island of the Blue Dolphins* was inspired by the true story of Juana Maria, a Nicoleño Native American who in the 1800s was left by herself on San Nicolas Island for 18 years. O'Dell's heroine is called Karana, and she tames a gray wolf, naming him Rontu.

MORE

- *The Wonderful Wizard of Oz* by L. Frank Baum
- *The Hunger Games* by Suzanne Collins
- *The Mighty Miss Malone* by Christopher Paul Curtis
- *Because of Winn-Dixie* by Kate DiCamillo
- *Olivia* by Ian Falconer
- *Coraline* by Neil Gaiman
- *Inside Out and Back Again* by Thanhha Lai
- *Number the Stars* by Lois Lowry
- *Counting by 7s* by Holly Goldberg Sloan
- *The Witch of Blackbird Pond* by Elizabeth George Speare
- *Dealing with Dragons* by Patricia C. Wrede

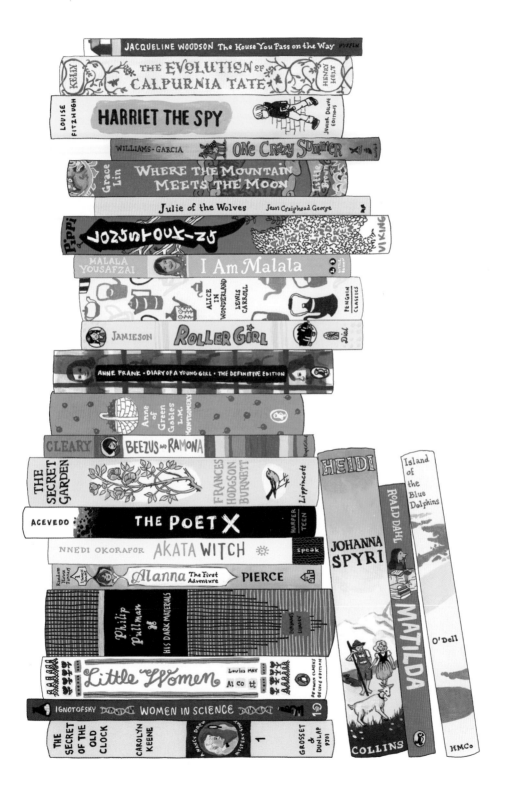

BOOKISH PEOPLE RECOMMEND

TRAVIS JONKER

Elementary school librarian at Wayland Union Schools, Michigan, USA

El Deafo
by Cece Bell

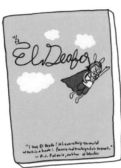

Harry N. Abrams → 2014 hardcover, design by Caitlin Keegan & Chad W. Beckerman, art by Cece Bell

"James Joyce said, 'In the particular is contained the universal.' I can think of no greater example of this than Cece Bell's graphic novel memoir, *El Deafo*. This story of Bell's childhood after hearing loss is deeply personal, yet hits on themes of friendship and acceptance that every reader will relate to. It's so masterfully executed that the Newbery committee took notice, and awarded it an honor—the very first for a graphic novel."

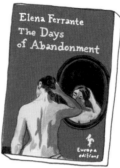

The Days of Abandonment
by Elena Ferrante

Europa Editions 2005 paperback, ← art by Emanuele Ragnisco

"*The Days of Abandonment* is always my first recommendation when people ask if they would enjoy the undertaking of reading Elena Ferrante's Neapolitan novels. A short, dark, angry as hell, insanely evocative glimpse into the life of a woman trying to hold it together (barely) after her husband leaves her, *The Days of Abandonment* is the perfect introduction to Ferrante's brutal yet magical world. If it punches you right in the gut in a way that somehow feels simultaneously like pleasure and pain, you will be a Ferrante fan for life."

MARIS KREIZMAN

Editorial director of Book of the Month

Anagrams
by Lorrie Moore

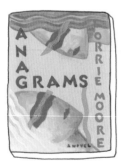

Knopf
1986 hardcover

"*Anagrams* broke apart all my expectations about what a novel could do. As you might guess from the book's title, it presents many different versions of its wonderfully flawed heroine, and maintains a delicate balance between funny and sad. It is eminently quotable, and it is definitive proof that puns can be profound."

MARIA POPOVA

Reader, writer, and founder of brainpickings.org, which is included in the Library of Congress permanent archive of culturally valuable materials

A Madman Dreams of Turing Machines
by Janna Levin

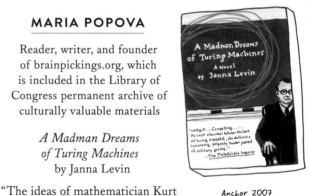

Anchor 2007 paperback, design by Peter Mendelsund

"The ideas of mathematician Kurt Gödel and computing pioneer Alan Turing fundamentally unsettled and reshaped modern life. Astrophysicist and author Janna Levin—one of the most poetic prose writers of our time—twines their parallel lives into a stunning novel exploring the limits of logic, the elusive nature of truth, and the roiling relationship between genius and madness."

Civil Disobedience
by Henry David Thoreau

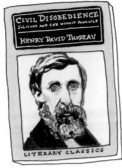

Prometheus Books
1998 paperback

"A century and a half ago, a young Transcendentalist poet, outraged by the inhumanity of slavery and the horrors of the Mexican American War, penned a manifesto for using civil disobedience to advance justice—a politically and socially wakeful masterpiece that would go on to influence such transformers of culture as Leo Tolstoy, Mahatma Gandhi, and Martin Luther King Jr."

ANDREW MEDLAR

Assistant commissioner for collections at the Chicago Public Library and past president of the Association for Library Service to Children

Pantheon 1986 hardcover, art by Philippe Weisbecker

Favorite Folktales from around the World
edited by Jane Yolen

"Stories have power. (If they didn't, this book wouldn't exist.) Perhaps their greatest is connecting us, and this deliciously thick treasury gathered by an esteemed wordsmith follows those threads of human experiences across the globe, making it clear that billions of us have many feelings, questions, and hopes in common.

From stories about stories (the Ashanti 'How Spider Obtained the Sky God's Stories') to 'The End of the World' (from the White River Sioux), Yolen organizes in order to illuminate. Her categories affirm that there are 'Tricksters, Rogues, and Cheats' from Jamaica to Japan, no shortage of 'Numskulls and Noodleheads' on every continent, 'Shape Shifters' on both sides of the equator, and,

redeemingly, 'Heroes: Likely and Unlikely' all around us.

While not quite a-thousand-and-one tales, there are more than enough here for a hundred bedtimes snuggled up with a little loved one or a single binge on a beach or by a fire. I'm sure your library has other folklore anthologies, possibly with prettier pictures, yet it's unlikely there are any as carefully curated and continually surprising, amusing, affirming, and powerful as this one."

ADAH FITZGERALD

Owner of Main Street Books in Davidson, North Carolina, USA

Scribner 1997 paperback, design by Calvin Chou, art by Walter Ford

The Song of the Dodo
by David Quammen

"Quammen superbly blends exquisite biographies of Charles Darwin and his nemesis and underdog Alfred Wallace with fascinating accounts of strange, contemporary creatures whose existential vulnerability is a real warning to each of us about the consequences of habitat destruction."

Atheneum 1972 hardcover, art by Alan E. Cober

JULIA HOBART

Bookbuyer at the Bookloft in Great Barrington, Massachusetts, USA

The Dark Is Rising
by Susan Cooper

"I read it as a kid, and it has stuck with me. As an adult I have reread the whole series and listened to the audiobook several times, and it still is as enjoyable as the first time."

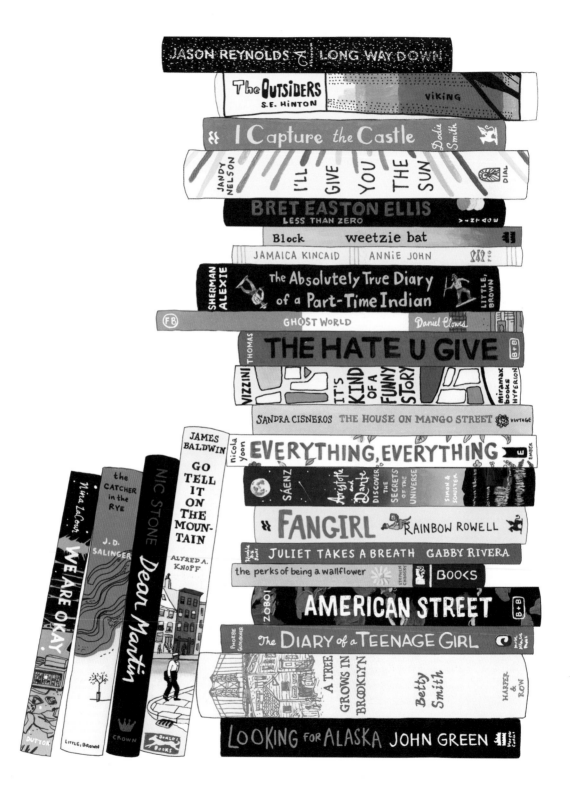

COMING OF AGE

Our poor hearts, it's a wonder they ever make it through those rough teen years when we find out what the world is really like and must figure out who we really are. These books share the pain and power of that growth and change.

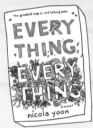

Ember 2017 paperback, art by Good Wives and Warriors, design by Natalie C. Sousa

Nicola Yoon wrote *Everything, Everything* over three years, working between 4 and 6 a.m. Her husband, David Yoon, illustrated the book, and she has said that her experience falling in love with him made it easy for her to write the tender love story. In 2017 a film version was released.

Sherman Alexie grew up on the Spokane Indian Reservation, as does Arnold Spirit Jr., the nerdy cartoonist protagonist in *The Absolutely True Diary of a Part-Time Indian* (with drawings by Ellen Forney). Alexie also wrote the screenplay for the movie *Smoke Signals*, the first all–Native American production.

Susan Eloise Hinton started writing *The Outsiders* when she was only 15 years old; it was published when she was 19.

Dell 1971 paperback →

Angie Thomas read a lot as a child, but less as a teen, because she didn't see herself in books. She feels that publishers assumed that "black kids don't read" and so books about black characters wouldn't sell. Thomas's book *The Hate U Give* is helping change that

misconception; 13 publishing houses bid for it, and Fox 2000 bought the film rights.

John Green modeled the boarding school in *Looking for Alaska* after one he attended in Alabama. When he's not writing, Green and his brother, Hank, are the Vlogbrothers, "raising nerdy to the power of awesome" on YouTube. They have over three million followers for their short videos about pretty much everything, from condom failure to Pokemon.

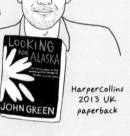

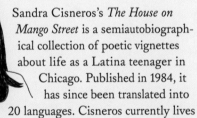

HarperCollins 2013 UK paperback

Sandra Cisneros's *The House on Mango Street* is a semiautobiographical collection of poetic vignettes about life as a Latina teenager in Chicago. Published in 1984, it has since been translated into 20 languages. Cisneros currently lives in San Miguel de Allende, Mexico, with four dogs.

MORE

- *Some Assembly Required* by Arin Andrews
- *Nine Years Under* by Sheri Booker
- *The Power of One* by Bryce Courtenay
- *The Brief Wondrous Life of Oscar Wao* by Junot Díaz
- *The Girl Who Fell from the Sky* by Heidi W. Durrow
- *Lord of the Flies* by William Golding
- *Silver Sparrow* by Tayari Jones
- *A Separate Peace* by John Knowles
- *King Dork* by Frank Portman
- *The Growing Pains of Adrian Mole* by Sue Townsend

BELOVED BOOKSTORES

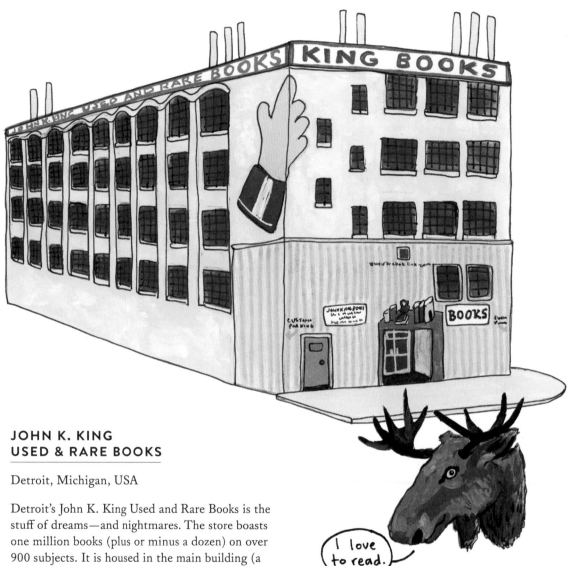

I love to read.

JOHN K. KING
USED & RARE BOOKS

Detroit, Michigan, USA

Detroit's John K. King Used and Rare Books is the stuff of dreams—and nightmares. The store boasts one million books (plus or minus a dozen) on over 900 subjects. It is housed in the main building (a five-story former glove factory) and in two smaller locations, all of which are organized and searched by hand. The majority of the store's stock is, as the staff says, "uncomputerized." Each section is managed by a knowledgeable employee who can help you find whatever you're looking for. If a search goes astray, there's a good chance you'll find something else that's probably more interesting.

In addition to books, the rarest John K. King finds include postcards, photos, maps, antique furniture, records, and, at one point, a collection of many things moose-related. Expert and amateur antiquarians everywhere can search these goods online at rarebooklink.com.

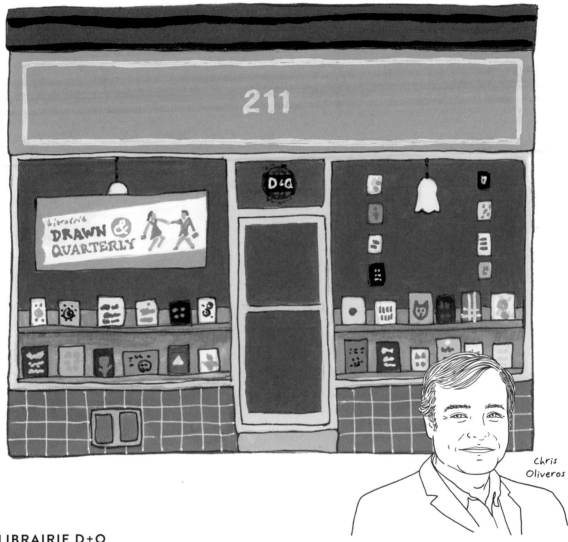

Chris Oliveros

LIBRAIRIE D+Q

Montreal, Québec, Canada

Librairie D+Q is the storefront home of
Montreal's Drawn & Quarterly. Inspired by Art
Spiegelman and Françoise Mouly's *Raw* (an alter-
native comics anthology), then 23-year-old Chris
Oliveros started publishing his own magazine
devoted to comics. Since 1990, his efforts have
grown to include comic books and graphic novels,
a non-comic book imprint, and a children's book
imprint (home of the popular Moomin works).
Oliveros's approach to working with artists, help-
ing them create the most beautiful books possible,
has drawn Lynda Barry, Daniel Clowes, Mary
Fleener, Shigeru Mizuki, Rutu Modan, Yoshihiro
Tatsumi, Adrian Tomine, and Chris Ware to pub-
lish with him.

CULT CLASSICS

A cult book might be panned by critics but evangelized by fans, hated by half the people who read it while the other half feel it's their favorite book of all time. Cult books are sometimes experimental, sometimes culturally fringy, often funny, and definitely life-changing for those they strike.

Chip Kidd created the 1989 first-edition dust jacket for Katherine Dunn's brilliant *Geek Love* when he was a junior designer at Knopf; he considers it a "personal breakthrough." In clever homage to the Binewskis (the book's charming family of sideshow freaks), he added a fifth leg to the Knopf borzoi logo at the bottom of the spine, which no one caught until after publication.

The manuscript for *A Confederacy of Dunces* was repeatedly rejected, and John Kennedy Toole committed suicide at 31, not living to see it published (with the help of Walker Percy) a decade later. The book immediately became a cult hit and eventually a commercial one. In 1981, Toole posthumously won the Pulitzer Prize, and today a statue of his flannel-shirted star, Ignatius J. Reilly, stands on Canal Street in New Orleans, under the clock where he waited for his mother in the book's opening scene.

Zen and the Art of Motorcycle Maintenance is in the Guinness World Records for being rejected by 121 publishers, more than any other best-selling book. It has since sold more than five million copies worldwide. For years, the book inspired philosophical fans to show up at Robert

A 1964 Honda CB77 Superhawk

M. Pirsig's house in search of a guru. Pirsig used a Swedish concept to explain the book's popularity; it became a *kulturbärare*, a "culture-bearer," exposing a change in the world that was already happening.

Brazilian writer Paulo Coelho's *The Alchemist*, about a shepherd on a quest, is one of the best-selling books of all time. Many people have called it life-changing, including music producer Pharrell Williams.

You can play a version of the super awesome *The Hitchhiker's Guide to the Galaxy* interactive text game, originally created in 1984 (and based on the 1979 novel, which was based on the 1978 radio show), on the BBC website (bbc.co.uk/h2g2game). Winning it might help you understand why 42 is the answer to the "Ultimate Question of Life, the Universe, and Everything."

MORE

- ~~*Speedboat* by Renata Adler~~
- *The Clan of the Cave Bear* by Jean Auel
- *Foucault's Pendulum* by Umberto Eco
- *The Virgin Suicides* by Jeffrey Eugenides
- *I Love Dick* by Chris Kraus
- *Água Viva* by Clarice Lispector
- *Norwegian Wood* by Haruki Murakami
- *Survivor* by Chuck Palahniuk
- *The Fountainhead* by Ayn Rand
- *Building Stories* by Chris Ware

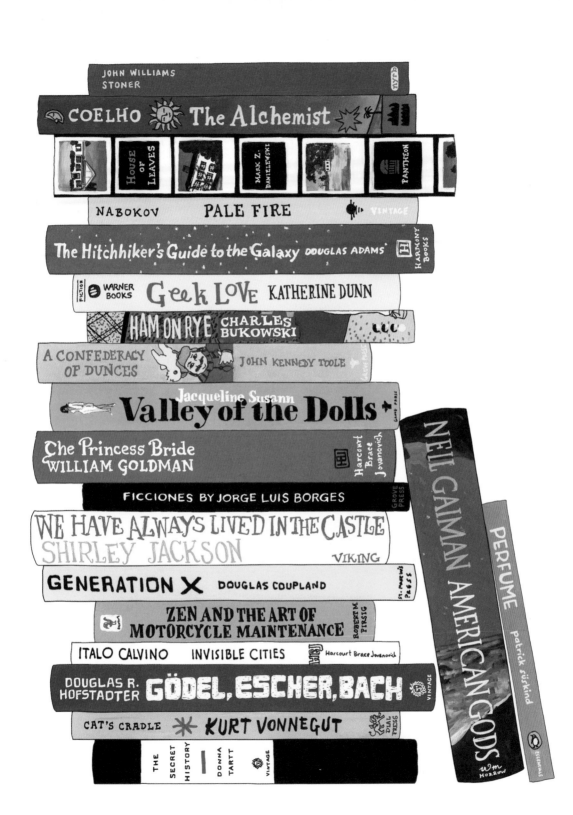

STRIKING LIBRARIES

BEINECKE RARE BOOK & MANUSCRIPT LIBRARY, YALE UNIVERSITY

New Haven, Connecticut, USA

Designed by Gordon Bunshaft of Skidmore, Owings & Merrill

Opened in 1963

The building has no windows, in order to keep direct sunlight from harming the rare books, but the very thin marble walls let low light in during the day. At night the building glows from the interior lighting within.

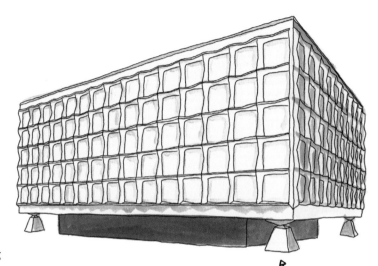

The collection inside includes a Gutenberg Bible from 1454 (one of only 48 known copies) and the mysterious medieval Voynich manuscript, which is filled with indecipherable text, strange diagrams, and illustrations of bizarre plants.

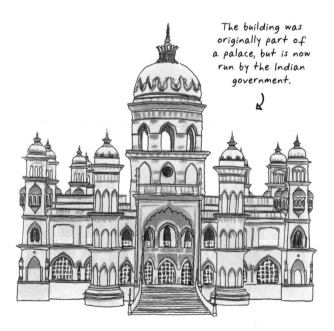

The building was originally part of a palace, but is now run by the Indian government.

THE RAMPUR RAZA LIBRARY

Rampur, Uttar Pradesh, India

Opened in 1904

Nawab Faizullah Khan began collecting items for the library in 1774, and later *nawabs* (governors) continued to do so. It's now one of the largest collections of Indo-Islamic cultural materials in the world, including 17,000 manuscripts, 60,000 printed books, calligraphy specimens, miniature paintings, astronomical instruments, and rare coins.

To create the mosaic, O'Gorman worked with a geologist to collect stones in 150 different natural colors from all around Mexico.

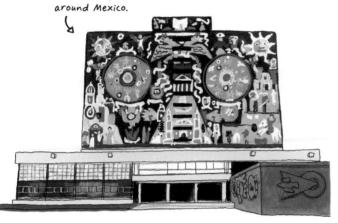

BIBLIOTECA CENTRAL, UNIVERSIDAD NACIONAL AUTÓNOMA DE MÉXICO (CENTRAL LIBRARY, NATIONAL AUTONOMOUS UNIVERSITY OF MEXICO)

Mexico City, Mexico

Designed by Gustavo Saavedra and Juan Martínez de Velasco

Opened in 1956

The giant mosaic murals were created by architect and artist Juan O'Gorman and tell the full history of Mexico.

VENNESLA BIBLIOTEK OG KULTURHUS (VENNESLA LIBRARY AND CULTURE HOUSE)

Vennesla, Norway

Designed by Helen & Hard Architects

Opened in 2011

Twenty-seven wooden ribs form the framework of the building, which includes a library, a café, and a meeting area. Above, the ribs form the roof support and house the lighting, and below they transform into shelving and comfortable seating areas.

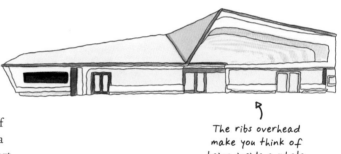

The ribs overhead make you think of being inside a whale, but it's a very warm and cozy whale.

Sejong City is a new capital city, opened in 2012 to be the home of most South Korean government facilities and agencies, moving them out of Seoul.

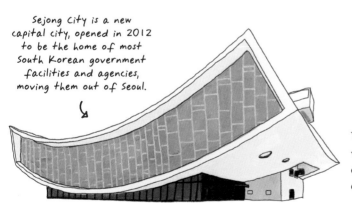

GOOKLEEJOONGAHNG DOSOKWAN (NATIONAL LIBRARY OF KOREA, SEJONG)

Sejong City, South Korea

Designed by Samoo Architects & Engineers

Opened in 2013

With the shape of the building, the architects wanted to evoke a page of a book being turned over. There are many books inside, and a café overlooking an excellent view of a lake.

NOVELS OF THE 1800S: BRIT LIT & FRIENDS

The Tale of Genji, written by Murasaki Shikibu in about 1000 AD, is generally considered to be the first novel. And while the modern era of novels began with Miguel de Cervantes's *Don Quixote* in the early 1600s, novels really came into their own in the 19th century. The public began to buy more books, and authors could retain their copyrights and make royalties, which encouraged them to write more stories that people would want to read. Cheaper printing and the first circulating libraries also led to a larger reading public.

Britain was the center of Western culture at the time (the height of colonialism). Writers there began the 1800s penning Gothic romances, then faced mounting social issues at mid-century, and finally looked to the future with the first science-fiction tales as they neared 1900.

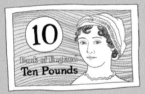

Jane Austen sold her first novel, *Susan*, to the publisher Crosby & Co. for £10. Six years later it still had not released the book and told her (in a mean-spirited letter) she could buy the rights back for the same £10 sum. She couldn't afford it at the time, but finally, after four of her other novels had been successfully published, she did so. After her death, her brother published that first novel as *Northanger Abbey*. In 2017, Jane Austen made her debut on none other than the £10 note.

Charlotte Brontë's Jane Eyre was an early modern heroine and feminist. As she says to Mr. Rochester, "I am no bird; and no net ensnares me: I am a free human being with an independent will."

Vintage 2009 paperback, art by Katherine Wolkoff, design by Megan Wilson

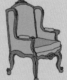

This is a chair you might have sat in to read these books: a French Wing Bergère, 19th century.

"It was the best of times, it was the worst of times . . ." is the opening line from Charles Dickens's *A Tale of Two Cities.* (The quote is actually much longer than that, and is about how people always believe their particular time in history is the most critical.) His novels, about emotional bonds and the struggle of the working class during the industrial revolution, epitomize those of the 1800s.

MORE

- *The Woman in White* by Wilkie Collins
- *The Adventures of Sherlock Holmes* by Sir Arthur Conan Doyle
- *Wives and Daughters* by Elizabeth Gaskell
- *Tess of the D'Urbervilles* by Thomas Hardy
- *The Scarlet Letter* by Nathaniel Hawthorne
- *Uncle Tom's Cabin* by Harriet Beecher Stowe
- *Anna Karenina* by Leo Tolstoy
- *Twenty Thousand Leagues Under the Sea* by Jules Verne
- *The Time Machine* by H. G. Wells
- *Germinal* by Émile Zola

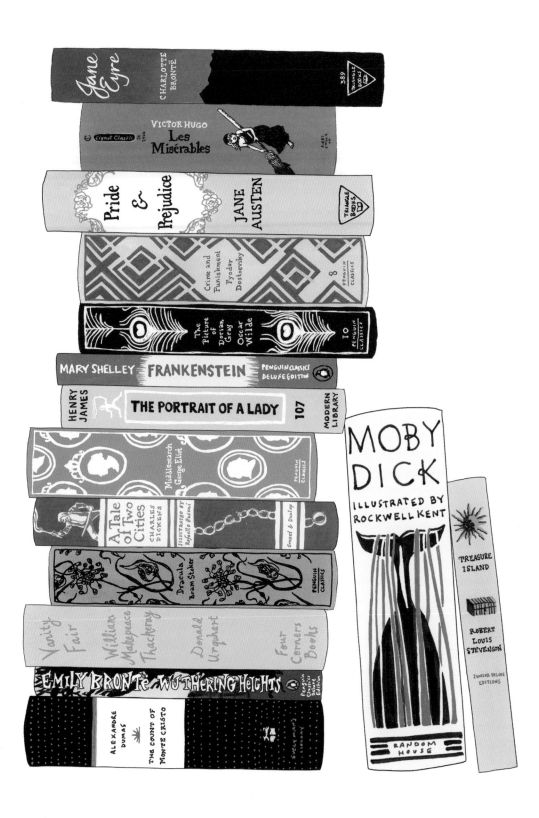

EDITIONS

PRIDE AND PREJUDICE

Jane Austen's *Pride and Prejudice* has been in publication continuously since 1813. It has sold over 20 million copies worldwide, and since it has been in the public domain for over 100 years already, many, many different editions have been published, with covers designed to appeal to readers of various eras. Here are just a few.

1813

T. Egerton hardcover, in three volumes

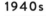

The very first edition ever! Titles were not on covers in those days. The initial print run was 1,500 copies, and they cost 18 shillings each.

1894

George Allen clothbound hardcover

Illustrated by Hugh Thomson

1930s

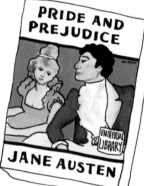

Universal Library hardcover

Cover art by Alfred Skrenda

Alfred Skrenda did a lot of beautiful cover illustrations in the 1930s for many classic novels.

1940s

Penguin mass market paperback

Cover design by Edward Young

In 1935, while managing director for British publisher Bodley Head, Allen Lane created Penguin paperbacks to make fiction affordable and accessible to everyone. Penguin became a separate company the next year.

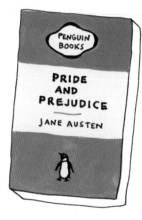

1960

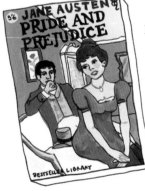

Bestseller Library mass market paperback

1964

Oxford
hardcover

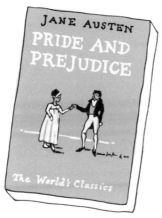

1983

Bantam Classics
mass market paperback

Cover art by Sir
Thomas Lawrence

This is the sort of
edition you buy when
you have to read
it for a school
↖ assignment, no?

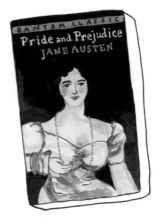

2009

HarperTeen
paperback

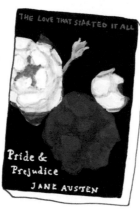

Stephenie Meyer's
Twilight series was
very popular at the
time, with covers
similar to this one.

One of a large
set of Penguin
Clothbound Classics,
all designed by the
ridiculously talented
Bickford-Smith.

All three
of these were
published in
2009!

2009

Penguin Classics
clothbound
hardcover

Cover design by
Coralie Bickford-Smith

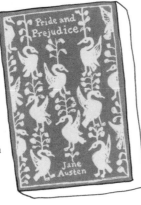

2009

Penguin Classics
Deluxe Edition
Paperback

Cover art by
Ruben Toledo

← Ruben Toledo
is a well-known
fashion illustrator.

WRITING ROOMS

HENRY DAVID THOREAU

For two years, two months, and two days, Henry David Thoreau lived in a one-room cabin he built on 14 acres owned by his friend, mentor, and fellow Transcendentalist, Ralph Waldo Emerson. While living on Walden Pond, Thoreau wrote *A Week on the Concord and Merrimack Rivers* and was inspired to write his masterpiece *Walden; or, Life in the Woods*, which he finished and published seven years later. After vacating Walden, Thoreau lived alternately at his parents' house (less than an hour's walk from his cabin) and Emerson's house (about a mile and a half away).

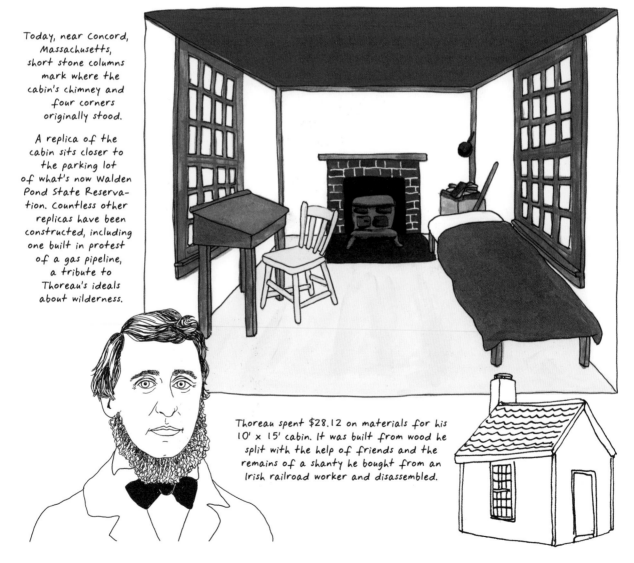

Today, near Concord, Massachusetts, short stone columns mark where the cabin's chimney and four corners originally stood.

A replica of the cabin sits closer to the parking lot of what's now Walden Pond State Reservation. Countless other replicas have been constructed, including one built in protest of a gas pipeline, a tribute to Thoreau's ideals about wilderness.

Thoreau spent $28.12 on materials for his 10' x 15' cabin. It was built from wood he split with the help of friends and the remains of a shanty he bought from an Irish railroad worker and disassembled.

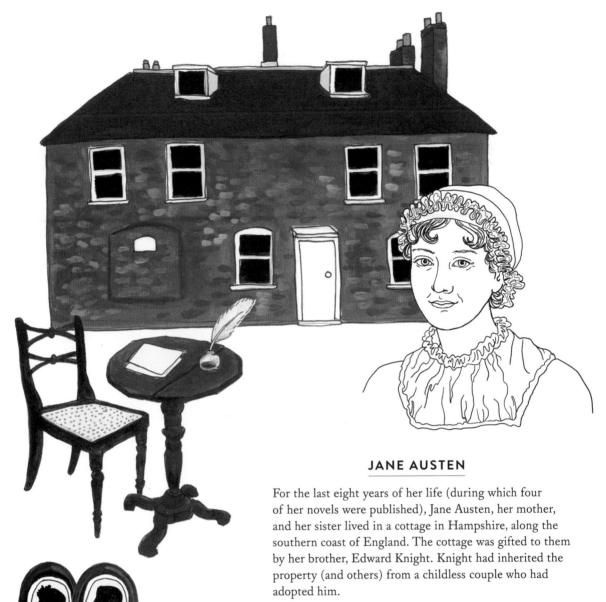

JANE AUSTEN

For the last eight years of her life (during which four of her novels were published), Jane Austen, her mother, and her sister lived in a cottage in Hampshire, along the southern coast of England. The cottage was gifted to them by her brother, Edward Knight. Knight had inherited the property (and others) from a childless couple who had adopted him.

That cottage is now the Jane Austen House Museum (also known as Chawton Cottage), home to a library that includes an original manuscript handwritten by Austen, early editions of her novels, and works by other women who either inspired Austen or were inspired by her.

The most sought and awe-worthy artifact in the museum might be Austen's tiny desk (if you can even call it that!). The walnut dodecagon table is just barely big enough for a few sheets of paper, a quill pen, and an inkwell.

Other items at the museum include Austen's small gold ring with a turquoise stone and small framed silhouettes of Austen's parents.

NOVELS OF THE EARLY 1900S: DISENCHANTMENT

The 1900s took flight on the tailwinds of colonialism and the industrial revolution, propelled by advancements in automobiles and aviation. World War I killed many millions, and the Great Depression raised unemployment in the US to 25%. Disillusioned, writers of this era tossed off the rose-colored glasses of Romanticism to portray the world as it was: horribly incomprehensible. Joseph Conrad published *Heart of Darkness* in 1899, finding no difference between so-called civilized people and savages, and Virginia Woolf declared that human character underwent a fundamental change "on or about December 1910," resulting in "a change in religion, conduct, politics, and literature" that we now think of as modernism.

After publishing more than 50 novels, short stories, plays, and essays, Zora Neale Hurston died broke and alone in a welfare home and was buried in an unmarked grave. In 1973, the author Alice Walker went to Eatonville, Florida, pretending to be Hurston's niece, to find her resting place. While Hurston had lived in Eatonville (the setting for *Their Eyes Were Watching God*), Walker eventually found what's believed to be her grave in Fort Pierce and bought a headstone for it. Along the way, Walker discovered that Hurston grew azaleas, morning glories, gardenias, and a robust vegetable garden, accompanied by her brown-and-white dog, Sport.

From a young age, Virginia Woolf relished the physical act of writing words on paper. She would experiment with different pens to find the ideal sensation. Mont Blanc now makes a "Writer's Edition" pen named after her.

In 265,000 words, or approximately 732 pages, James Joyce's *Ulysses* tells the story of just one ordinary day in the life of Leopold Bloom, the 16th of June, 1904. Joyce fans now celebrate the date as Bloomsday.

Random House 1934 hardcover, design by Ernst Reichl

This is a chair you might have sat in to read these books: Le Corbusier, Charlotte Perriand, and Pierre Jeanneret's LC2, 1928.

Virginia Woolf's *To the Lighthouse* used the then-new stream-of-consciousness narrative technique (as did her *Mrs. Dalloway* in 1925, and, before that, Joyce's *Ulysses* in 1922). The book glitters with insights into the timeless questions of life, like *What is happiness?* and *What are we doing here?*

Hogarth Press 1927 hardcover, design by Vanessa Bell, Woolf's sister

MORE

- *The Good Earth* by Pearl S. Buck
- *Rebecca* by Daphne Du Maurier
- *The Sound and the Fury* by William Faulkner
- *The Great Gatsby* by F. Scott Fitzgerald
- *The Good Soldier* by Ford Madox Ford
- *Howards End* by E. M. Forster
- *The Trial* by Franz Kafka
- *Gone with the Wind* by Margaret Mitchell
- *Nausea* by Jean-Paul Sartre
- *The Hobbit* by J. R. R. Tolkien

BELOVED BOOKSTORES

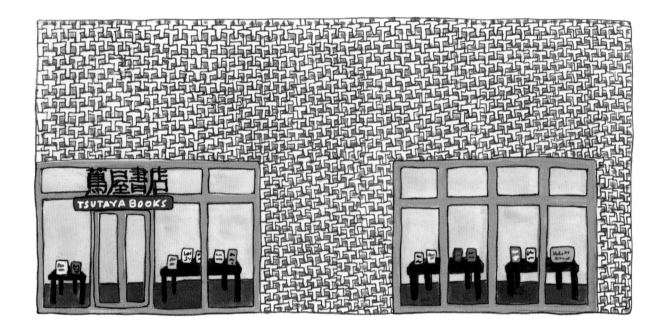

DAIKANYAMA TSUTAYA

Tokyo, Japan

Created with the idea of "a library in the woods" in mind, Daikanyama Tsutaya is a sprawling refuge from the teeming streets of Tokyo. Three buildings are smartly linked by Ts—a nod to the building's owner from its designers at Klein Dytham Architecture. The buildings grow into a forest complete with racks for bikes and knobs for dog leashes, so that both may wait as their owners while away hours and hours, browsing Daikanyama Tsutaya's epic wares.

Readers will not only find rooms upon rooms of books—Japanese and Western titles covering food, travel, cars and motorcycles, architecture and design, art, humanities, and literature side by side—but also CD and DVD archives, and a stationery section that even includes quill pens.

I LOVE BOOKS.

The T-site complex also includes a lounge, a travel concierge, a toy store, a camera shop, a vet, and a pet hotel.

A second-floor salon specializes in vintage magazines, featuring more than 30,000 Japanese and international issues, mostly from the 1960s and '70s. Too much great stuff for one building—good thing there are three.

UNITY BOOKS

Auckland, New Zealand

Unity Books' Auckland location makes big promises. Text that wraps around the store's exterior reads:

"What's in Unity Books? ★ Something that sings ★ That argues ★ That tells a story ★ Something wonderful ★ Something that can see the future ★ Something that seduces ★ Excites."

With another location in Wellington, the store delivers New Zealand authors, international titles, and "a lamentable section of vampire porn." They can find just about anything else and will "import odd, mysterious titles from across oceans just for you."

TYPE BOOKS

Toronto, Ontario, Canada

Comfortable, modern, pretty, and bright is just the type of bookstore Joanne Saul and Samara Walbohm daydreamed about opening while completing their dissertations on Canadian literature. A decade later, Type Books was born.

Type Books is known for both local and viral marketing efforts. The front shop window regularly features incredibly crafted, finely detailed cut-paper displays by Kalpna Patel that show off a smartly edited collection of books.

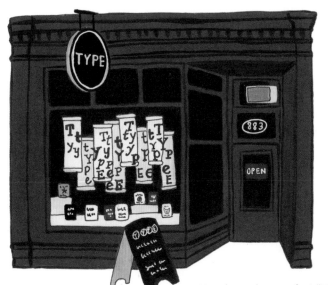

The store also created "The Joy of Books," a short, paper-crafted, stop-motion video about the secret lives of books after booksellers go home at night that has been viewed more than four million times (www.typebooks.ca/posts/28).

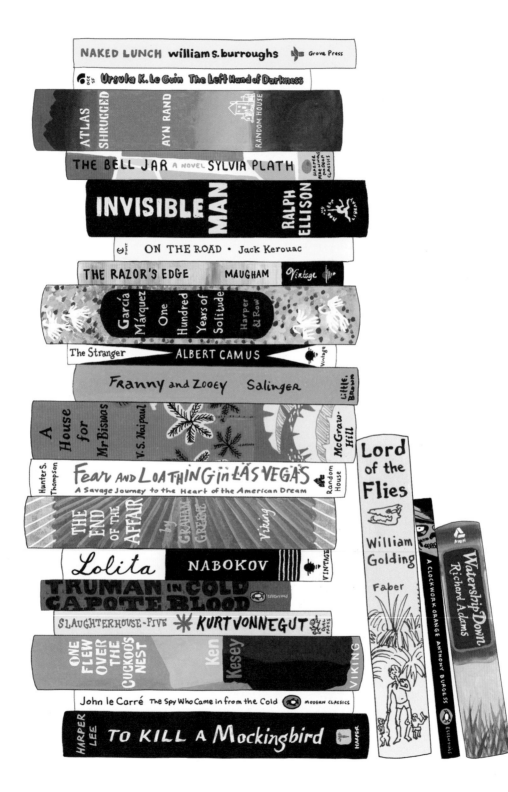

MID-CENTURY NOVELS: LOSING IT

Culture shattered and scattered in the wake of World War II. Writers picked up the pieces and reassembled them into new forms of literature, which came to be known as postmodernism. But postmodernism is tricky to pin down. Some authors turned to dystopias or satire, others wrote fiction based on real life or used fictional storytelling methods to write "nonfiction novels," known as New Journalism.

Truman Capote traveled to Kansas to write *In Cold Blood*, accompanied by his friend Harper Lee. The two assembled thousands of pages of notes from interviews. Capote dedicated the book to Lee but didn't acknowledge her contributions.

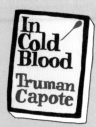

Random House
1965 hardcover
design by S. Neil Fujita

Harper & Row
1970 hardcover,
design by
Guy Fleming

Gabriel García Márquez's *One Hundred Years of Solitude* has been translated into 37 languages. The English translation is by Gregory Rabassa, who was born in Yonkers to a Cuban father and New Yorker mother. García Márquez said Rabassa's version was better than the original.

In his National Book Award acceptance speech, Ralph Ellison said the significance of *Invisible Man* was its experimental style, its "prose which was flexible, and swift as American change is swift, confronting the inequalities and brutalities of our society forthrightly, but yet thrusting forth its images of hope, human fraternity, and individual self-realization." Barack Obama cites the book as an inspiration.

Ursula K. Le Guin's *The Left Hand of Darkness* is about a male traveler's visit to a planet of ambisexual beings, and how sex and gender affect culture.

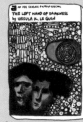

1969 Ace mass-market paperback cover art by Leo and Diane Dillon

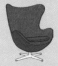

This is a chair you might have sat in to read these books: Arne Jacobsen's Egg, 1958.

Sylvia Plath originally published *The Bell Jar* under the pseudonym Victoria Lucas, in part because it was so close to real people and events. She and her protagonist both interned at a women's magazine in New York, both women ate an entire bowl of caviar at a luncheon, and both suffered from depression and attempted suicide. Plath eventually did kill herself by placing her head in an oven with the gas on.

MORE

- *Giovanni's Room* by James Baldwin
- *Catch-22* by Joseph Heller
- *The Old Man and the Sea* by Ernest Hemingway
- *Love in a Cold Climate* by Nancy Mitford
- *The Godfather* by Mario Puzo
- *The Little Prince* by Antoine de Saint-Exupéry
- *A Tree Grows in Brooklyn* by Betty Smith
- *East of Eden* by John Steinbeck
- *Rabbit, Run* by John Updike
- *All the King's Men* by Robert Penn Warren

ICONIC COVERS

Books were originally hand-bound and expensive. They originally had leather covers meant to protect the paper within, but in the early 19th century new machines allowed for cloth covers. Dust jackets were invented to protect nice fabric, at least until a buyer got the book home. But around the 1830s, publishers saw an opportunity and began to market the book on the jacket.

At the end of the century, *The Yellow Book*, a literature quarterly, began using avant-garde designs on its covers, many by Aubrey Beardsley, its first art editor. In the 1920s, during the inspiring postwar period of Soviet and German design, publishers began turning to artists for covers, and by the mid-20th century designers were creating striking, unforgettable combinations of images and type.

Fitzgerald was still writing the novel when Cugat, a Spanish artist, was hired to illustrate the cover. The writer loved it and told his publisher that he had "written it into the book." It was the only cover Cugat ever designed, and he was paid $100 for it. ⤷

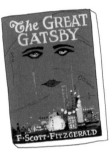

THE GREAT GATSBY

by F. Scott Fitzgerald

Scribners 1925 hardcover, art by Francis Cugat

MOBY DICK

by Herman Melville

Random House 1930 hardcover, art by Rockwell Kent

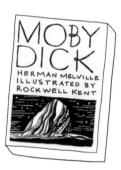

THREE LIVES

by Gertrude Stein

New Directions New Classics hardcover 1945, design by Alvin Lustig

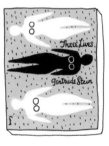

In less than 10 years Lustig designed more than 70 amazing modern covers for New Directions' New Classics series. He worked on the series right up until his death in 1955, at age 40, from diabetes that he'd developed as a teenager.

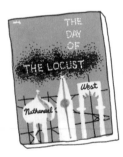

THE DAY OF THE LOCUST

by Nathanael West

New Directions New Classics hardcover 1950, design by Alvin Lustig

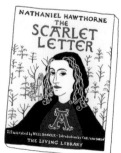

THE SCARLET LETTER

by Nathaniel Hawthorne

World Publishing Co. 1946 hardcover, art by Nell Booker

THE CATCHER IN THE RYE

by J. D. Salinger

Little, Brown 1951 hardcover, design by E. Michael Mitchell

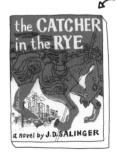

Salinger had strong opinions about the covers of his books and insisted the only copy that could appear on them were his name and the book's title (no blurbs, bios, or summary). He and Mitchell, who drew the carousel horse, had been friends for over 40 years, having met as neighbors in Westport, Connecticut.

INVISIBLE MAN

by Ralph Ellison

Random House 1952 hardcover, design by Edward McKnight Kauffer

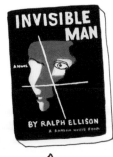

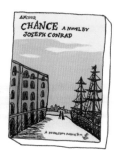

McKnight Kauffer designed advertising posters, including many for the London Underground and American Airlines. He considered book jackets to be mini-posters.

CHANCE

by Joseph Conrad

Doubleday Anchor 1957 paperback, art by Edward Gorey

Gorey is better known for the books he both wrote and illustrated, like "The Gashlycrumb Tinies," but he also designed many covers while working in the Doubleday art department in the 1950s.

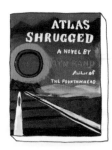

ATLAS SHRUGGED

by Ayn Rand

Random House 1957 hardcover, design by George Salter

DUBLINERS

by James Joyce

Compass 1959 paperback, design by Ellen Raskin

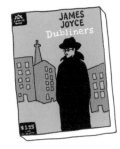

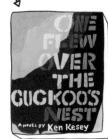

TO KILL A MOCKINGBIRD

by Harper Lee

Lippincott 1960 hardcover, design by Shirley Smith

Bacon designed covers for more than 6,500 books and was known for the "big book look," with large type and simple, colorful imagery. About the design process, he once said, "I'd always tell myself, 'You're not the star of the show. The author took three-and-a-half years to write the goddam thing, and the publisher is spending a fortune on it, so just back off.'"

ONE FLEW OVER THE CUCKOO'S NEST

by Ken Kesey

Viking Press 1962 hardcover, design by Paul Bacon

Pelham was Penguin's art director and had hired an illustrator to create an image for the cover that would feel like a movie poster, since Stanley Kubrick's movie was soon to be released. When the illustrator fell through, he created the enduring image himself, very last-minute.

THE BELL JAR

by Sylvia Plath

Faber 1966 hardcover, design by Shirley Tucker

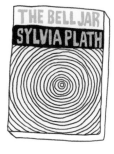

← To create the unforgettable cover image, Tucker used a drafting compass to make wider and wider circles, then cropped it perfectly.

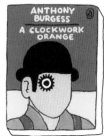

A CLOCKWORK ORANGE

by Anthony Burgess

Penguin 1972 paperback, design by David Pelham

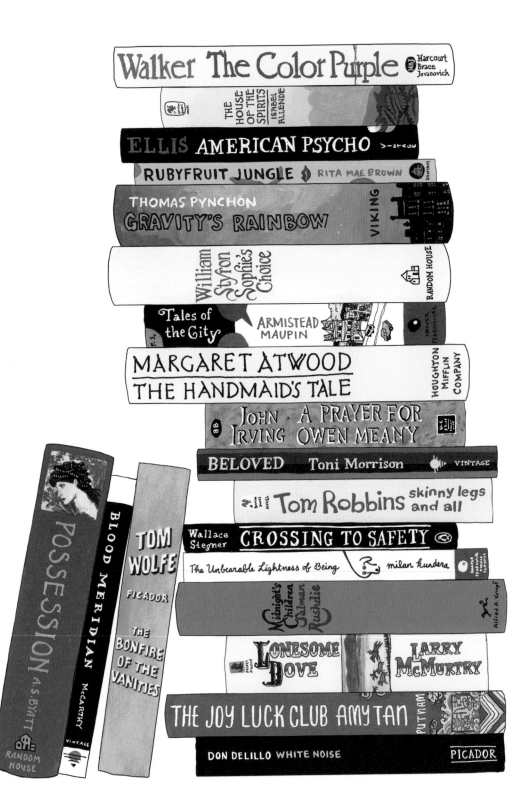

NOVELS OF THE LATE 1900S: GREED & GROWTH

A 1976 *New York Magazine* cover story by Tom Wolfe defined the 1970s as "The 'Me' Decade." The 1980s brought the "yuppie" and MTV. Consumerism was on the rise, until Black Monday brought global markets to a halt. The Vietnam War was dwindling as the Cold War ratcheted up. But it got better. The Berlin Wall fell. Nelson Mandela was finally freed. And in literature, "Me" was proving to be an increasingly diverse cast of characters. Readers devoured stories by and about people of many ethnicities, genders, and sexual orientations. Taking it all in, you may think (a little bit like John Irving) that life, in its multitudes, is miraculous.

On January 8, 1981, Isabel Allende received the news that her grandfather was dying. That day, she started a farewell letter to him, chronicling everything he had ever told her about his life, their family, and their country. By the end of the year, she had the first manuscript for *The House of the Spirits.* Since then, Allende has started each of her novels on January 8.

Though Cormac McCarthy's *Blood Meridian* is called one of the best American novels, many critics admit to having a hard time reading it, due to the intense violence it depicts. It's not surprising that all attempts to turn the book into a movie have failed.

Random House 1985 hardcover, art by Salvador Dalí, design by Richard Adelson

In a 1989 interview, Toni Morrison noted the lack of memorials for victims of the slave trade: "There is no suitable memorial, or plaque, or wreath, or wall, or park, or skyscraper lobby. There's no 300-foot tower, there's no small bench by the road. . . ." Her words inspired the installation of such small benches by the road in locations from Sullivan's Island, South Carolina, to Fort-de-France, Martinique.

In 2017 Amy Tan released a memoir called *Where the Past Begins*. She confronts difficult aspects of her life—her mother left a first family in China to emigrate to California, and when Tan was 14, her father and brother both died of brain tumors.

This is a chair you might have sat in to read these books: Marc Newson's Lockheed Lounge (LC1), 1985.

MORE

- *The Prince of Tides* by Pat Conroy
- *VALIS* by Philip K. Dick
- *Geek Love* by Katherine Dunn
- *The Lover* by Marguerite Duras
- *Foucault's Pendulum* by Umberto Eco
- *Neuromancer* by William Gibson
- *The Stand* by Stephen King
- *The English Patient* by Michael Ondaatje
- *The Shipping News* by Annie Proulx
- *Interview with the Vampire* by Anne Rice

BELOVED BOOKSTORES

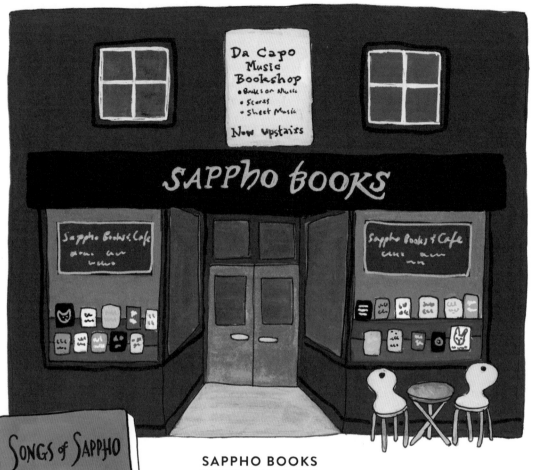

Peter Pauper Press
1966 hardcover, art
by Stanley Wyatt

SAPPHO BOOKS

Sydney, New South Wales, Australia

Sappho Books is a sprawling compound in Sydney, with indoor and outdoor spaces spread out over three floors. It's also home to a café, a bar, and a self-service, secondhand music shop. Fans call it magical, inspirational, and eclectic.

Sappho was an archaic Greek poet from the island of Lesbos, best known for her lyric poems about love and women. Paying fair due to its name, Sappho Books hosts Sydney's biggest poetry event, on the second Tuesday of each month.

POWELL'S

Portland, Oregon, USA

For booklovers, Powell's is almost synonymous with Portland, but the store got its start in 1970 in Chicago. A graduate student, Michael Powell, was encouraged by friends, including Saul Bellow, to open a store. He borrowed $3,000 to do so and was so successful he paid back the loan in two months. Michael's father, Walter, a retiring painting contractor, worked in the store over the summer and loved it so much, he decided to open his own store in Oregon, in 1971. Third-generation Powell's owner Emily now presides over five Powell's storefronts around the Portland area.

If Emily had any more room in her store, she'd add space for people to stay overnight.

Powell's flagship store, City of Books, is the largest independent used and new bookstore in the world. Occupying an entire city block, in a former car dealership (look closely and you can see clues to the building's past), the store carries about a million books.

NOVELS OF THE MILLENNIUM: OPTIMISTIC CONFUSION

Another *fin de siècle*, another existential crisis. Instead of print media, people were consuming cable news and the internet. Natural disasters were devastating developing countries, and developed countries were worried about Y2K. The US was attacked by domestic and foreign terrorists and started a war on terror. Thankfully, as always, we could find hope and refuge in books.

When *Infinite Jest* was published, David Foster Wallace had never used the internet. Yet in the book, he predicts videoconferencing on smartphones. People in the book initially love the feature, but it falls out of favor quickly due to emotional stress and physical vanity.

Wallace thought the cover resembled an American Airlines safety booklet. According to his editor, he had suggested an image of a "giant modern sculpture made of industrial trash."

Little, Brown 1996 hardcover, design by Steve Snider

day just decided to try his hand at a novel. He says his style is very influenced by music, especially jazz.

Sceptre 2014 paperback edition, design by Kai & Sunny

David Mitchell's many novels seem quite different from each other, from the time-hopping *Cloud Atlas*, to the historical *Thousand Autumns of Jacob de Zoet*, to the semiautobiographical *Black Swan Green*, to the fantastical *The Bone Clocks*. Paying close attention, though, reveals that all the books combine into a single, connected cosmology, with characters reappearing in several books.

This is a chair you might have sat in to read these books: Marcel Wanders's Knotted Chair, 1996.

Arundhati Roy won the Man Booker Prize for *The God of Small Things*. She published her second novel, *The Ministry of Utmost Happiness*, 20 years later. In that time she became an activist, writing several books' worth of searing political essays, including "The End of Imagination," which argues against nuclear-bomb testing.

Haruki Murakami began writing at 29. At the time he ran a coffee house/jazz club in Tokyo and one

MORE

- *Oryx & Crake* by Margaret Atwood
- *Jonathan Strange & Mr. Norrell* by Susanna Clarke
- *Disgrace* by J. M. Coetzee
- *The Hours* by Michael Cunningham
- *The Line of Beauty* by Alan Hollinghurst
- *High Fidelity* by Nick Hornby
- *The Kite Runner* by Khaled Hosseini
- *The Time Traveler's Wife* by Audrey Niffenegger
- *Austerlitz* by W. G. Sebald
- *Snow Flower and the Secret Fan* by Lisa See

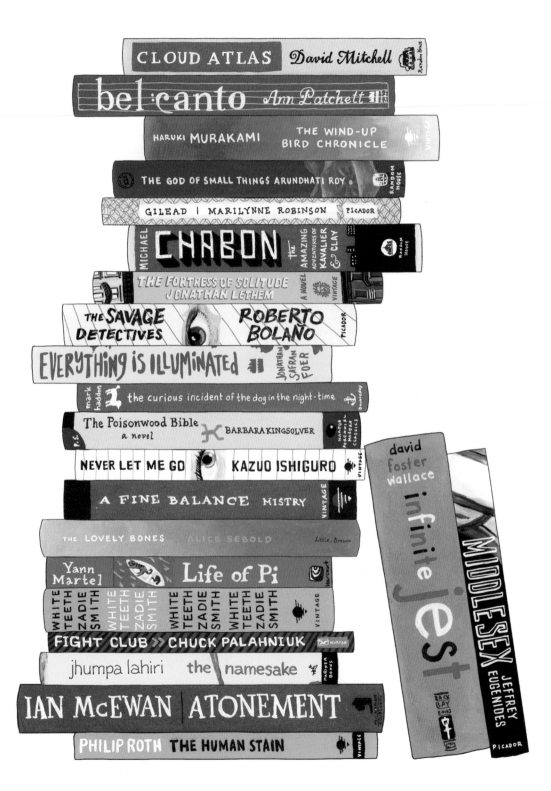

WRITER-OWNED BOOKSTORES

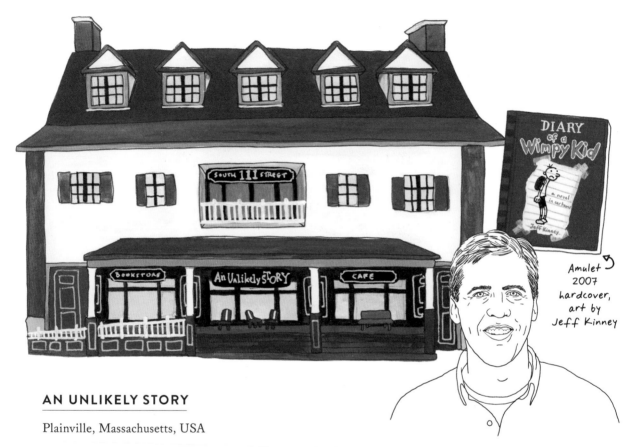

Amulet
2007
hardcover,
art by
Jeff Kinney

AN UNLIKELY STORY

Plainville, Massachusetts, USA

Jeff Kinney might have one of the unlikeliest of unlikely stories. The author of *Diary of a Wimpy Kid* first set out wanting to be a Bureau of Alcohol, Tobacco, Firearms, and Explosives agent. Instead, he became a programmer at a medical software company and then a game designer at Funbrain, an educational gaming website. He and his wife moved to Plainville, Massachusetts, in part because it was close to Funbrain's Boston HQ. Eventually, Funbrain invited Kinney to post a loosely autobiographical comic strip he had been working on as a side project for six years. Soon millions of young readers were Wimpy Kid fans.

Two years later, Kinney sold the comic to the publishing house Abrams. Even with his fame and fortune (the wild success garnered Kinney $20 million in 2014 alone), he decided to stay in Plainville, and even to invest in it. He bought a decrepit building in the town's center that had been a barbershop, a drugstore, a tearoom, and a general store before sitting vacant for nearly two decades. After entertaining other ideas from his primary audience—a group of local fifth-graders—including a roller coaster and a swimming pool filled with M&Ms, Kinney settled on a bookstore for his newest flight of fancy.

PARNASSUS BOOKS

Nashville, Tennessee, USA

Author Ann Patchett watched two chain bookstores open and close in her hometown (one of which had taken over a cherished indie bookstore, Davis-Kidd). The profitable-but-apparently-not-profitable-enough sellers left Nashville without a bookstore to call its own. Instead of a loss, Patchett saw an opportunity to give the city once known as the Athens of the South the bookstore it deserved. She joined forces with her friends Karen Hayes and Mary Grey James, both publishing industry veterans, to open Parnassus Books in November 2011.

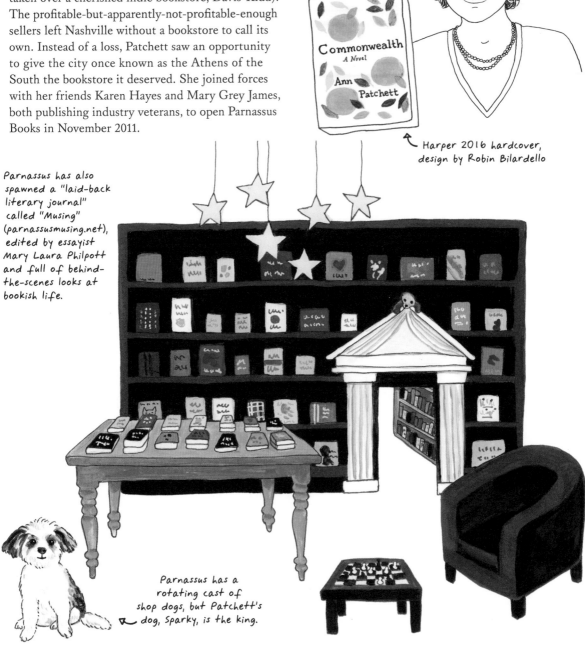

Harper 2016 hardcover, design by Robin Bilardello

Parnassus has also spawned a "laid-back literary journal" called "Musing" (parnassusmusing.net), edited by essayist Mary Laura Philpott and full of behind-the-scenes looks at bookish life.

Parnassus has a rotating cast of shop dogs, but Patchett's dog, Sparky, is the king.

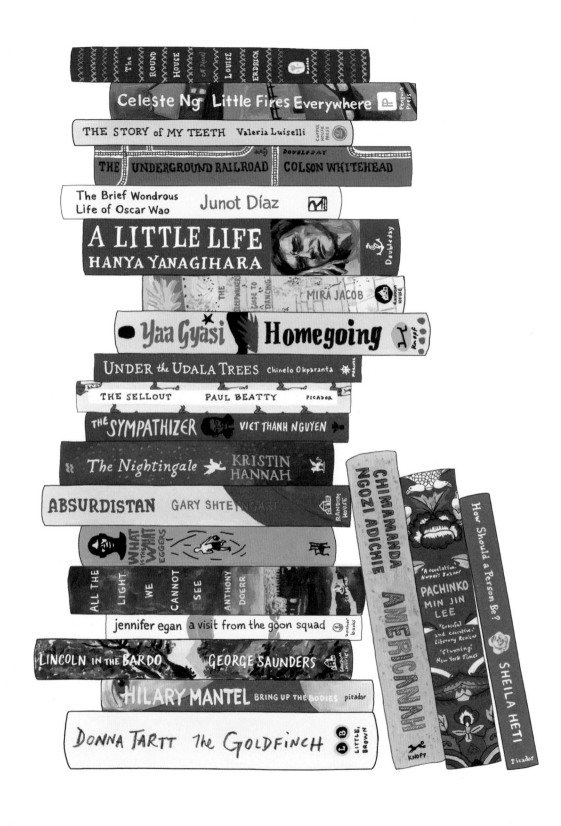

NOVELS OF THE 21ST CENTURY: THE SHRINKING WORLD

In the third millennium, the world's as wonderful and wicked as ever. Sales of *1984* increased almost 10,000% after the US presidential election of 2016, and 26% of American adults didn't read a single book that year. Instead, one billion hours of video were watched on YouTube daily. But social media was also credited with catalyzing pro-democracy uprisings across the Middle East. Change every-where forced people from their homes and 65.3 million became refugees. As they have always done, books gave us windows into other lives and worlds, making us more open to this constant change.

In 2017, the mayor of New York City launched One Book, One New York, a citywide book club. Five books were chosen; the public voted; and Chimamanda Ngozi Adichie's *Americanah* won. Penguin Random House gave 1,500 copies to the city's public libraries, and local Barnes & Noble sales of the book increased by 400%.

Knopf 2013 hardcover, design by Abby Weintraub

Hanya Yanagihara's *A Little Life* is anything but little, physically or emotionally. The 700+-page novel deals with what trauma steals from us, and how friendships help us but can't save us. She lives in a one-bedroom Manhattan apartment with over 12,000 books, organized alphabetically by author. (She feels anyone arranging them by color "doesn't truly care what's in the books.")

This is a chair you might have sat in to read these books: Zaha Hadid's Tippy, 2016.

"Wao" is "Wilde," spoken with a Spanglish accent. Junot Díaz recounts an evening when an acquaintance started talking about his favorite writer in the world: "I love Oscar Wao. Oscar Wao is bril-liant." Díaz went to sleep that night with the inspi-ration for *The Brief Wondrous Life of Oscar Wao.*

The mongoose appears throughout Díaz's book as a force of good. In a "New York Times" essay, Díaz wrote that mongooses were brought to the Carib-bean to work in the fields just like his people and were also able to "become free, and flourish."

MORE

- *The Sense of an Ending* by Julian Barnes
- *Room* by Emma Donoghue
- *My Brilliant Friend* by Elena Ferrante
- *Freedom* by Jonathan Franzen
- *The Great Fire* by Shirley Hazzard
- *Tree of Smoke* by Denis Johnson
- *Beast* by Paul Kingsnorth
- *The Road* by Cormac McCarthy
- *The Light Between Oceans* by M. L. Stedman
- *My Absolute Darling* by Gabriel Tallent

BEAUTIFUL CONTEMPORARY COVERS

Whether or not you think judging a book by its cover is a good idea, we do it all the time. Here are a bunch of amazing ones recently published. For more, check out The Casual Optimist (casualoptimist.com), a review of great cover design run by Dan Wagstaff; and *Spine* (spinemagazine.co), an online magazine covering book creation founded by Emma J. Hardy and edited by Eric C. Wilder.

THE UNDERGROUND RAILROAD

by Colson Whitehead

Doubleday 2016 hardcover, design by Oliver Munday

THE MASTER AND MARGARITA

by Mikhail Bulgakov

Vintage Classics 2010 paperback, design by Suzanne Dean

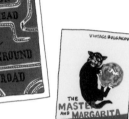

THE PICTURE OF DORIAN GRAY

by Oscar Wilde

Penguin 2009 hardcover, design by Coralie Bickford-Smith

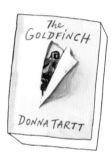

THE GOLDFINCH

by Donna Tartt

Little, Brown 2013 hardcover, design by Keith Hayes

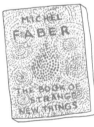

THE BOOK OF STRANGE NEW THINGS

by Michel Faber

Canongate Books 2014 hardcover, design by Rafi Romaya, art by Yehrin Tong

Bickford-Smith designed the Penguin Clothbound series, a large set of foil-stamped, cloth-covered classic books, each featuring a pattern of symbolic imagery from the story. The first books in the series were released in the UK in 2008.

Bickford-Smith is also the author of two children's books, "The Fox and the Star" and "The Worm and the Bird."

WE ARE OKAY

by Nina LaCour

Dutton 2017 hardcover, design by Samira Iravani, art by Adams Carvalho

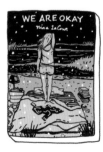

GIRL IN PIECES

by Kathleen Glasgow

Delacorte Press 2016 hardcover, design by Jen Heuer

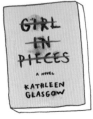
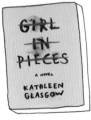

THE SELLOUT

by Paul Beatty

Farrar, Straus and Giroux 2015 hardcover, design by Rodrigo Corral, art by Matt Buck

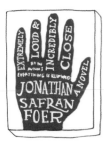

EXTREMELY LOUD AND INCREDIBLY CLOSE

by Jonathan Safran Foer

Houghton Mifflin Harcourt
2005 hardcover,
design by John Gray

THE METAMORPHOSIS & OTHER STORIES

by Franz Kafka

Schocken 2009 paperback,
design by Peter Mendelsund

Mendelsund's covers have won many design awards, and he has written two books himself: "Cover," about his brilliant work, and "What We See When We Read," about how words create mental images.

Yes, the text is upside down! Get it?

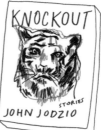

BUT WHAT IF WE'RE WRONG?

by Chuck Klosterman

Blue Rider Press
2016 hardcover, design
by Paul Sahre

NORWEGIAN WOOD

by Haruki Murakami

Vintage 2000
paperback, design
by John Gall

Vintage released a comprehensive (at the time) set of Murakami books in 2000, all designed by Gall with a consistent look and feel. Gall designed a new set (including Murakami's recent books) in 2015, and when the covers are viewed all together they create a "map" of Murakami's surreal universe.

STAY WITH ME

by Ayobami Adebayo

Knopf 2017 hardcover,
design by Janet Hansen

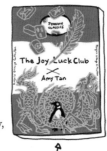

KNOCKOUT

by John Jodzio

Soft Skull Press
2016 paperback,
design by
Matt Dorfman

NEVER LET ME GO

by Kazuo Ishiguro

Vintage
2006 paperback,
design by Jamie Keenan,
photo by Gabrielle
Rever/Getty Images

THE STRANGER

by Albert Camus

Vintage
1989 paperback,
design by
Helen Yentus

THE JOY LUCK CLUB

by Amy Tan

Penguin Classics
2016 paperback,
design by Paul Buckley,
art by Eric Nyquist

For the Penguin Orange Collection, creative director Paul Buckley worked with illustrator Eric Nyquist to update the iconic orange and white Penguin Classic cover in a clever, playful way for a set of twelve American books.

MOONGLOW

by Michael Chabon

HarperCollins
2016 hardcover,
design by
Adalis Martinez

HISTORICAL FICTION

The authors of these stories sometimes write about real figures, but often make up exemplary individuals to show us the truths of the time more clearly. After all, facts and dates are easier to retain when someone you "know" lives through them, whether it's Roman emperor Claudius, Hester Prynne, or Tom Builder. Even better if the story's told around a fire. It's believed that many epic tales about historical events—like *The Iliad*, *Beowulf*, and the *Njáls Saga* from Iceland—were shared orally long before they were written down. Historical fiction may be the original and most enduring form of edutainment.

As soon as she began *Wolf Hall*, Hilary Mantel was certain it would be the best thing she'd ever written. She's the first woman to win the Man Booker Prize twice, for *Wolf Hall* in 2009, and then for its 2012 sequel, *Bring Up the Bodies*. Both focus on Thomas Cromwell, chief minister to King Henry VIII of England in the 1500s.

Marlon James's *A Brief History of Seven Killings* also won the Man Booker Prize, in 2015. It's an epic tale, told by 15 characters, of Jamaica in the 1970s and the attempted assassination of Bob Marley.

A Suitable Boy is a 19th-century-style novel set in the 1950s, published in 1993. Vikram Seth's almost 600,000-word tome (You will love every word! And learn so much!) about India just after independence focuses on Lata Mehra, a 19-year-old college student, and everyone around her as she comes of age.

The title of Chinua Achebe's *Things Fall Apart* comes from W. B. Yeats's poem "The Second Coming." It was one of the first novels about Africa written by an African.

← *Anchor 2008 paperback, art by Edel Rodriguez, design by Helen Yentus*

NOT BAD, RIGHT?

Death is of course present, directly or not, in every historical novel, but perhaps the only novel it narrates is *The Book Thief*.

MORE

- *The Red Tent* by Anita Diamant
- *The Name of the Rose* by Umberto Eco
- *Sea of Poppies* by Amitav Ghosh
- *The Signature of All Things* by Elizabeth Gilbert
- *The Other Boleyn Girl* by Philippa Gregory
- *Hawaii* by James Michener
- *Paris* by Edward Rutherfurd
- *The Twentieth Wife* by Indu Sundaresan
- *War and Peace* by Leo Tolstoy
- *The Winds of War* by Herman Wouk

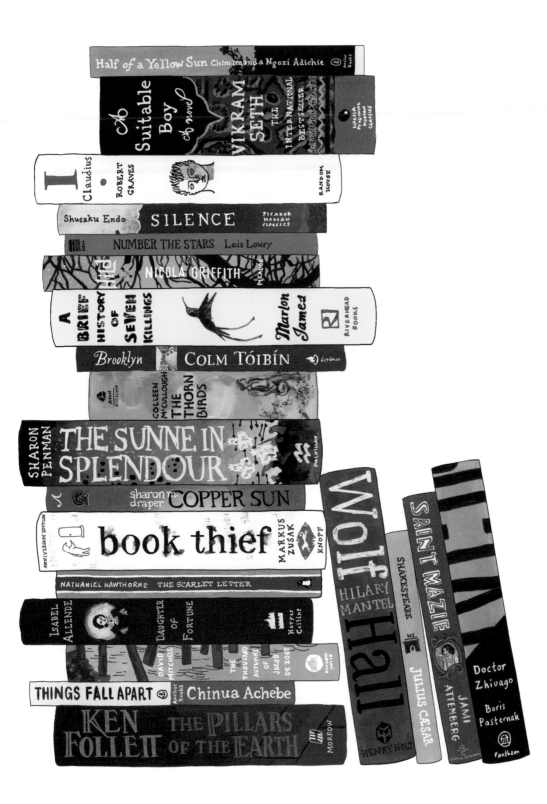

TYPES OF FICTION

There are many different structures and styles in which to write a work of fiction, and you can slice and dice them endlessly. Here are some that were very popular once, and a few that still are.

Bantam 2015 paperback, design & art by Rachel Willey

PICARESQUE

Originating in 16th-century Spain, these stories recount the episodic adventures of a wandering rogue, or *pícaro*.

Examples: *Don Quixote* by Miguel de Cervantes, *Candide* by Voltaire, and *Rubyfruit Jungle* by Rita Mae Brown

GOTHIC

These scary, creepy, or ghostly stories are usually set in large old buildings, and were extremely popular in 19th-century England.

Examples: *The Haunting of Hill House* by Shirley Jackson, *Interview with the Vampire* by Anne Rice, and *The Fall of the House of Usher & Other Stories* by Edgar Allan Poe

Vintage Classics 2010 paperback

EPISTOLARY

These narratives are told through documents such as letters, emails, or journal entries.

Examples: *Bridget Jones's Diary* by Helen Fielding, *Les liaisons dangereuses* by Pierre Choderlos de Laclos, and *The Color Purple* by Alice Walker

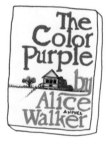

Harcourt Brace Jovanovich 1982 hardcover, design by Judith Kazdym Leeds

Simon & Schuster 1987 hardcover, design & art by George Corsillo

ROMAN À CLEF

These novels recount real lives and events thinly disguised as fiction.

Examples: *Oranges Are Not the Only Fruit* by Jeanette Winterson, *All the King's Men* by Robert Penn Warren, and *Postcards from the Edge* by Carrie Fisher

Random House 2016 hardcover, design by Peter Mendelsund, lettering by Jenny Pouech

BILDUNGSROMAN

In these works, a young person gets an education of some sort and comes of age.

Examples: *A Portrait of the Artist as a Young Man* by James Joyce, *The Goldfinch* by Donna Tartt, and *The Girls* by Emma Cline

SOCIAL

Popular during the industrial revolution, these are novels that shed light on the crappy life conditions of a group of people.

Examples: *Native Son* by Richard Wright, *Behold the Dreamers* by Imbolo Mbue, and *Bleak House* by Charles Dickens

Penguin 2011 hardcover, design by Coralie Bickford-Smith

MAGICAL REALISM

Originating in Latin America in the early 20th century, these are stories set in the real world but with a little magic thrown in, without fanfare.

Examples: *One Hundred Years of Solitude* by Gabriel García Márquez, *Midnight's Children* by Salman Rushdie, and *Exit West* by Mohsin Hamid

Riverhead Books 2017 hardcover, design by Rachel Willey

SATIRICAL

These novels challenge the status quo and the powers-that-be through irony and sarcasm.

Examples: *Animal Farm* by George Orwell, *The Sellout* by Paul Beatty, and *Gulliver's Travels* by Jonathan Swift

Vintage Classics 2007 paperback

METAFICTION

These stories remind you with a nod and a wink that they are stories, not real life, often by nestling other stories within themselves.

Examples: *Slaughterhouse-Five* by Kurt Vonnegut, *The Blind Assassin* by Margaret Atwood, and *If on a Winter's Night a Traveler* by Italo Calvino

Mariner Books 2015 paperback, design by Peter Mendelsund & Oliver Munday

These days, critics and readers often break novels down into just two main categories:

- **Literary Fiction** is often character-driven, concerned with how we humans think and interact.

- **Genre Fiction** is more plot-driven, and is further broken down into topics like science fiction, mystery, and fantasy.

Many writers don't like this system so much. Speaking about the genre with which she is usually associated, the great Ursula K. Le Guin said, "For most of my career, getting that label—sci-fi— slapped on you was, critically, a kiss of death." She also said:

Ursula K. Le Guin

> I don't think *science fiction* is a very good name for it, but it's the name that we've got. It is different from other kinds of writing, I suppose, so it deserves a name of its own. But where I can get prickly and combative is if I'm just called a sci-fi writer. I'm not. I'm a novelist and poet. Don't shove me into your damn pigeonhole, where I don't fit, because I'm all over. My tentacles are coming out of the pigeonhole in all directions. . . .

She noted things are now changing (and especially for her work, more critically acclaimed than ever), but she still resented the need for genre-labeling fiction and sticking authors into categories. Other writers have joined her in breaking down the walls, including David Mitchell, Kazuo Ishiguro, and N. K. Jemisin. As (Le Guin fan) Mitchell said, "The book doesn't give a damn about genre, it just is what it is."

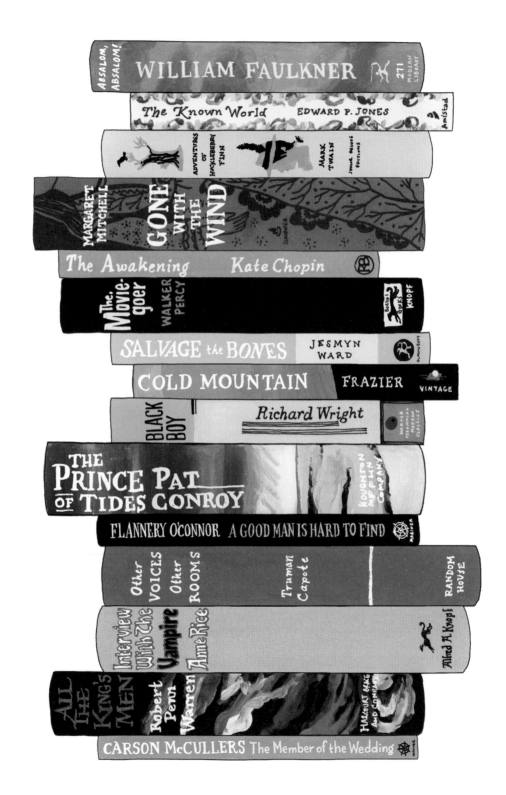

SOUTHERN LIT

We don't talk about Northern Lit in the United States, only Southern Lit. Maybe it's the heat. Characters seem both more intense and more laid-back in the South, and the stories have a stronger sense of place, infused with drama, mystery, and evening fireflies.

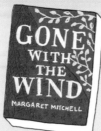

In early drafts of *Gone with the Wind*, Scarlett was called Pansy O'Hara, and she almost lived at Fountenoy Hall. Margaret Mitchell considered many possible titles for the book, including *Tomorrow Is Another Day*, *Bugles Sang True*, *Not in Our Stars*, and *Tote the Weary Load* (!). The title she finally chose is a line from the poem "Non Sum Qualis Eram Bonae sub Regno Cynarae" by Ernest Dowson.

Scribner 2017 paperback, art and design by Kimberly Glyder

In a 1956 interview, William Faulkner explained that the thesis he always hammered at was that "man is indestructible because of his simple will to freedom."

Flannery O'Connor was born in Savannah, Georgia, in 1925, and you can still visit her childhood home there.

Edward P. Jones composed *The Known World* in his head for 10 years, and then finally put it all to paper in just three months, in 2001, after being laid off from his day job at a tax journal. It won the Pulitzer Prize for Fiction in 2004.

Esch, the teenage protagonist of Jesmyn Ward's *Salvage the Bones*, obsessively reads Greek myths, both to help explain and to escape from her world, a small fictional town on the Gulf Coast called Bois Sauvage. She particularly loves the powerful and tragic tale of Medea.

Bloomsbury 2012 paperback, design by Patti Ratchford

Ward's lyrical 2017 novel, "Sing, Unburied, Sing," is also set in Bois Sauvage, a town very similar to the one she grew up and still lives in: DeLisle, Mississipi.

MORE

- *A Death in the Family* by James Agee
- *Bastard Out of Carolina* by Dorothy Allison
- *All Over but the Shoutin'* by Rick Bragg
- *Cold Sassy Tree* by Olive Ann Burns
- *A Lesson Before Dying* by Ernest J. Gaines
- *Airships* by Barry Hannah
- *To Kill a Mockingbird* by Harper Lee
- *A Confederacy of Dunces* by John Kennedy Toole
- *Delta Wedding* by Eudora Welty
- *A Streetcar Named Desire* by Tennessee Williams

BELOVED BOOKSTORES

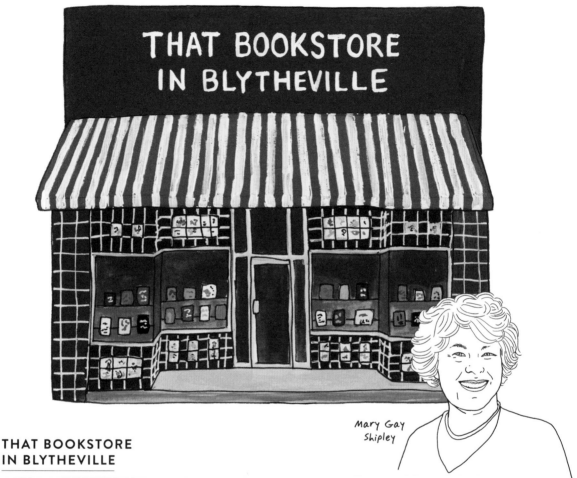

Mary Gay Shipley

THAT BOOKSTORE IN BLYTHEVILLE

Blytheville, Arkansas, USA

Initially a paperback exchange when it opened in 1976, That Bookstore in Blytheville got its name because it was the only one around in the largest city of Mississippi County, Arkansas. The store's founder, schoolteacher Mary Gay Shipley, saw a need in her community for a space to foster readers and writers alike. So she created it.

Shipley's influence extends far beyond her neighborhood. She was an early supporter of John Grisham (back when he was selling his books out of the back of his car), as well as Rebecca Wells's

Little Altars Everywhere, Terry Kay's *To Dance with the White Dog*, Melinda Haynes's *Mother of Pearl*, and David Guterson's *Snow Falling on Cedars*, prompting Malcolm Gladwell to proclaim, "People like Mary Gay Shipley don't merely predict sleeper hits; they create sleeper hits."

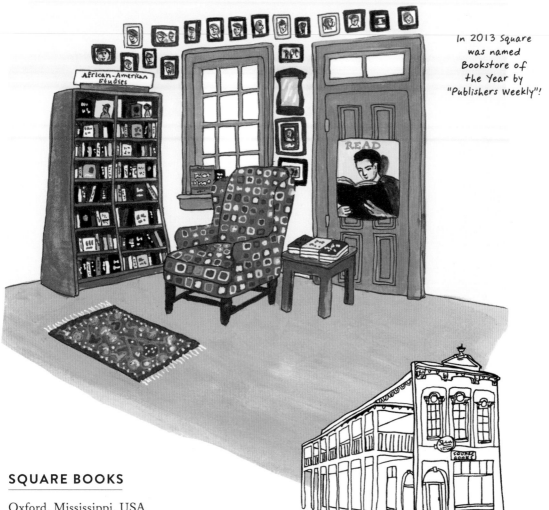

In 2013 Square was named Bookstore of the Year by "Publishers Weekly"!

The main building is a beautiful historic landmark in Oxford, formerly Blaylock Drug Store. When Square moved into it in 1986, its book sales immediately doubled. (It is just for browsing and buying books; events are held in the Off Square Books annex.)

SQUARE BOOKS

Oxford, Mississippi, USA

Square Books was founded by Richard and Lisa Howorth in 1979. It spreads across three separate buildings in the town square of Oxford, Mississippi. Early on the Howorths worked with the University of Mississippi community to bring authors such as Toni Morrison, William Styron, Alice Walker, and James Dickey to the store, and they continue to host great writers today. They also created a live radio show called *Thacker Mountain*, which includes author readings and many different types of musical performances.

LOVE & ROMANCE

What's the difference between a love story and a romance? It's most likely a love story if it includes regret, a rough patch, or greater tragedy, and is also critically regarded. See *Romeo and Juliet*, *Giovanni's Room*, and *Anna Karenina*. Critics tend to pan romances, but those are simply love stories with happy endings. In other words, Jane Austen wrote excellent romance novels.

Rainbow Rowell's *Eleanor & Park* is a story of first and true love set in the 1980s Midwest. Rowell, a former newspaper columnist and ad writer who published four successful novels in four years, met her husband in junior high school, so she knows something about love stories.

St. Martin's Griffin 2013 hardcover, art by Harriet Russell, design by Olga Grlic

Leo Tolstoy married his wife Sofia after just a few weeks of courtship, when she was 18 and he was 34. The night before their wedding, he made her read his journals, which included accounts of all his previous sexual escapades and acknowledged that one of the serfs on his property had borne him a son.

Touchstone 2009 paperback, art by Michael Koelsch

Sisters Bea and Leah Koch opened The Ripped Bodice, the first romance-novels-only bookstore, in Los Angeles in 2016. As the sisters say, "A great romance novel inspires you to believe in a happy ending for yourself." It's no wonder, then, that the genre generated more than $1 billion in sales in 2013 in the US. If you want to know more about romance novels, read *Beyond Heaving Bosoms* by Sarah Wendell and Candy Tan.

AND IF YOU WANT TO READ SOME ROMANCE, BEA AND LEAH RECOMMEND:

An Extraordinary Union
by Alyssa Cole

The Siren
by Tiffany Reisz

When a Scot Ties the Knot
by Tessa Dare

It Happened One Autumn
by Lisa Kleypas

For Real
by Alexis Hall

Slave to Sensation
by Nalini Singh

Indigo
by Beverly Jenkins

Vision in White
by Nora Roberts

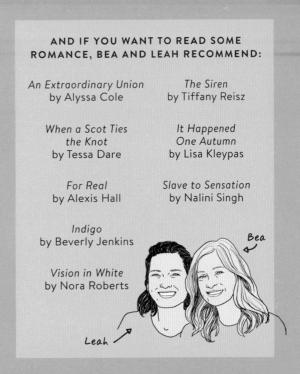

Bea

Leah

MORE

- *Chéri* by Colette
- *Captain Corelli's Mandolin* by Louis de Bernières
- *The French Lieutenant's Woman* by John Fowles
- *Cold Mountain* by Charles Frazier
- *The Hunchback of Notre Dame* by Victor Hugo
- *Atonement* by Ian McEwan
- *Brokeback Mountain* by Annie Proulx
- *Love Story* by Erich Segal
- *The Notebook* by Nicholas Sparks
- *Blankets* by Craig Thompson

SONGS ABOUT BOOKS

"1984"

by David Bowie

Album: *Diamond Dogs*

Book: *Nineteen Eighty-Four*
by George Orwell

David Bowie wanted to write
an entire musical based on *Nineteen Eighty-Four*
but couldn't get the rights to do so from Orwell's
widow. Several songs on his album *Diamond Dogs*
directly reference the book, including "1984,"
"Big Brother," and "We Are the Dead."

The book has inspired many songs since it was
published in 1949, like "2+2=5" by Radiohead,
"The Resistance" by Muse, and Coldplay's
"Spies."

"FOR WHOM THE BELL TOLLS"

by Metallica

Album: *Ride the Lightning*

Book: *For Whom the Bell Tolls*
by Ernest Hemingway

Metallica wrote this song about a particular scene
in the book, in which five soldiers are killed during
an air strike.

Several other metal bands wrote songs based
on literature. Anthrax's "Among the Living"
was inspired by Stephen King's *The Stand*, and
Rush nods to Ayn Rand's *Anthem* in "2112." Iron
Maiden, perhaps the world's most literary band,
riffed on poems by Tennyson and Coleridge, a
story by Edgar Allan Poe, *The Name of the Rose*
by Umberto Eco, and Frank Herbert's *Dune*.

"TEA IN THE SAHARA"

by The Police

Album: *Synchronicity*

Book: *The Sheltering Sky*
by Paul Bowles

Sting, a former schoolteacher, worked literature
into many of the songs he wrote for The Police
and for himself. His music includes direct quotes
from T. S. Eliot's "The Love Song of J. Alfred
Prufrock" and William Shakespeare's sonnets,
and references to Homer's *The Odyssey* and
Vladimir Nabokov's *Lolita*. The lyrics for "Moon
over Bourbon Street" were directly inspired by
Anne Rice's *Interview with the Vampire*. "Tea in
the Sahara" is based on a legend recounted in *The
Sheltering Sky*, about three sisters who had tea in
the desert with a prince.

"WHITE RABBIT"

by Grace Slick
of Jefferson Airplane

Album: *Surrealistic Pillow*

Book: *Alice's Adventures
in Wonderland*
by Lewis Carroll

Grace Slick wrote this song before joining
Jefferson Airplane, but her recording of it with
them became a huge hit. For her, the White
Rabbit is a symbol of following your curiosity
where it leads you.

Due to the many perception-changing substances
that Alice, the caterpillar, and others consume
in the book, the song is generally thought to be
about hallucinogenic drugs.

"LOST BOY"
by Ruth B.

Album: *The Intro*

Book: *Peter Pan*
by J. M. Barrie

Ruth B. wrote "Lost Boy" about being lonely and then finding your place in the world. In 2015, it reached number 24 on the Billboard Hot 100 charts.

"SCENTLESS APPRENTICE"
by Nirvana

Album: *In Utero*

Book: *Perfume*
by Patrick Süskind

Kurt Cobain loved the novel *Perfume*, which is about a man with an excellent sense of smell but no body odor. Cobain said he used the story as inspiration for "Scentless Apprentice."

"CALYPSO"
by Suzanne Vega

Album: *Solitude Standing*

Book: *The Odyssey*
by Homer

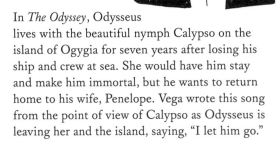

In *The Odyssey*, Odysseus lives with the beautiful nymph Calypso on the island of Ogygia for seven years after losing his ship and crew at sea. She would have him stay and make him immortal, but he wants to return home to his wife, Penelope. Vega wrote this song from the point of view of Calypso as Odysseus is leaving her and the island, saying, "I let him go."

"WUTHERING HEIGHTS"
by Kate Bush

Album: *The Kick Inside*

Book: *Wuthering Heights*
by Emily Brontë

Kate Bush wrote this song when she was just 18. She sings it from Catherine Earnshaw's point of view as she waits outside Heathcliff's window begging to be allowed in.

"THE GHOST OF TOM JOAD"
by Bruce Springsteen

Album: *The Ghost of Tom Joad*

Book: *The Grapes of Wrath*
by John Steinbeck

Bruce Springsteen sings about the spirit of Steinbeck's main character living on in America today and prevailing over injustice. Springsteen had not actually read the book before writing this song! Perhaps he had seen the movie. He did eventually read it afterward, though.

Many other bands have recorded covers of the song, most notably Rage Against the Machine.

There are many others!

"Ramble On" by Led Zeppelin salutes *The Lord of the Rings* by J. R. R. Tolkien, with lines about Mordor and Gollum. Sonic Youth pays tribute to science-fiction novels by William Gibson in their songs "Pattern Recognition" and "The Sprawl." The Smashing Pumpkins, the Strokes, and Deadmau5 have all created songs called "Soma," seemingly referring to the pleasure drug of the same name in *Brave New World* by Aldous Huxley. In "Yertle the Turtle," the Red Hot Chili Peppers pretty much just sing all the words in the book *Yertle the Turtle*, written by Dr. Seuss.

UNHAPPY FAMILIES EACH IN THEIR OWN WAY

Sometimes you read a book to think, Ah, they are going through the same crappy things we're going through, and that's how they dealt. But sometimes you just need to read a book that makes you think, Well, at least they're more screwed up than we are.

Alison Bechdel spent seven obsessive years perfecting her graphic memoir *Fun Home*, titled after her family's name for the funeral parlor her dad ran. She studied her own journals, hand-copied old photos and maps, and photographed herself in every pose her characters make just to get the drawings exactly right. But there's much more to the book than pictures; as the *New York Times* put it, it's "a comic book for lovers of words!" And one of its central themes is the ability of literature to help us sort out our own lives.

Bechdel is also known for creating the Bechdel Test to assess gender inequality in film: a movie passes if two female characters talk to each other about something other than a man.

Houghton Mifflin 2006 hardcover

Curtis Sittenfeld's *Eligible* is a modern retelling of *Pride and Prejudice*. It's a product of the Austen Project, which pairs popular authors with Jane Austen classics. Other Austen Project products include *Emma: A Modern Retelling* by Alexander McCall Smith and *Sense and Sensibility* by Joanna Trollope. (Please

Random House 2017 paperback, art by Chuhail, design by Gabrielle Bordwin

note: *Pride and Prejudice and Zombies* by Seth Grahame-Smith is not part of the Austen Project.)

Zadie Smith wrote *On Beauty* just after she got married, and described the book to radio host Terry Gross as being "about what would it be like to be married for 30 years."

Before Zadie Smith's father passed away, he told her he felt his life had been a failure and disappointment. She thought this was because he had creative talents that went unfulfilled. Instead, he had five children whom he loved and cared for deeply (cooking meals the memory of which would bring Smith to tears), and who all grew up to be artists.

Penguin Press 2005 hardcover, design by Scott Williams and Henrik Kubel

MORE

- *Flowers in the Attic* by V. C. Andrews
- *The Middlesteins* by Jami Attenberg
- *The Great Santini* by Pat Conroy
- *Matilda* by Roald Dahl
- *Our Endless Numbered Days* by Claire Fuller
- *The Liar's Club* by Mary Karr
- *Angela's Ashes* by Frank McCourt
- *The Emperor's Children* by Claire Messud
- *Everything I Never Told You* by Celeste Ng
- *Stitches* by David Small

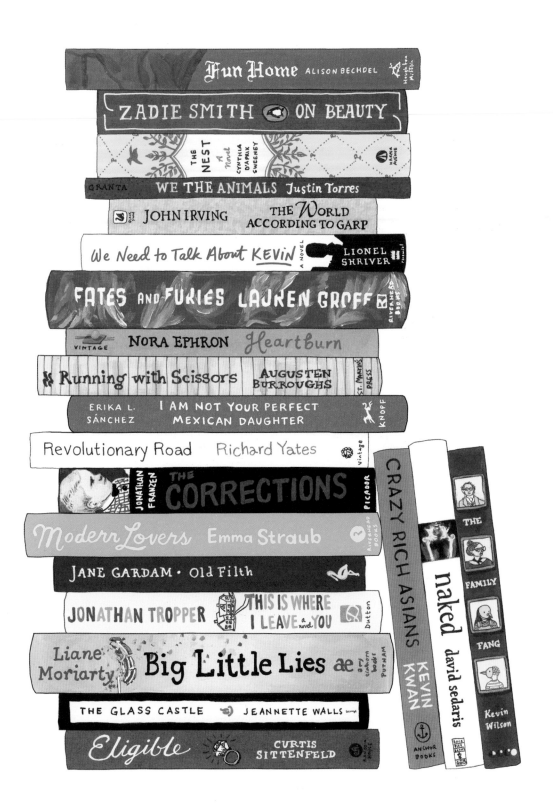

WRITER-OWNED BOOKSTORES

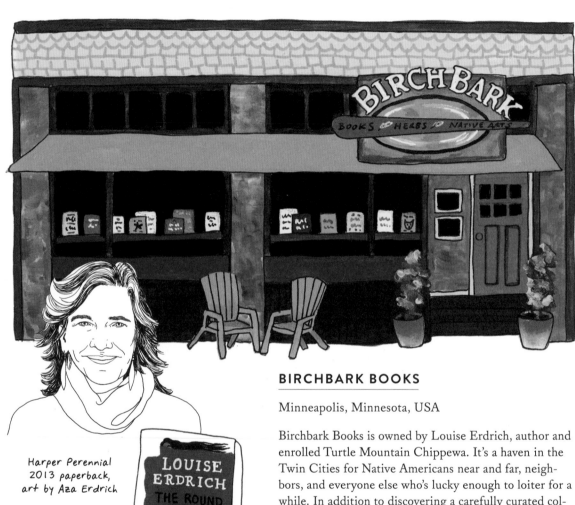

Harper Perennial 2013 paperback, art by Aza Erdrich

BIRCHBARK BOOKS

Minneapolis, Minnesota, USA

Birchbark Books is owned by Louise Erdrich, author and enrolled Turtle Mountain Chippewa. It's a haven in the Twin Cities for Native Americans near and far, neighbors, and everyone else who's lucky enough to loiter for a while. In addition to discovering a carefully curated collection specializing in great Native authors and subjects, you'll also find quillwork, basketry, silverwork, dreamcatchers, and paintings.

If you're seeking absolution instead of acquisition, Birchbark Books has something for you, too: a confessional dedicated to cleanliness and godliness, decorated by Erdrich with images of her own sins.

BOOKS & BOOKS @ THE STUDIOS

Key West, Florida, USA

While she isn't exactly like most booksellers, Judy Blume, Library of Congress Living Legend, has a familiar complaint: She doesn't have enough time to read anymore. Blume and her husband founded this chapter of Books & Books in 2016 (the original store, founded by Mitchell Kaplan, is in Coral Gables). Key West, long a literary retreat that inspired the likes of Ernest Hemingway, Tennessee Williams, Elizabeth Bishop, and Annie Dillard, was nevertheless missing a bookstore. Books & Books is now nestled in The Studios of Key West, a nonprofit that provides studio space for local artists, a residency program for visiting artists, galleries, and classes.

Knopf 2015 hardcover, design by Kelly Blair

BOOKS ARE MAGIC

Brooklyn, New York, USA

When Brooklyn's beloved Book Court shut down in 2016, Emma Straub lost her favorite place to hang out. A former Book Court employee, Straub and her husband, Michael, acted quickly to correct the loss, finding a space in the same neighborhood to open their own shop within the next year.

The whimsical name was chosen simply because it's fun to say. And also, of course, because it's true. One of Straub's first recommended staff picks was, appropriately, *Magic for Beginners*, a collection of short stories by Kelly Link.

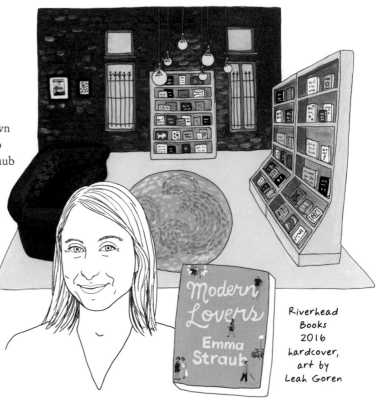

Riverhead Books 2016 hardcover, art by Leah Goren

BOOK CLUB DARLINGS

The first known "literature circle" in America was founded in 1634 by a Puritan settler, Anna Hutchinson, as a women's bible study group. Her group was eventually banned by paranoid Puritan men. But since then, the book club movement has grown exponentially. In 1990, there were about 50,000 book clubs in the US, and by 2000 twice that many, all over the country.

Brit Bennett

Oprah Winfrey started Oprah's Book Club in 1996 on her talk show. Over the next 15 years, she picked 70 books for her audience to read, one per month. Many of those books, some little known when she picked them, went on to sell millions of copies. In 2012, she relaunched Oprah's Book Club on her new TV network, OWN, and in conjunction with *O: The Oprah Magazine*. The first book she picked for it was Cheryl Strayed's *Wild*.

Knopf 2012 hardcover, design by Gabriele Wilson

MFA, and writing essays about race and injustice for publications including the *New York Times Magazine* and *Jezebel*, before selling the book to Riverhead.

In the HBO adaptation of Elizabeth Strout's short story collection *Olive Kitteridge*, Frances McDormand plays the flawed and honest Olive.

Simon & Schuster
UK 2011 paperback

Many celebrities have started their own book clubs. Emma Watson created a feminist one called Our Shared Shelf through Goodreads. Reese Witherspoon runs hers on Instagram.

Emma Watson

MORE

- *People of the Book* by Geraldine Brooks
- *The Girls* by Emma Cline
- *Middlesex* by Jeffrey Eugenides
- *The Kitchen House* by Kathleen Grissom
- *Water for Elephants* by Sara Gruen
- *The Snow Child* by Eowyn Ivey
- *Mountains Beyond Mountains* by Tracy Kidder
- *Balzac and the Little Chinese Seamstress* by Dai Sijie
- *The Immortal Life of Henrietta Lacks* by Rebecca Skloot
- *Cutting for Stone* by Abraham Verghese

Brit Bennett started writing *The Mothers* at just 17. She spent several years perfecting it while getting an English degree and an

Riverhead 2016 hardcover, design by Rachel Willey

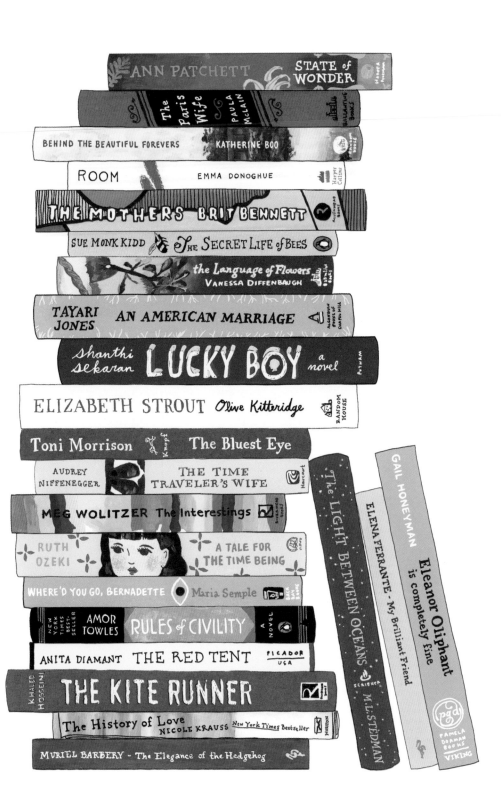

FIVE-WORD SYNOPSIS QUIZ

Name each book summarized into just five words.

1 Earth and tea gone forever.

2 Bunny is loved to life.

3 Fireman stops burning books, reads.

4 Hairy-footed thief bests dragon.

5 Girl fixes roses, boy, self.

6 Teens battle thanks to despot.

7 Hungry orphan ultimately makes good.

8 Shipwrecked bullies are still bullies.

9 Mom suffers for baby Father.

10 Spoiled heroine matchmakes, misconstrues love.

11 Aging fisherman battles giant marlin.

12 Worm poo enables space travel.

13 Car, girls, smokes, booze, pie.

14 Plague fosters evangelists and heroes.

15 Prince tells skull about death.

16 Civil War of the sexes.

17 E-book makes great girl's babysitter.

18 Jazz age flap, tragic spectacle.

19 Ten bodies, not one innocent.

20 Dust Bowl joyride, sans joy.

21 Cheeky monkey meets monochromatic man.

22 Canine tales end as expected. (multiple answers accepted)

23 Academy for naïve organ donors.

24 Plush life lessons? Bear east.

25 Ash, father, boy, ocean, fire.

26 Why everyone's afraid of clowns.

27 Kleptomaniac, former punk grO old.

28 Epic hike of loss, love.

29 Benevolent friendship or abusive relationship?

30 Outside seeing everything and nothing.

31 Somber California glamour and madness.

32 Do you see us now?

33 Matriarchy survives poverty, war, patriarchy.

34 Lost boys find courage together.

35 Bedtime bunny fails Irish exit.

36 Snobby classicists murder, then implode.

37 Playlists turn a relationship around.

38 Kin too close for comfort.

39 Poetic adolescent struggles, with *esperanza*.

ANSWERS

1) *The Hitchhiker's Guide to the Galaxy* by Douglas Adams
2) *The Velveteen Rabbit* by Margery Williams
3) *Fahrenheit 451* by Ray Bradbury
4) *The Hobbit* by J. R. R. Tolkien
5) *The Secret Garden* by Frances Hodgson Burnett
6) *The Hunger Games* by Suzanne Collins
7) *Oliver Twist* by Charles Dickens
8) *Lord of the Flies* by William Golding
9) *The Scarlet Letter* by Nathaniel Hawthorne
10) *Emma* by Jane Austen
11) *The Old Man and the Sea* by Ernest Hemingway
12) *Dune* by Frank Herbert
13) *On the Road* by Jack Kerouac
14) *The Stand* by Stephen King
15) *Hamlet* by William Shakespeare
16) *Gone with the Wind* by Margaret Mitchell
17) *The Diamond Age* by Neal Stephenson
18) *The Great Gatsby* by F. Scott Fitzgerald
19) *And Then There Were None* by Agatha Christie
20) *The Grapes of Wrath* by John Steinbeck
21) *Curious George* by H. A. & Margret Rey
22) *Where the Red Fern Grows* by Wilson Rawls, *Old Yeller* by Fred Gipson, or *Marley & Me* by John Grogan
23) *Never Let Me Go* by Kazuo Ishiguro
24) *The Tao of Pooh* by Benjamin Hoff
25) *The Road* by Cormac McCarthy
26) *It* by Stephen King
27) *A Visit from the Goon Squad* by Jennifer Egan
28) *Wild* by Cheryl Strayed
29) *The Giving Tree* by Shel Silverstein
30) *Pilgrim at Tinker Creek* by Annie Dillard
31) *Play It as It Lays* by Joan Didion
32) *Invisible Man* by Ralph Ellison
33) *Little Women* by Louisa May Alcott
34) *What Is the What* by Dave Eggers
35) *Goodnight Moon* by Margaret Wise Brown
36) *The Secret History* by Donna Tartt
37) *High Fidelity* by Nick Hornby
38) *Dress Your Family in Corduroy and Denim* by David Sedaris
39) *The House on Mango Street* by Sandra Cisneros

The Big Sleep CHANDLER

THE MALTESE FALCON BY DASHIELL HAMMETT ALFRED A. KNOPF

The Intuitionist COLSON WHITEHEAD ANCHOR BOOKS

CARDS on the TABLE AGATHA CHRISTIE DODD MEAD & Company

P.D. JAMES An Unsuitable Job for a Woman SCRIBNER

PATRICIA HIGHSMITH • THE TALENTED MR. RIPLEY NORTON

TANA FRENCH IN THE WOODS MARINER

THE NAME OF THE ROSE UMBERTO ECO MARINER

HENNING MANKELL FIREWALL Vintage Crime

BURY YOUR DEAD LOUISE PENNY

Rebecca DAPHNE DU MAURIER

The Redbreast JO NESBO VINTAGE

The BLACK ECHO Michael Connelly LITTLE, BROWN

Smilla's Sense of Snow PETER HØEG PICADOR

BENJAMIN EVEN THE DEAD BLACK HENRY HOLT

ARTHUR CONAN DOYLE SHERLOCK HOLMES

MYSTERIES

Mystery readers pit their brains against those of the greatest sleuths and the nastiest criminals, trying to beat them to a punch that's already been thrown but not yet seen (unless you skip to the last page, which is cheating, of course). They scour the text for clues while following nefarious scoundrels and dubious heroes through dark alleys and darker bars, dodging bullets and knives and sharp wits, all without leaving their armchairs.

P. D. James felt that mystery novels, with their concluding restoration of order, are calming to readers, and that this explains their popularity in periods of upheaval and anxiety. In addition to many mysteries, James wrote the dystopian *The Children of Men*, set in 2021, about human extinction due to infertility.

Sloppy?

James kept several Burmese cats at her home and said, "I want my cats affectionate and sloppy."

character from a previous book. After reading just one, you are likely to tell everyone you know about it and then immediately read another.

The Mysterious Bookshop in Manhattan is the oldest and largest mystery-focused bookstore in the US. The owner, Otto Penzler, also founded a publishing imprint and has encouraged countless writers since he opened shop in 1979. In an interview he recounts reading Raymond Chandler and Dashiell Hammett for the first time and realizing, "This is literature. It's not just puzzles, it's not just telling a nice story."

The Mysterious Bookshop

Nordic noir began with Maj Sjöwall and Per Wahlöö's Martin Beck series in the 1960s, achieved literary recognition with Peter Høeg's *Smilla's Sense of Snow*, and became a phenomenon with the novels of Henning Mankell, Jo Nesbø, and Stieg Larsson. While crime-solving, the detectives in these books deal with personal problems and often expose social injustices.

THE LAUGHING POLICEMAN THE MARTIN BECK SERIES

MAJ SJÖWALL & PER WAHLÖÖ

Harper Perennial 2007 paperback

Dashiell Hammett was known to his friends as Sam. His protagonist, Sam Spade, set the hard-boiled, hard-drinking American private eye standard.

MORE

- *Killing Floor* by Lee Child
- *Suspect* by Robert Crais
- *The Cuckoo's Calling* by Robert Galbraith (J. K. Rowling)
- *The Third Man* by Graham Greene
- *Jar City* by Arnaldur Indriðason
- *Mystic River* by Dennis Lehane
- *Death at La Fenice* by Donna Leon
- *The Dreadful Lemon Sky* by John D. MacDonald
- *Gaudy Night* by Dorothy L. Sayers

Tana French's Dublin Murder Squad series changes the mystery game. Instead of chronicling the same detective on different cases, each book is narrated by a different squad member, usually a minor

BOOKS MADE INTO GREAT MOVIES

EMMA

by Jane Austen

Clueless, directed by Amy Heckerling, 1995

Penguin 2011 paperback, art by Jillian Tamaki

THE MALTESE FALCON

by Dashiell Hammett

The Maltese Falcon, directed by John Huston, 1941

Knopf 1930 hardcover

L.A. CONFIDENTIAL

by James Ellroy

L.A. Confidential, directed by Curtis Hanson, 1997

The Mysterious Press 1990 hardcover, design by Paul Gamarello, art by Stephen Peringer

JAWS

by Peter Benchley

Jaws, directed by Steven Spielberg, 1975

Bantam 1975 paperback, art by Roger Kastel

The amazing cover image helped sell millions of paperback copies of the book, and was so successful that it was also used for the movie poster.

Another example of great cover design that was also used for the movie posters. →

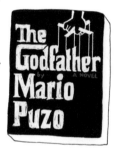

CASINO ROYALE

by Ian Fleming

Casino Royale, directed by Martin Campbell, 2006

Jonathan Cape 1953 hardcover, design by Ian Fleming

That's right, Fleming designed this first edition cover of the first James Bond book himself!

THE GODFATHER

by Mario Puzo

The Godfather, directed by Francis Ford Coppola, 1972

Putnam 196 hardcover, design by S. Neil Fujita

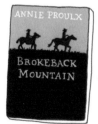

BROKEBACK MOUNTAIN

by Annie Proulx

Brokeback Mountain, directed by Ang Lee, 2005

4th Estate 1998 paperback

This was first published as a short story in the "New Yorker" in 1997, then issued as a book in the UK, and then included in Proulx's story collection "Close Range" in 1999.

FANTASTIC MR. FOX

by Roald Dahl

Fantastic Mr. Fox, directed by Wes Anderson, 2009

Puffin 2016 hardcover, art by Quentin Blake

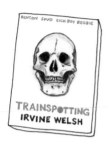

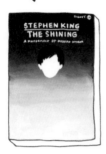

King's works have been made into over 60 films and television shows. He has said he doesn't like Kubrick's adaptation, feeling it to be too "cold" and "misogynistic," and not true enough to the book.

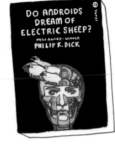

DO ANDROIDS DREAM OF ELECTRIC SHEEP?

by Philip K. Dick

Bladerunner, directed by Ridley Scott, 1982

Bladerunner 2049, directed by Denis Villeneuve, 2017

Signet 1969 paperback, art by Bob Pepper

TRAINSPOTTING

by Irvine Welsh

Trainspotting, directed by Danny Boyle, 1996

Vintage 2013 paperback, design by Sarah-Jane Smith

THE SHINING

by Stephen King

The Shining, directed by Stanley Kubrick, 1980

Signet 1978 paperback, design by James Plumeri

AMERICAN PSYCHO

by Bret Easton Ellis

American Psycho, directed by Mary Harron, 2000

Picador 1991 hardcover, art by Marshall Arisman

FIGHT CLUB

by Chuck Palahniuk

Fight Club, directed by David Fincher, 1999

W. W. Norton 1996 hardcover, design by Michael Ian Kaye

One more example of a great cover recycled for movie posters.

PSYCHO

by Robert Bloch

Psycho, directed by Alfred Hitchcock, 1960

Simon and Schuster 1959 hardcover, design by Tony Palladino

Goldman was also a screenwriter and won Academy awards for the screen plays of "Butch Cassidy and the Sundance Kid" and "All the President's Men." He also wrote the novel "Marathon Man" and adapted both it and "The Princess Bride" for film.

THE PRINCESS BRIDE

by William Goldman

The Princess Bride, directed by Rob Reiner, 1987

Harcourt Brace Jovanovich 1973 hardcover, design by Wendell Minor

WE NEED TO TALK ABOUT KEVIN

by Lionel Shriver

We Need to Talk About Kevin, directed by Lynne Ramsay, 2011

Harper Perennial 2006 paperback, design by Gregg Kulick, photo by Matthew Alan

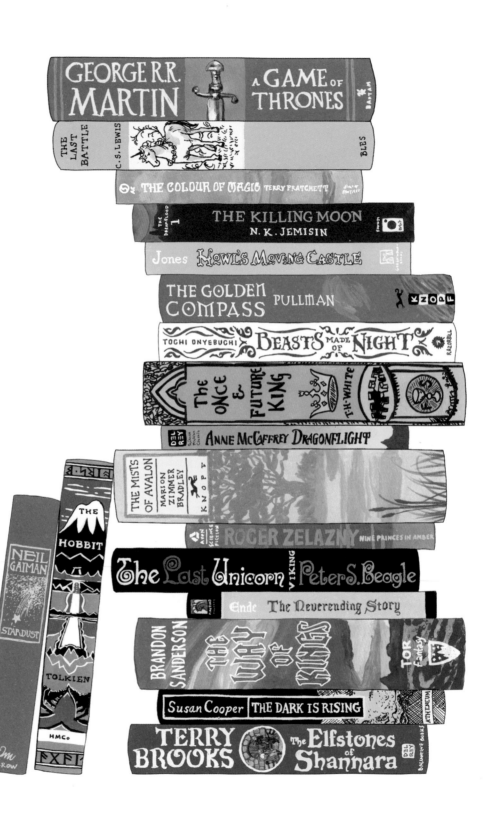

FANTASY

After finishing a story, Neil Gaiman wrote that "the world always seems brighter when you've just made something that wasn't there before." This may be especially true for fantasy writers, who invent entire worlds. Many of us read to visit some other version of the universe—maybe better, or maybe worse (see also Dystopia, page 95)—that gives us the perspective to see the real universe more clearly.

Gaiman's *Stardust* was originally published in 1997 as a four-part comic book, then as a single book in 1998, both versions illustrated by Charles Vess. In 1999, it was released as a novel without illustrations and, in 2007, adapted into a movie directed by Matthew Vaughn and starring Charlie Cox and Claire Danes.

2007 Vertigo hardcover, art by Charles Vess ↳

Diana Wynne Jones started writing books for children when she realized there weren't any she liked reading aloud to her own kids. When she died in 2011, she had written over 30 books, many set in the real world but full of magic and rooted in mythology.

Gaiman, a fan and a friend of hers, wrote, "She was the funniest, wisest, fiercest, sharpest person I've known, a witchy and wonderful woman, intensely practical, filled with opinions. . . ."

T. H. White's epitaph reads, "Author who from a troubled heart delighted others." According to his biographer, Sylvia Townsend Warner, White was alone, lonely, and cripplingly shy. We don't know if he had any serious relationships with men or women,

but he did very much love his dog, an Irish Setter named Brownie. White was heartbroken when she died, writing to a friend, "She has been to me more perfect than anything else in all my life. . . ."

Everyman's Library 2011 hardcover, art by Kate Baylay

In Philip Pullman's *His Dark Materials* trilogy, all humans have a dæmon, a physical manifestation of their soul or spirit in animal form. Pullman says that if he had a visible dæmon, she would be a bird from the Corvidae family, such as a magpie, who looks for "shiny, bright things and steals them."

MORE

- *The Book of Three* by Lloyd Alexander
- *The Darkest Part of the Forest* by Holly Black
- *The Princess Bride* by William Goldman
- *The Buried Giant* by Kazuo Ishiguro
- *Redwall* by Brian Jacques
- *The Eye of the World* by Robert Jordan
- *The Gunslinger* by Stephen King
- *The Lies of Locke Lamora* by Scott Lynch
- *Eragon* by Christopher Paolini
- *The Name of the Wind* by Patrick Rothfuss

BOOKISH PEOPLE RECOMMEND

COLBY SHARP

Fifth-grade teacher in Parma, Michigan, USA, and author of *The Creativity Project*

Scholastic 2015 hardcover, design and art by Nina Goffi

The Honest Truth
by Dan Gemeinhart

"Kids often dream of running away from home. In *The Honest Truth*, Mark plans out an elaborate trip that will take him and his dog Beau away from their home to one of the tallest mountains in Washington State. As the book progresses, readers slowly begin to realize that Mark's journey to the mountain might be the last thing he ever does."

KELLY ORAZI

Assistant manager at Mysterious Galaxy Bookstore in San Diego, California, USA

The Once and Future King
by T. H. White

Harper Voyager 2015 paperback, art by Joe McLaren

"If there were only one book that I could recommend to anyone, it would be T. H. White's *The Once and Future King*. Here is a book that transports you to the magical and tumultuous world of King Arthur and his tutor, Merlyn. Read it and you will fall in love with the legend of King Arthur, but beware: In its sorcerous depths, you will learn what it is to laugh and despair and cry

and love. This is a magical, touching, and tragic novel, but above all it's a novel that celebrates being human. And it is utterly beautiful for doing so."

The Chronicles of Chrestomanci
by Diana Wynne Jones

HarperCollins 2001 paperback, art by Dan Craig

"Diana Wynne Jones simply has a magic to her writing like none other. I picked up *Howl's Moving Castle* when I was a just a young kid, desperately trying to fill the void in between Harry Potter novels. I quickly devoured everything I could by her and never looked back. Her immense backlist somehow still flies under the radar. The Chrestomanci novels remain some of my favorite books to read again and again, but to pick up any one of her books is to encounter something entirely, perfectly special."

RACHEL FERSHLEISER

Internet-enabled literary enthusiast

The Turner House
by Angela Flournoy

Houghton Mifflin Harcourt 2015 hardcover, design by Martha Kennedy

"Officially, this book is about a family with 13 grown children figuring out what to do with the family home on Detroit's East Side as property values deteriorate and parents age and die. Also race and class and

addiction and love and belief and the supernatural and mental health and manhood and womanhood and forgiveness. But here's what I love most about it: Often when I read a book that weaves together past and present stories and several perspectives, there are some I like less and slog through to get back to the better ones. In *The Turner House*, I was always excited to read what came next, only slowing down to try and spend more time with these characters. It feels like every single person is real, living and breathing out there, each one flawed—difficult, dishonest, failing, flailing—and yet so wholly engaging. I loved them even when I didn't like them."

The Girls from Corona del Mar
by Rufi Thorpe

"This debut novel about a lifelong friendship asks the most brutal questions about family, disability, abortion, responsibility, and what, if anything, we are owed or deserve. It's a quintessential entry in the Women Processing Their Shit genre where I find most of my favorite, most thought-provoking books. Thorpe invites us to inhabit the lived experience of people we are tempted to judge from afar, and it is somehow both deeply unsettling and a nonstop joy to read."

Vintage
2015 paperback,
design by
Linda Huang

Henry Holt and Co.
2009 hardcover,
design by April Ward,
art by Beth White

DIANE CAPRIOLA

Co-owner of Little Shop of Stories in Decatur, Georgia, USA

The Evolution of Calpurnia Tate
by Jacqueline Kelly

"Eleven-year-old Calpurnia is the only girl in a family of seven siblings, wedged in the middle of six boisterous brothers who are all permitted to be whatever and however they choose. Her mother wants her to be a proper young lady, but Calpurnia has different plans, other desires. Taken under the wing of her science-loving, Darwinist grandfather, Callie Vee begins to observe not only the natural world and the complex relationships in it, but the societal norms and constructs influencing her relationships with others as well, as she considers what it means to be a girl in turn-of-the-century Galveston, Texas.

I get goosebumps when I think about the final chapter of this lovely book. Without giving away anything, it speaks to the idea that the world is always making itself anew, that anything is possible, that we should always expect the unexpected as we navigate the world and our place in it. Most importantly, it speaks to the promise of change and growth for a girl as being endless. *The Evolution of Calpurnia Tate* is the most hopeful novel for children that I have ever read."

SARAH HOLLENBECK

Co-owner of Women & Children First in Chicago, Illinois, USA

Bad Feminist
by Roxane Gay

Harper Perennial
2014 paperback,
design by
Robin Bilardello

"In *Bad Feminist* Roxane Gay blends personal narrative with brilliant, often hilarious critiques of pop culture and politics. She claims the messy contradictions within both the movement and herself. She stares down and shreds apart the feminist killjoy stereotype using all the tools in her belt—irony, vulnerability, jokes, and just plain common sense."

BELOVED BOOKSTORES

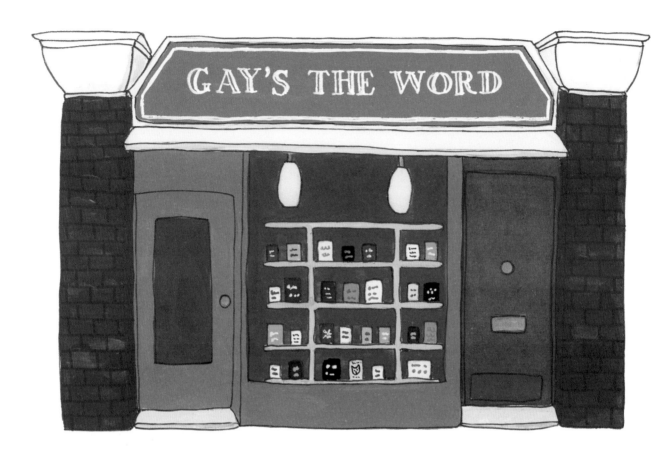

GAY'S THE WORD BOOKS

London, UK

When Gay's the Word Books opened in London in 1979, much of its stock had to be imported from the US because the UK didn't publish enough gay books. Along with the typical trials of an independent bookstore—rent increases and competition from online sales—Gay's the Word survived a search and seizure of thousands of pounds' worth of books by Her Majesty's Customs and Excise in 1984. Works by Tennessee Williams, Gore Vidal, Christopher Isherwood, and Jean Genet were among the books taken under accusations of pornography and conspiracy to import indecent books. The charges were eventually dropped, though no apology for the wrongful accusations was ever issued. Gay's the Word has since endured as an information source as well as community hub, hosting meetings for organizations including Icebreakers, the Lesbian Discussion Group, Gay Black Group, the Gay Disabled Group, and TransLondon.

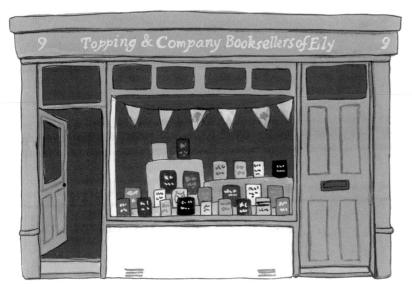

TOPPING & COMPANY BOOKSELLERS

Ely, UK

Travel to Ely to see its cathedral; stay for Topping & Company Booksellers. The Toppings will welcome you with a free cup of coffee or tea as you browse handsome shelves glutted with well-organized books of all kinds, including many signed and collectible editions (also browsable on its website). Note the signs, handwritten by Mrs. Topping.

Topping & Company also has locations in Bath and the university town of St. Andrews, Scotland.

THE KING'S ENGLISH BOOKSHOP

Salt Lake City, Utah, USA

The King's English Bookshop started the way many bookstores do. Two Salt Lake City booklovers, Betsy Burton and Ann Berman, thought they'd support their writing aspirations with a store. Not long after opening in 1977, they realized taking care of their customers was actually a full-time job that left little room for writing, but they've been a community treasure ever since.

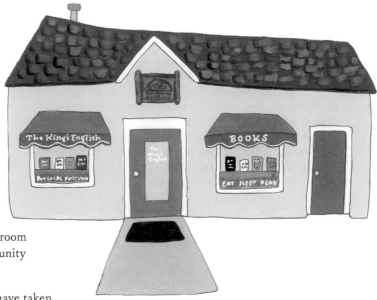

As the store has grown, the owners have taken advantage of space in unusual ways. They used a grant from James Patterson to raise the roof and add windows to their children's room, which now includes an elevated "tree house" for reading and play.

SPECIAL POWERS

Most of us spend a decent chunk of childhood wishing we had special powers; some of us never stop. Who doesn't dream of being born with magic, or extra smarts, or mutant capabilities? We all know we're special in some way, we just have to figure out how.

A bildungsroman is a coming-of-age story in which a young hero seeks knowledge of some kind, is dramatically changed by it, and ultimately finds him- or herself. The German philologist Karl Morgenstern coined the term in 1819, and Johann Wolfgang Goethe's *Wilhelm Meister's Apprenticeship* is usually thought to be the first book in the genre.

2016 Hamburger Lesehefte paperback

Over 400 million Harry Potter books have been sold since the first one's debut in 1997. Several publishers rejected Harry, many thinking the book too long for kids. Finally, Nigel Newton at Bloomsbury gave a sample to his eight-year-old daughter. When she finished and demanded more, he knew he had a winner. Rowling has become a billionaire, but for the first book she received just a £2,500 advance.

In the beginning of *The Name of the Wind*, the enchanting protagonist Kvothe says his father once told him his name means "to know." Kvothe then recounts all the incredible things he has learned so far and how (including the true name of the wind). Patrick Rothfuss wrote the book over the nine years he spent getting a B.A. in English. Fans desperately await the third and final book in the Kingkiller Chronicle series, but Rothfuss takes the time to get things right.

In the second book, "The Wise Man's Fear," Kvothe plays a chess-like strategy game called Tak. Rothfuss teamed up with game designer James Ernest and, thanks to a successful Kickstarter campaign, you can play Tak in real life.

Long before Harry went to Hogwarts, Ged went to the School for Wizards on the island of Roke in Ursula K. Le Guin's *A Wizard of Earthsea* (1968). And before that, Professor X taught Jean Grey, Scott Summers, Bobby Drake, Warren Worthington III, and Hank McCoy how to use their mutant abilities for good, at Xavier's School for Gifted Youngsters, in Stan Lee and Jack Kirby's *X-Men* comics (1963).

MORE

- *Red Queen* by Victoria Aveyard
- *Ender's Game* by Orson Scott Card
- *Graceling* by Kristin Cashore
- *City of Bones* by Cassandra Clare
- *Lionboy* by Zizou Corder
- *Charmed Life* by Diana Wynne Jones
- *MIND MGMT Volume 1* by Matt Kindt
- *I Am Number Four* by Pittacus Lore
- *Sabriel* by Garth Nix
- *SuperMutant Magic Academy* by Jillian Tamaki

STRIKING LIBRARIES

DET KONGELIGE BIBLIOTEK (THE ROYAL LIBRARY)

Copenhagen, Denmark

Designed by Schmidt Hammer Lassen

Opened in 1999

The exterior is made of polished black granite, and because of that and its angular shape, everyone calls it *den Sorte Diamant* (the Black Diamond). It sits right on the waterfront.

This is the view from the water.

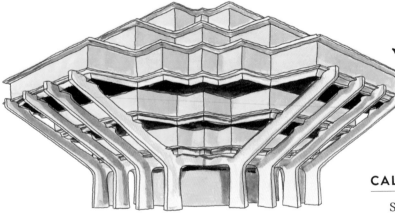

Theodore Geisel is better known as Dr. Seuss! The library's collection includes 8,500 drawings, manuscripts, photos, and other Dr. Seuss memorabilia.

GEISEL LIBRARY, UNIVERSITY OF CALIFORNIA SAN DIEGO

San Diego, California, USA

Designed by William L. Pereira Associates

Opened in 1970

This Brutalist building was originally called the Central Library, but renamed in 1995 after Audrey and Theodore Geisel.

INFORMATIONS-, KOMMUNIKATIONS- UND MEDIENZENTRUM, BRANDENBURGISCHE TECHNISCHE UNIVERSITÄT (INFORMATION, COMMUNICATIONS, AND MEDIA CENTER, BRANDENBURG UNIVERSITY OF TECHNOLOGY)

Cottbus, Germany

Designed by Herzog & de Meuron

Opened in 2004

The library is very colorful inside, with rooms in various shades and a bright pink-and-green spiral staircase.

◄— It's covered in text excerpts and alphabets in many languages, but they overlap so much that they aren't very legible.

KANAZAWA UMIMIRAI LIBRARY

Kanazawa, Ishikawa Prefecture, Japan

Designed by Kazumi Kudo and Hiroshi Horiba of Coelacanth K&H Architects

Opened in 2011

All those little dots are holes! They're filled with translucent glass to let in the perfect amount of natural light, encouraging people to hang out and read, not just check out a book and go.

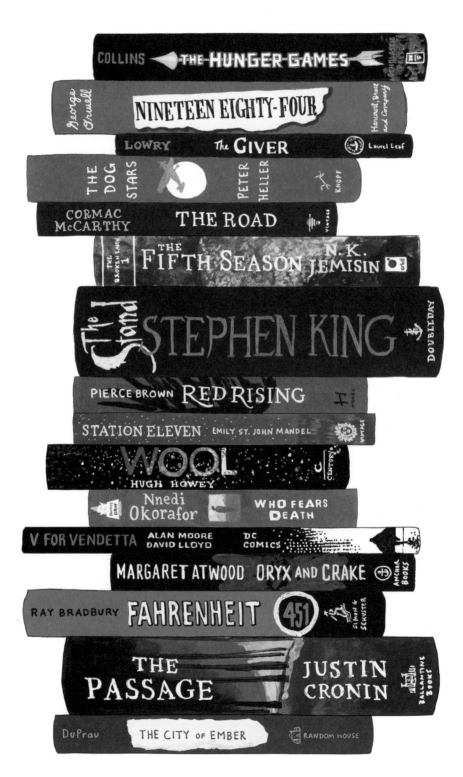

DYSTOPIA

Interest in dystopian fiction boomed just before, during, and after World War II; in the early 1960s, at the dawn of the Cold War; and again in 2008, around when Suzanne Collins's *The Hunger Games* was published. Dystopian fiction is a powerful lens, revealing what we need to change in the present, and how to survive afterward if we don't.

George Orwell published *Nineteen Eighty-Four* way back in 1949. In 2017, in the time of "alternative facts," surveillance debates, and cult-of-personality leaders, it topped Amazon's best-seller list in the US.

The Signet Classics paperback that was in print in 1984.

Jemisin notes, "As a black woman, I have no particular interest in maintaining the status quo. Why would I? The status quo is harmful, the status quo is significantly racist and sexist and a whole bunch of other things that I think need to change."

Orbit 2015 paperback, design by Lauren Panepinto

Orwell gave us many terms we still use, including *Big Brother*, *Newspeak*, the *Thought Police*, *doublethink*, *memory hole*, and *2+2=5*. The word "Orwellian" describes a dystopia, a totalitarian state that constantly watches its denizens and controls all media, history, and thought.

Hugh Howey originally self-published *Wool* as a digital short story on Amazon's Kindle Direct Publishing system. Readers begged for more, and he delivered additional installments. Before Simon & Schuster published a print version in 2013, *Wool* had already sold more than 400,000 e-books and the film rights had been bought by 20th Century Fox. Howey retained the full digital rights.

Howey lives on a 50-foot catamaran called "Wayfinder," sailing around the world.

N. K. Jemisin became the first black writer to win the Best Novel Hugo Award (science fiction's most prestigious prize), for *The Fifth Season*, in 2016. That same year, groups of right-wing writers, called the Sad Puppies and the Rabid Puppies, tried to game the Hugo system so that more traditional and conservative books and authors would win the prizes.

The Fifth Season is not a traditional fantasy story about a threat to the status quo and the threat's eventual defeat. Instead, it deals with a flawed status quo that must undergo dramatic change.

MORE

• *A Clockwork Orange* by Anthony Burgess
• *The Parable of the Sower* by Octavia Butler
• *Brave New World* by Aldous Huxley
• *Never Let Me Go* by Kazuo Ishiguro
• *The Iron Heel* by Jack London
• *Legend* by Marie Lu
• *The Host* by Stephenie Meyer
• *A Canticle for Leibowitz* by Walter M. Miller Jr.
• *Divergent* by Veronica Roth
• *We* by Yevgeny Zamyatin

EDITIONS

NINETEEN EIGHTY-FOUR

George Orwell's *Nineteen Eighty-Four* is perhaps the best-known dystopian novel, published in 1949 but ever-relevant. Orwell also considered calling it *The Last Man in Europe*, but his editor pushed him toward *Nineteen Eighty-Four*. It has been translated into more than 65 languages, and editions abound because it is already in the public domain in some countries; here are just a few.

UNITED KINGDOM

Secker and Warburg
1949 hardcover

This is the very first edition.

INDONESIA

Bentang
2003 paperback

TURKEY

Can Yayinlari
2014 paperback,
art by
Utku Lomlu

UNITED KINGDOM

Penguin
2008 paperback,
design by
Shepard Fairey

Fairey is the founder of OBEY. He designed the iconic Barack Obama "Hope" posters from 2008, as well as the 1989 "Andre the Giant Has a Posse" street art campaign.

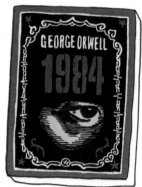

UNITED STATES

Houghton Mifflin
Harcourt
2017 hardcover,
design by
Mark R. Robinson

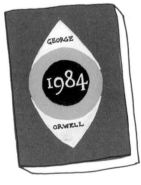

CANADA

Harper Perennial
2014 paperback

The title and author's name are embossed and then printed over with black ink. Brilliant!

UNITED KINGDOM

Penguin Classics
2013 paperback,
design by
David Pearson

GERMANY

Ullstein Verlag
1976 paperback

CROATIA

Šareni dućan
2015 paperback

Don't miss the one guy in the crowd who's rebelling by turning his head the wrong way.

FRANCE

Éditions Gallimard
Folio 1974 paperback,
art by Jean Gourmelin

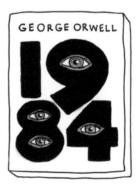

SWEDEN

Atlantis
1983 hardcover

SPAIN

Austral
2012 paperback

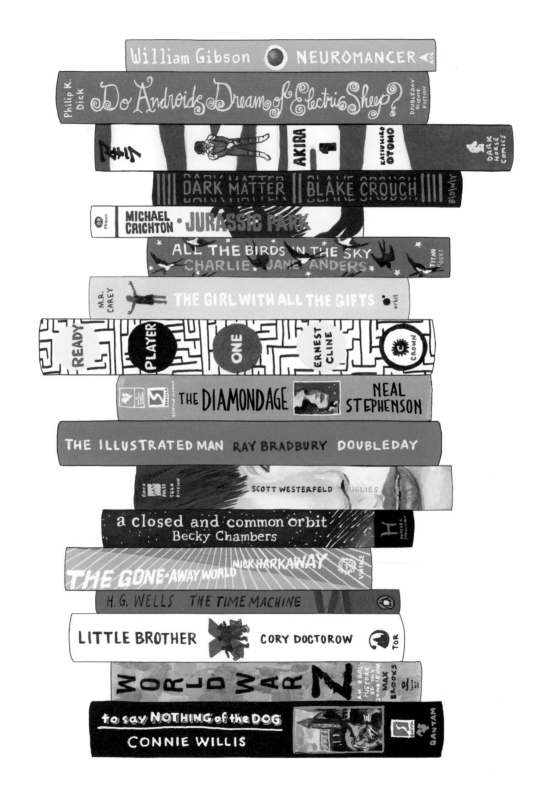

TECHNOTHRILLS & CYBERPUNKS

Technology changes so fast now that ideas don't stay fiction for long. While we still don't have flying cars or converse with androids, there is always room to dream, of electric sheep or anything else.

In Philip K. Dick's *Do Androids Dream of Electric Sheep?* the one thing differentiating us from androids is that we can feel empathy. Detective Rick Deckard tests for that ability when hunting down errant "andys," administering an extreme sort of Turing test. Meanwhile, Deckard and his wife use a Penfield Mood Organ machine to select feelings for themselves, and tend to the electric sheep they keep on their roof.

Dick had an intense personal life. He and his twin sister were born prematurely, and she didn't survive infancy. His parents divorced, and he grew up in Berkeley, did drugs, married five times, attempted suicide, had paranormal experiences and hallucinations, and died of a stroke at age 53. He was buried next to his twin; his name had been engraved on their tombstone when she passed.

William Gibson started writing fiction as the world turned the digital corner. He coined the term "cyberspace" in his 1982 short story "Burning Chrome," after witnessing kids in early video-game arcades. It appeared to him that the players would go through the screen to the other, pixelated side if they could. When he bought an Apple IIc, he realized the

Aleph Editoria 2016
Brazilian edition, art
by Josan Gonzales

same yearning would affect adults as they used the first personal computers. His debut novel, *Neuromancer*, became a cornerstone of the cyberpunk movement.

Neal Stephenson believes dystopia is overrated, and that science-fiction writers have a responsibility to be optimists, to dream up new tech. Past examples, such as Isaac Asimov's robot, or Robert A. Heinlein's spaceship, present both an innovation and a complete reality of how it integrates into society, and they inspire engineers and programmers to get to work.

Stephenson's "The Diamond Age" is a bildungsroman about a young girl living in a neo-Victorian nanotechnology-driven future slum, who gets a book, of sorts, that changes everything.

A YOUNG LADY'S ILLUSTRATED PRIMER

MORE

- *I, Robot* by Isaac Asimov
- *Transmetropolitan* by Warren Ellis & Darick Roberton
- *The Ghost in the Shell* by Shirow Masamune
- *I Am Legend* by Richard Matheson
- *Green Earth* by Kim Stanley Robinson
- *Trouble and Her Friends* by Melissa Scott
- *The Strange Case of Dr. Jekyll and Mr. Hyde* by Robert Louis Stevenson
- *20,000 Leagues Under the Sea* by Jules Verne
- *When Worlds Collide* by Philip Wylie & Edwin Balmer
- *The Day of the Triffids* by John Wyndham

BOOKMOBILES & MORE

The truck plays a tune to let the kids know he's coming, just like an ice cream truck. ↓

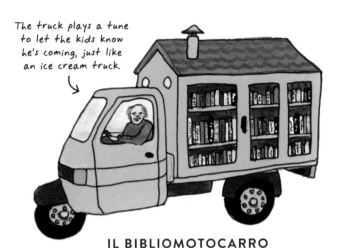

IL BIBLIOMOTOCARRO

Basilicata, Italy

Antonio La Cava taught school for 42 years. Then, in 2003, he bought a humble three-wheeled truck, added on a shelving system, stocked it with books to lend, and took off driving around the Italian countryside. He makes eight stops over 300 miles each week, bringing a love of reading to children who might not have found it in school.

The donkeys are named Alfa and Beto! This is Alfa. ↘

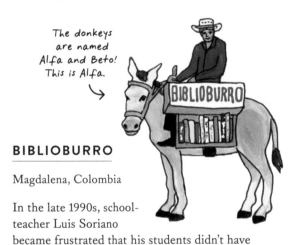

BIBLIOBURRO

Magdalena, Colombia

In the late 1990s, school-teacher Luis Soriano became frustrated that his students didn't have books at home, so he decided he would change that. He and his two donkeys distribute books through-out the Magdalena region of Colombia, near the Caribbean Sea.

WALKING BOOKFAIRS

Bhubaneswar, India

Satabdi Mishra and Akshaya Ravtaray drove their biblio-truck over 6,000 miles in 2016, selling and lending books across India. They also have a small bookstore in Bhubaneswar, and they keep prices low so that more people have access to a love of books.

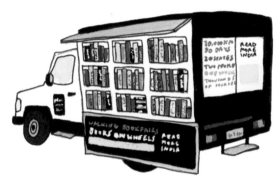

TELL A STORY

Lisbon, Portugal

Three friends, Francisco Antolin, Domingos Cruz, and João Correia Pereira, want to spread their love of Portuguese literature to all the tourists visiting Lisbon. They drive their van around town, stocked with books by authors such as José Saramago and Miguel Torga, translated into English, German, French, and more.

This is a restored 1975 Renault Estafette. ↙

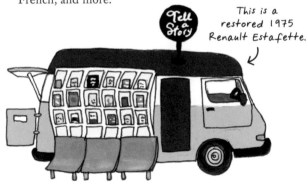

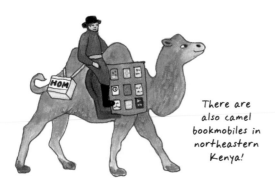

There are also camel bookmobiles in northeastern Kenya!

THE MONGOLIAN CHILDREN'S MOBILE LIBRARY

Gobi Desert, Mongolia

Over the last 20 years, Dashdondog Jamba has traveled more than 50,000 miles around the Mongolian desert, usually by camel. He brings books (including several he wrote or translated himself) to children in remote villages lacking libraries.

LA CARRETA LITERARIA

Cartagena de Indias, Colombia

Martín Murillo used to sell water in Cartagena but now lends books for free to promote the love of reading, with help from several sponsors. He pushes his cart through town, often stopping to read stories aloud to children.

One day the Colombian Nobel Prize–winning author Gabriel García Márquez visited the cart, saw a first edition of his book "Love in the Time of Cholera," and signed it for Murillo.

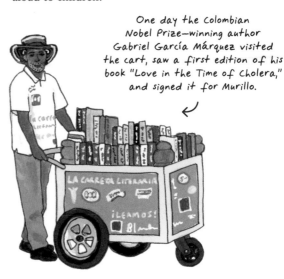

THE GARDEN LIBRARY FOR REFUGEES AND MIGRANT WORKERS

Tel Aviv, Israel

This library in popular Levinski Park holds 3,500 books for both children and adults, in 16 languages. It was founded in 2010 by the non-profit ARTEAM and the aid group Mesila and designed by Yoav Meiri Architects. It's always open and glows from within at night, providing books to marginalized readers.

BIBLIO-MAT AT THE MONKEY'S PAW

Toronto, Ontario, Canada

The Monkey's Paw is a small antiquarian bookstore in Toronto, known for its quirky window displays. Owner Stephen Fowler worked with animator Craig Smalls to build the Biblio-Mat, a vending machine that spits out random books for $2 each.

When the book falls out, a bell rings!

SPACE & ALIENS

Sometimes we must travel light-years away just to really see the Earth. And sometimes we must meet extraterrestrial beings just to look into the mirror.

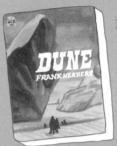

Ace 1965
paperback, art by
John Schoenherr

In 1959 Frank Herbert, a freelance reporter, visited the sand dunes near Florence, Oregon, for a story. The shifting sands eventually inspired a novel about desert cultures and how ecological disaster can lead to the rise of religion and a messiah. He spent six years researching and writing *Dune*, and it was turned down by 20 publishers for being too long before Chilton (better known for car manuals) released it in 1965. *Dune* won the very first Nebula award in 1966 but wasn't an instant success, more a slow-burning cult classic that gained in popularity as it aged. In 2012, *Wired* readers named it the best science-fiction novel of all time.

Director Alejandro Jodorowsky originally planned to make a *Dune* film with Orson Welles as Baron Harkonnen, Salvador Dalí as the Emperor, and visuals by Moebius and H. R. Giger, but Hollywood balked at the visionary risk. David Lynch made a critically panned version in 1984 (with Sting as Feyd-Rautha, pictured). British novelist and journalist Hari Kunzru argues that a perfect *Dune* movie (about a boy destined to lead, a desert planet, and an evil emperor) had already been made in 1977. It was called *Star Wars*.

The title of Cixin Liu's *The Three-Body Problem* refers to the classic orbital mechanics question of how three neighboring celestial bodies affect each other's pattern of movement. But the real question the trilogy explores is: What happens when we humans find out we're not alone? The book was released in China in 2006 and was an enormous success. It was translated into English by Ken Liu (himself an award-winning writer), and published in the US by Tor in 2014.

The writer Nnedi Okorafor didn't like outer space (preferring colorful, lush, magical places), but she confronted her dislike to grow as a writer and as a person. She decided to start small, though, so *Binti*—about a young woman who leaves Earth to attend a species-diverse intergalactic university—is a novella.

Andy Weir released a "classroom edition" of *The Martian* in 2016, without the 160+ swear words, so that middle and high school science teachers could use it as a teaching aid.

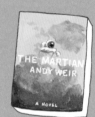

Crown 2014 hardcover,
design by Eric White

MORE

- *The Hitchhiker's Guide to the Galaxy* by Douglas Adams
- *The Stars My Destination* by Alfred Bester
- *2001: A Space Odyssey* by Arthur C. Clarke
- *Babel-17* by Samuel R. Delaney
- *The Forever War* by Joe Haldeman
- *A Wrinkle in Time* by Madeleine L'Engle
- *Saga* by Brian K. Vaughan & Fiona Staples
- *We Are Legion (We Are Bob)* by Dennis E. Taylor
- *A Fire Upon the Deep* by Vernor Vinge
- *The War of the Worlds* by H. G. Wells

 ADRIAN TCHAIKOVSKY CHILDREN OF TIME PAN

Solaris Stanislaw Lem 合合

THE MARTIAN ANDY WEIR CROWN

Nnedi Okorafor BINTI TOR

 The Martian Chronicles RAY BRADBURY

heinlein starship troopers putnam

the long way to a small angry planet Becky Chambers HODDER

ANCILLARY JUSTICE Ann Leckie

OCTAVIA E. BUTLER DAWN WARNER BOOKS

 DUNE Frank Herbert

CHILDHOOD'S END ARTHUR C. CLARKE

 THE THREE-BODY PROBLEM CIXIN LIU

NEAL STEPHENSON SEVENEVES

THE SIRENS OF TITAN KURT VONNEGUT

Ringworld LARRY NIVEN SFBC

TOR ENDER'S GAME ORSON SCOTT CARD

LEVIATHAN WAKES
THE EXPANSE
JAMES S. A. COREY

HYPERION DAN SIMMONS

ISAAC ASIMOV FOUNDATION GNOME PRESS

FICTIONAL PLANET UNIVERSE

Name the book or comic in which each of the below planets exists
(some appear in more than one) and the author.
(Please note the images are not to scale nor,
perhaps, accurately colored.)

4) Trantor

1) Arrakis

2) Asteroid B-612

3) Kern's World

5) Shis'urna

7) Camazotz

6) Shikasta

8) Barrayar

9) Tralfamadore

10) Gethen

11) Zorg

12) Ego

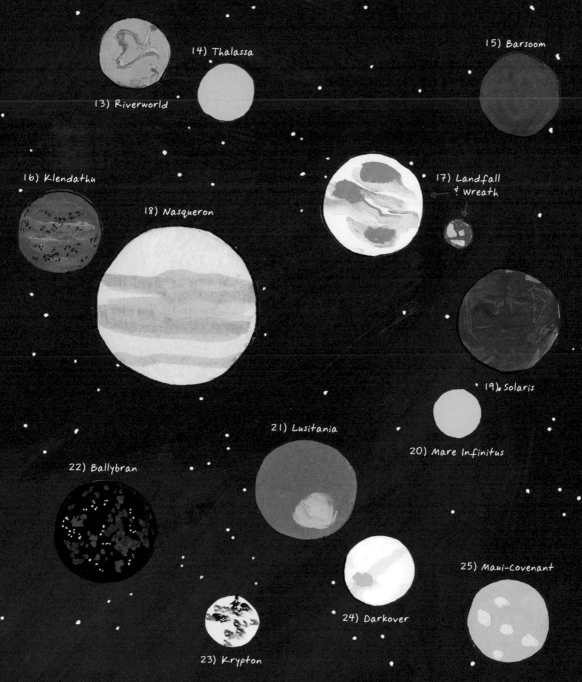

14) Thalassa

15) Barsoom

13) Riverworld

16) Klendathu

17) Landfall & Wreath

18) Nasqueron

19) Solaris

20) Mare Infinitus

21) Lusitania

22) Ballybran

25) Maui-Covenant

24) Darkover

23) Krypton

ANSWERS

1) *Dune* by Frank Herbert; 2) *The Little Prince* by Antoine de Saint-Exupéry; 3) *Children of Time* by Adrian Tchaikovsky; 4) *Foundation* by Isaac Asimov; 5) *Ancillary Justice* by Ann Leckie; 6) *Shikasta* by Doris Lessing; 7) *A Wrinkle in Time* by Madeleine L'Engle; 8) *Shards of Honor* by Lois McMaster Bujold; 9) *Slaughterhouse-five* by Kurt Vonnegut; 10) *The Left Hand of Darkness* by Ursula K. Le Guin; 11) *Calvin and Hobbes* by Bill Watterson; 12) *Thor* by Stan Lee and Jack Kirby; 13) *To Your Scattered Bodies Go* by Philip José Farmer; 14) *The Songs of Distant Earth* by Arthur C. Clarke; 15) *A Princess of Mars* by Edgar Rice Burroughs; 16) *Starship Troopers* by Robert A. Heinlein; 17) *Saga* by Brian K. Vaughan & Fiona Staples; 18) *The Algebraist* by Iain M. Banks; 19) *Solaris* by Stanislaw Lem; 20) *Endymion* by Dan Simmons; 21) *Speaker for the Dead* by Orson Scott Card; 22) *The Crystal Singer* by Anne McCaffrey; 23) *Superman* by Jerry Siegel and Joe Shuster; 24) *The Planet Savers* by Marion Zimmer Bradley; 25) *Hyperion* by Dan Simmons

GRAPHIC NOVELS & COMICS

Graphic novels are (usually) stand-alone stories, while comic books are (usually) serialized stories. In both cases, there are pictures! These are (sometimes) drawn in sequenced panels, (sometimes) with text nearby or in speech balloons. The rules are loose, allowing for much innovation and brilliance.

Will Eisner was one of the first cartoonists in the comic book industry. His career spanned nearly 70 years, and the Eisner Award is named for him. He created *A Contract with God and Other Tenement Stories* for adults, and wanted it sold in bookstores, not comic shops. So he pitched it as a "graphic novel," and it was the first book to popularize the term. Bookstores weren't sure where to put it.

Michael Chabon fictionalized Eisner for his novel "The Amazing Adventures of Kavalier & Clay."

Picador 2000 paperback, design by Henry Sene Yee

Emil Ferris was paralyzed by a West Nile virus–infected mosquito at age 40. She eventually began to draw again by duct-taping a pen to her hand, earned an MFA, and created the intricate, sketchbook-style *My Favorite Thing Is Monsters*, all while raising her young daughter.

Saga is an epic space-opera series written by Brian K. Vaughan and illustrated by Fiona Staples. Vaughan began incubating *Saga* when he was a kid, bored in math class. When he and his wife were expecting their second daughter, he introduced parents from warring alien races who struggle to survive with a newborn. That child narrates the story.

Staples co-owns the series and draws everything, designing all the characters, vehicles, alien races, and planets. She plans with thumbnail sketches, but mostly works digitally, likening the outcome to animation cels, with inked figures and painted backgrounds. She also letters the narration herself, which is rare in comics.

Chris Ware is a master of the comics medium, but his work spans other media. He was commissioned by Chip Kidd to design the inner workings of the wind-up bird on the cover of Haruki Murakami's *The Wind-Up Bird Chronicle*, and by Dave Eggers to create the mural on his literary nonprofit, 826 Valencia.

MORE

- *The Best We Could Do* by Thi Bui
- *What I Hate: From A to Z* by Roz Chast
- *Preacher* by Garth Ennis & Steve Dillon
- *Asterios Polyp* by David Mazzucchelli
- *The Property* by Rutu Modan
- *Big Questions* by Anders Nilsen
- *Persepolis* by Marjane Satrapi
- *This One Summer* by Mariko Tamaki & Jillian Tamaki
- *The Infinite Wait and Other Stories* by Julia Wertz
- *Fables Vol. 1: Legends in Exile* by Bill Willingham & Lan Medina

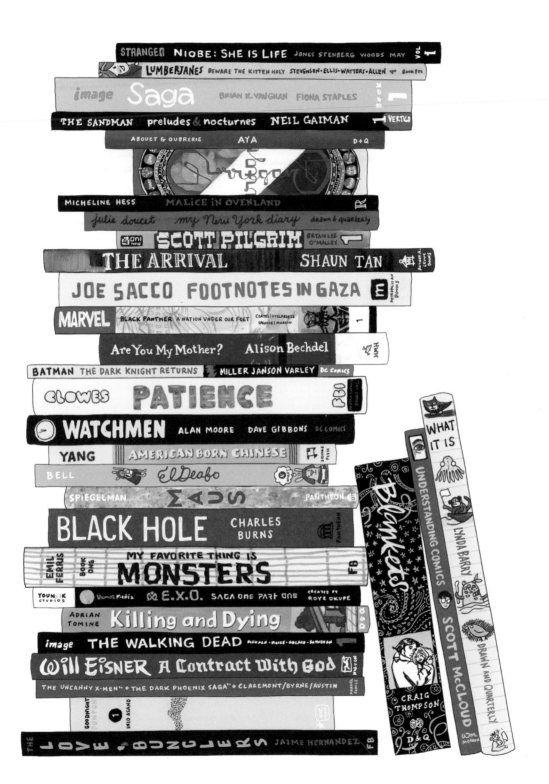

BELOVED BOOKSTORES

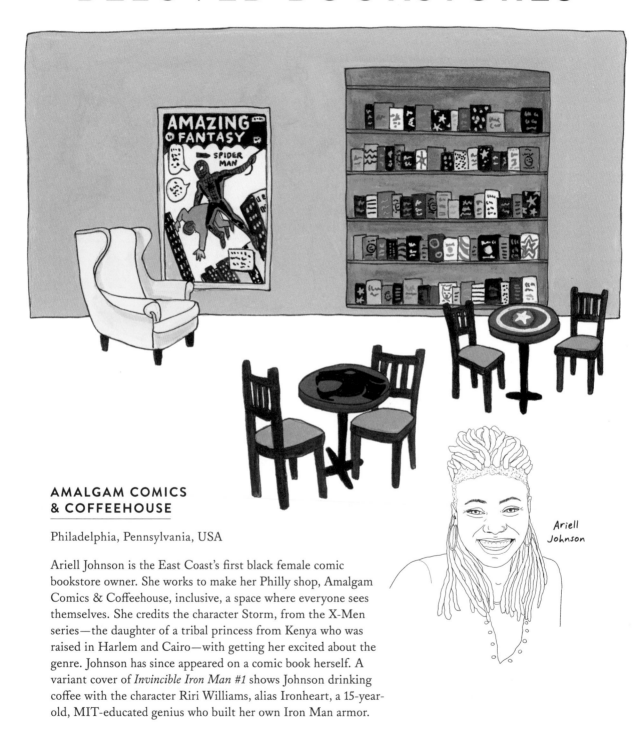

Ariell Johnson

AMALGAM COMICS & COFFEEHOUSE

Philadelphia, Pennsylvania, USA

Ariell Johnson is the East Coast's first black female comic bookstore owner. She works to make her Philly shop, Amalgam Comics & Coffeehouse, inclusive, a space where everyone sees themselves. She credits the character Storm, from the X-Men series—the daughter of a tribal princess from Kenya who was raised in Harlem and Cairo—with getting her excited about the genre. Johnson has since appeared on a comic book herself. A variant cover of *Invincible Iron Man #1* shows Johnson drinking coffee with the character Riri Williams, alias Ironheart, a 15-year-old, MIT-educated genius who built her own Iron Man armor.

ATOMIC BOOKS

Baltimore, Maryland, USA

Atomic Books is not only the best place in Charm City to find unusual literature and underground comic books; it's also the place to send John Waters fan mail (3620 Falls Road, Baltimore, Maryland 21211). The acclaimed director, writer, actor, stand-up comedian, visual artist, and art collector is native to the city and occasionally stops by the store to pick up his mail.

John Waters

Josh Spencer

THE LAST BOOKSTORE

Los Angeles, California, USA

The Last Bookstore opened in 2005, when both Borders and independent bookstores were rapidly closing. Owner Josh Spencer knew opening the store was a risk, but he says he was relatively comfortable with it because he had already endured greater losses: a moped accident in 1996 cost him the ability to walk.

The store lives in the cavernous shell of an old bank in downtown Los Angeles. Marble pillared rooms with high ceilings are piled with books, sometimes at random to encourage fortuitous

discoveries. Readers can browse sci-fi and horror books in an old vault, walk through a tunnel of stacked tomes, and admire literary art installations such as a flying typewriter and a light switch disguised as a book spine.

Spencer wants the store to feel warm and human. However you'd describe it, his efforts are working. The store is busy, with regular customers returning every day of the week and often leaving with piles of books.

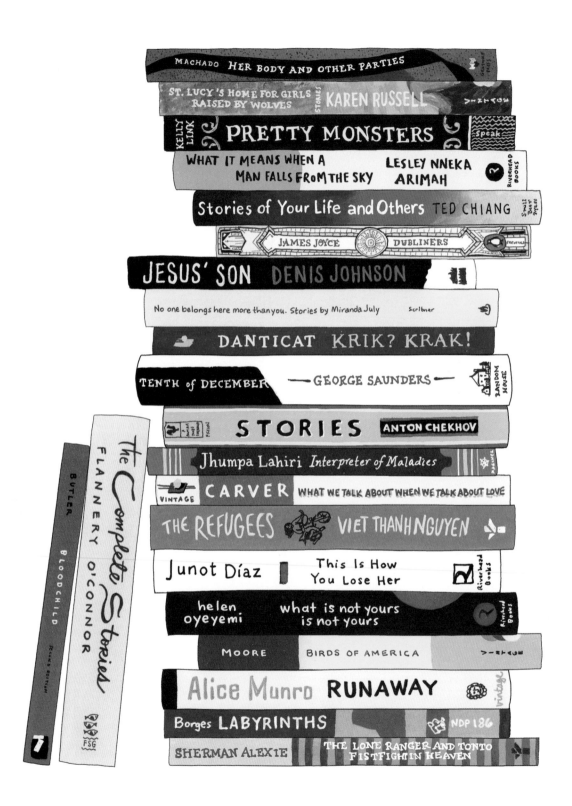

SHORT STORIES

Many writers' debut books are story collections, and you can sometimes witness the author working things out and growing. But for writers who embrace the format, it's not just a step on the path, it's a glorious destination.

George Saunders, a king of stories, even talks to them, saying, "Don't bloat. Don't bloat! Let's get in and out of here as fast as we can.'"

On his way to writing stories, Saunders worked as a geophysical engineer, an oil exploration crew member, a Beverly Hills doorman, a roofer, a convenience-store clerk, a country-and-western guitarist, a knuckle-puller in a West Texas slaughterhouse, and a tech writer for a pharmaceutical company. In 2017 he published his first novel, *Lincoln in the Bardo*, and won the Man Booker prize for it.

Kelly Link has said that her short stories are inspired by what she calls "nighttime logic," which is kind of odd, like dream logic, but instead of being nonsensical, has the ring of truth to it.

"Pretty Monsters" is Link's first collection for teens. She has written several other collections for adults, including "Get in Trouble" in 2015.

Random House hardcover, design by Alex Merto

Jhumpa Lahiri's father was a librarian, and so she owned very few books as a child, having to borrow them instead. Her first, at age five or six, was Jean Kyler McManus's *You'll Never Have to Look for Friends*.

American Greetings 1970 hardcover, art by Fran Kariotakis

Lahiri's mother tongue is Bengali. She wrote two novels and two short-story collections in English before moving her whole family to Rome for three years. There she learned—and wrote a memoir called *In Other Words* in—Italian. She says that her Italian, though imperfect, has given her freedom and power she didn't have in English.

In 1995 Octavia E. Butler became the first science-fiction writer to win a MacArthur Fellowship (aka a Genius Grant). Her mother was a housemaid and her father a shoeshine man. As a shy, dyslexic girl, she hid from bullies in the Pasadena Public Library, reading fairy tales, horse stories, and science-fiction magazines. At age 10 she begged her mother for a typewriter. She later said, "I began writing about power because I had so little."

MORE

- *Sixty Stories* by Donald Barthelme
- *The Illustrated Man* by Ray Bradbury
- *The Bloody Chamber* by Angela Carter
- *The Stories of John Cheever* by John Cheever
- *Drinking Coffee Elsewhere* by ZZ Packer
- *Close Range* by Annie Proulx
- *Goodbye Columbus* by Philip Roth
- *Nine Stories* by J. D. Salinger
- *Everything Ravaged, Everything Burned* by Wells Tower
- *You Can't Keep a Good Woman Down* by Alice Walker

BELOVED BOOKSTORES

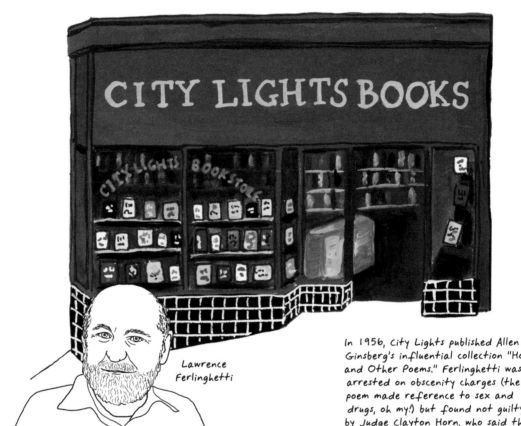

Lawrence Ferlinghetti

In 1956, City Lights published Allen Ginsberg's influential collection "Howl and Other Poems." Ferlinghetti was arrested on obscenity charges (the poem made reference to sex and drugs, oh my!) but found not guilty by Judge Clayton Horn, who said the poem was of "redeeming social importance." The trial did lead to the sale of many more copies of the book.

CITY LIGHTS

San Francisco, California, USA

City Lights is both a bookstore and a publisher in San Francisco, where North Beach meets Chinatown. It was founded in 1953 by poet Lawrence Ferlinghetti and professor Peter D. Martin (who left two years later) to specialize in "world literature, the arts, and progressive politics." It was originally the first paperback-only bookstore in the US (now it sells hardcovers, too). In 2001, City Lights became an official historic landmark.

Allen Ginsberg

HOWL
AND OTHER POEMS
ALLEN GINSBERG
Introduction by
William Carlos Williams

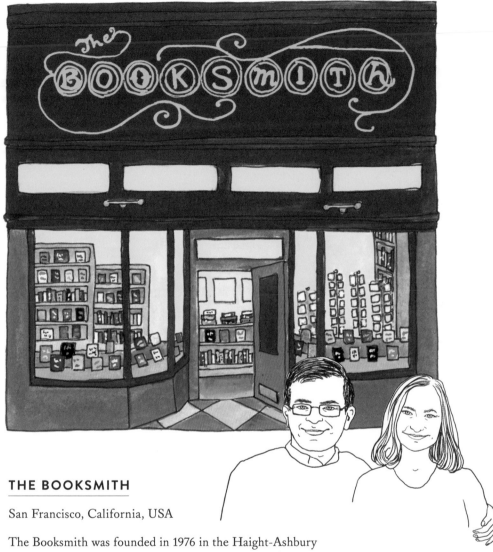

THE BOOKSMITH

San Francisco, California, USA

The Booksmith was founded in 1976 in the Haight-Ashbury neighborhood of San Francisco, the original home of US counterculture. The store hosts a robust events program, and visiting speakers and authors have included philosopher Timothy Leary, science-fiction legend Ray Bradbury, charismatic journalist Hunter S. Thompson, kids' author Lemony Snicket, musicians Neil Young and Patti Smith, Phil Lesh and Mickey Hart from the Grateful Dead, and photographers Richard Avedon and Annie Leibovitz. Allen Ginsberg gave his last reading ever at the Booksmith.

Christin Evans and her husband, Praveen Madan, bought the Booksmith in 2007 from founder Gary Frank.

POETRY

According to the National Endowment for the Arts, the number of people who read at least one work of poetry per year has steadily dropped, from 17% in 1992 to just 6.7% in 2012. Poetry is less popular than jazz (but still wins out over opera!). But poetry is the opposite of statistics. A true poem hits your heart directly, naming unrecognized feelings and burning through any junk in its path.

Harper & Row
1974 hardcover

The first book of poetry many American children read is *Where the Sidewalk Ends*. Its author, Shel Silverstein, was a Korean War vet, an illustrator for *Playboy* (and a regular at the Mansion), a Golden Globe and Academy Award nominee, and a two-time Grammy winner (one for writing Johnny Cash's song *A Boy Named Sue*, and one for an audio version of *Where the Sidewalk Ends*).

Tracy K. Smith's Pulitzer Prize–winning *Life on Mars* is a tribute to her father, a Hubble space telescope engineer. But a tribute wasn't her original intention; she was more focused on "space as a kind of metaphor through which to consider some of the facts and problems of life here on Earth."

Many loving parents have named their boys Pablo after Pablo Neruda, but that's a name he gave himself. His original name was Ricardo Eliécer Neftalí Reyes Basoalto. Neruda was also a diplomat, a senator, and an adviser to Chile's socialist president Salvador Allende (a relative of writer Isabel Allende). He was in the hospital for cancer treatment when Allende was overthrown by Augusto Pinochet, but left when a doctor injected him with an unknown substance. Neruda died at home six and a half hours later, either from poison or, as reported, from prostate cancer. In 2013, his bones were exhumed and examined in Chile, Spain, the US, and Switzerland, but, so far, without conclusion.

The best-selling poet in the US is Rumi, a Persian Sufi mystic and Islamic scholar who was born in what is now Tajikistan, studied in Iran and Syria, and lived most of his life in Turkey. His popularity is thanks in part to the modern translations by Coleman Barks, but Rumi's poems of love, spirituality, and unity speak to people everywhere.

HarperSanFrancisco
2004 paperback,
design by
Nita Ybarra

love + roses

In the early 1900s, the poet Rainer Maria Rilke worked as a secretary for the sculptor Auguste Rodin and wrote about his work. Rachel Corbett wrote a book about their friendship, *You Must Change Your Life*.

MORE

- *Self-Portrait in a Convex Mirror* by John Ashbery
- *Collected Poems* by W. H. Auden
- *Standing Water* by Eleanor Chai
- *Family Values* by Wendy Cope
- *Pictures of the Gone World* by Lawrence Ferlinghetti
- *Mountain Interval* by Robert Frost
- *The Wild Iris* by Louise Glück
- *Birthday Letters* by Ted Hughes
- *Stag's Leap* by Sharon Olds
- *Spring and All* by William Carlos Williams

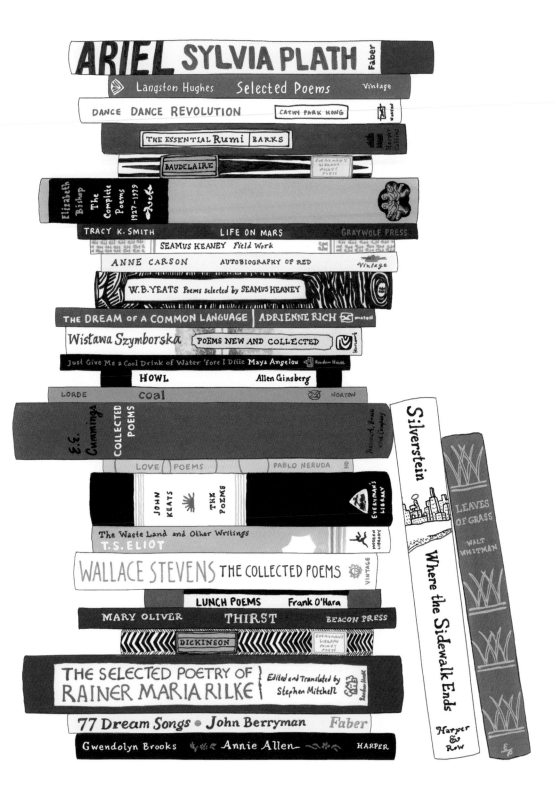

WRITING ROOMS

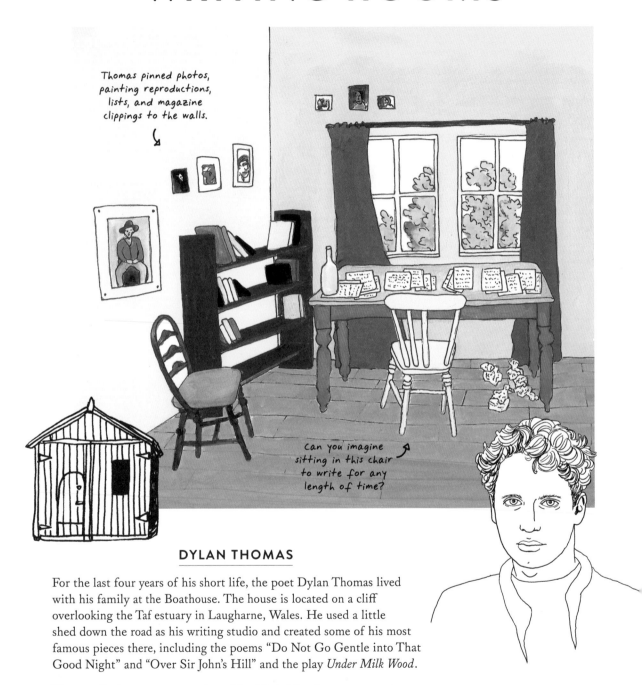

Thomas pinned photos, painting reproductions, lists, and magazine clippings to the walls.

Can you imagine sitting in this chair to write for any length of time?

DYLAN THOMAS

For the last four years of his short life, the poet Dylan Thomas lived with his family at the Boathouse. The house is located on a cliff overlooking the Taf estuary in Laugharne, Wales. He used a little shed down the road as his writing studio and created some of his most famous pieces there, including the poems "Do Not Go Gentle into That Good Night" and "Over Sir John's Hill" and the play *Under Milk Wood*.

Thomas died at age 39 on a trip to New York City, from pneumonia and a lifetime of drinking too much.

JAMES BALDWIN

At age 46, feeling alienated and persecuted in the US, author and social critic James Baldwin left his country for Saint-Paul-de-Vence, a medieval village on France's Côte d'Azur. He spent the last 18 years of his life in a villa nestled among orchards, rosemary hedges, and fields of wild strawberries. There Baldwin wrote several works, including his famous "An Open Letter to My Sister, Angela Y. Davis."

Tragically, Baldwin's former home most likely won't stand for much longer. Shortly after his death, it was bought by a developer with plans to build apartment buildings. Baldwin's family and a group called His Place in Provence have made attempts to acquire and preserve it, but the wing he lived in has already been destroyed.

One of Baldwin's typewriters, a Smith-Corona Coronamatic 2200.

Baldwin hosted Josephine Baker, Miles Davis, Nina Simone, Ella Fitzgerald, Beauford Delaney, Harry Belafonte, and Sidney Poitier. He was adding to the long list of famous artist visitors to Saint-Paul-de-Vence (Henri Matisse, Georges Braque, Pablo Picasso, Fernand Léger, Joan Miró, Alexander Calder, Jean Cocteau, and Marc Chagall had all spent time there).

A large table in Baldwin's gardens is fondly remembered by guests as the place for lively eating, drinking, and conversing. Baldwin called it his "welcome table." One visitor recalls that it was under a towering grove of cedars, another under grape arbors. Baldwin's last work is a play called *The Welcome Table*.

ESSAYS

Michel de Montaigne published his *Essais*—full of anecdotes and insights and written with *bonne foi* (honesty)—in 1580. Ever since, we have been reading essays on things we want to know about—even if we didn't realize we wanted to know about them before. Essayists distill expansive subjects and elucidate mysterious ones, weave multiple ideas together, or whittle just one to a fine point. As Aldous Huxley said, "The essay is a literary device for saying almost everything about almost anything."

Rebecca Solnit sees the world more clearly than most of us, and can explain what she sees better than perhaps anyone. She is a truth-teller, mobilizer, and hope-giver. She also inspired the term "mansplaining," now recognized by the Oxford online dictionary as when a man explains something "to someone, typically a woman, in a manner regarded as condescending or patronizing."

David Sedaris debuted on NPR's *Morning Edition* on December 23, 1992, reading an essay called "Santaland Diaries" about being a Christmas elf at Macy's. Since then he's written several extremely popular collections, including *Me Talk Pretty One Day*, about his childhood in Raleigh, North Carolina, and his move to France as an adult, as well as his attempts to learn French. When asked about learning to write well, Sedaris recommends reading: "There's no such thing as somebody who's never read a book before suddenly sitting down one day and writing one. You have to learn how to captivate a reader."

Me Talk Pretty One Day
DAVID Sedaris

Little, Brown 2001 paperback, design by Michael Ian Kaye & Melissa Hayden

John McPhee's nearly 30 books of essays range in topic from oranges to basketball players, Alaska to truck driving, the Swiss army to nuclear physics. He has taught writing at Princeton for decades. He tells his classes, "Taking things from one source is plagiarism; taking things from several sources is research."

The polemicist (and George Orwell fan) Christopher Hitchens was antitotalitarian and antitheist, and felt science, not religion, should inform ethics. He once had himself waterboarded to write about what it was like, and he has an asteroid named after him. He was diagnosed with esophageal cancer in 2010. When Charlie Rose asked him if he regretted his past smoking and drinking, Hitchens said, "Writing is what's important to me, and anything that helps me do that—or enhances and prolongs and deepens and sometimes intensifies argument and conversation—is worth it to me."

You can call me Chris.

When Hitchens died in 2011, his friend, the writer Andrew Sullivan, said his last words were "Capitalism. Downfall."

MORE

- *The Boys of My Youth* by Jo Ann Beard
- *An Omelette and a Glass of Wine* by Elizabeth David
- *Teaching a Stone to Talk* by Annie Dillard
- *But Beautiful* by Geoff Dyer
- *The Firmament of Time* by Loren Eiseley
- *Thirteen Ways of Looking at a Black Man* by Henry Louis Gates Jr.
- *The Book of My Lives* by Aleksandar Hemon
- *Against Joie de Vivre* by Phillip Lopate
- *Art & Ardor* by Cynthia Ozick
- *The Braindead Megaphone* by George Saunders

BOOKISH PEOPLE RECOMMEND

SHELLEY M. DIAZ

Reviews manager and editor at *School Library Journal*

Anne of Green Gables: A Graphic Novel
adapted by Mariah Marsden & illustrated by Brenna Thummler

Andrews McMeel
Publishing 2017
paperback

"Lucy Maud Montgomery's *Anne of Green Gables* was the book that made me a reader. I had devoured books before then, but that classic reinforced in me that a book could be an escape and a vehicle at the same time. In Anne I had found a kindred spirit—another awkward preteen whose head was filled with stories and never quite fit in. I do wish that Mariah Marsden and Brenna Thummler's graphic novel edition existed when I was 10, though. This lush adaptation condenses Montgomery's long (and often verbose) novel into a volume that I would give to any child."

Cinco Puntos Press
2014 paperback,
design and art by
Zeke Peña

Gabi, a Girl in Pieces
by Isabel Quintero

"*Gabi, a Girl in Pieces* is a book I wished I had as a teen. Gabi is a loud, fat, budding poet who is constantly trying to meet the expectations of her mother, friends, and school counselors. Her journal entries could've been my diary entries at age 18, when I was trying to find the right balance between meeting my single mother's expectations and juggling my place in two worlds—the American one and the traditional Dominican one."

CELIA SACK

Owner of Omnivore Books on Food, San Francisco, California, USA

The Zuni Cafe Cookbook
by Judy Rodgers

W. W. Norton & Company
2002 hardcover, photo
by Gentl & Hyers/Edge

"*The Zuni Cafe Cookbook* is the cookbook I love and recommend most. It tells you why you're doing what you're doing in the kitchen in a concise yet poetic way. It's the kind of book you want to take to bed with you and read all night. You learn what a dish should sound like when it's ready—how the sizzle slows or speeds up. How a syrup feels on the spoon when it's done."

Bloomsbury 2009
hardcover, design
by David Mann, art
by Victoria Sawdon

SANDI TORKILDSON

Co-owner of A Room of One's Own, Madison, Wisconsin, USA

Oryx and Crake
by Margaret Atwood

"A dystopian novel set in the near future, a *Brave New World* for the 21st century. Both a love story and a story of total destruction, in which one man struggles to survive in a world where it seems everyone else has been killed by a plague. A terrifying vision of what could happen if we allow greed to take genetic engineering to an unimaginable end. All this plus it is funny often, since we humans are."

The History of Love
by Nicole Krauss

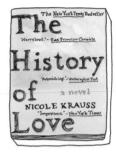

"Both heartbreaking and hilarious, this is the story of Leo Gursky, a Polish Jew who survived the invasion of his village in World War II by hiding out in the woods, and 60 years later is near death in New York City, holding on to each precious day. His story is intertwined with that of 14-year-old Alma, as she reads her mother's translation of a novel Leo wrote as a young man. Their lives are lived within the same city, ages apart but about to collide."

W. W. Norton & Company 2006 paperback, design by Kapo Ng & Sam Chung

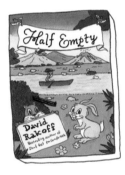

MARY LAURA PHILPOTT

Essayist; Emmy-winning cohost of *A Word on Words*; founding editor of *Musing*, the online magazine of Parnassus Books; and author of *Penguins with People Problems*

Anchor 2011 paperback, design by David Rakoff & John Fontana, art by Mark Matcho

Half Empty
by David Rakoff

"If I were a book-waitress, walking around offering people a refreshing palate-cleanser between heavy novel courses, I'd hold out a tray of humorous essay collections and let them take their pick. If someone had trouble choosing, I might say, 'The David Rakoff is particularly fresh this evening.' Then I'd set *Half Empty* before them. They'd open it up and discover Rakoff's voice, the unique way he had of blending hilarity, melancholy, and—the title notwithstanding—stubborn optimism. 'It reminds me of . . . ,' they'd say, laughing, and I'd finish their sentence, '. . . David Sedaris, yes. But a little different, right?' Then I'd restock my tray so I could offer it to someone

else, too. If we can't have David Rakoff back in our world, the least I can do is bring his writing into someone else's."

EMILY PULLEN

Assistant book buyer at the New York Public Library Shop

Forever
by Pete Hamill

"Through a slight twist of magical realism, this novel tells the history of New York City, from 1740 to 2001, through the eyes of a single narrator: Cormac O'Connor. As a young boy, he follows the man who killed his parents from Ireland to America. He learns a trade, fights in the Revolutionary War, and then has his life saved by an African shaman whom he befriended on the voyage over. The one condition of his survival is that he must not leave Manhattan, so we see the island (and the nation) grow as Cormac stays the same. Will anything break his curse? Love, perhaps? You'll have to read it to find out."

Little, Brown 2002 hardcover, photo by Michael Magill

Matilda
by Roald Dahl

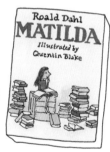

"My favorite book of all time is *Matilda* by Roald Dahl. I was already a well-established 'reader' by the time it found me, but it really served to solidify that identity for life (I now have a Matilda tattoo!). Matilda was able to find solace and magic through books and learning, and she was able to move past dreary days (and insufferable parents and principals) through her smarts. And don't we all dream of going off to live with Miss Honey in a little cottage full of books?"

Viking Kestrel 1988 hardcover, art by Quentin Blake

Orange-
fronted
yellow
finch

"What do you think of my beak?"

NATURE & ANIMALS

The more we learn about animals, trees, and any other living component of the world around us, the more we realize that we underestimate their ability to think, feel, and generally be more like humans, except in ways they are special and perhaps better than humans. This is pretty well summed up by the title of Frans de Waal's book *Are We Smart Enough to Know How Smart Animals Are?*

In his essay "Why Look at Animals?" from 1980's *About Looking*, John Berger traces the history of humans' relationships with animals, as we went from living with them as neighbors, to using them for labor, to keeping them in cages. He suggests we have done the same to our own species, reducing ourselves to "isolated productive and consuming units."

"how about mine?"

Scaly-breasted
munia
(spice finch)

When he became a supervisor of New Mexico's million-acre Carson National Forest in 1913, Aldo Leopold, environmentalist and cofounder of the Wilderness Society, shot wolves and built roads. But he and his colleagues became disillusioned with tactics like these, realizing that manipulating nature to serve short-term economic goals would have bad long-term effects.

While researching *The Soul of an Octopus*, Sy Montgomery spent many hours with several octopuses at various aquariums. When one empathetically rose from the bottom of its tank to hug a young aquarium volunteer who was feeling sad, Montgomery observed that there might be no better hug than from "someone with eight arms and three hearts."

Alexander von Humboldt was the quintessential 18th-century naturalist explorer: brilliant, adventurous, and very famous at the time (although mostly forgotten now). During a five-year trek

through South America, he developed the idea of nature as an interconnected system, one that, even then, he could see human intervention was harming. Andrea Wulf brings him back to us in her award-winning biography, *The Invention of Nature*.

The INVENTION of NATURE
ALEXANDER VON HUMBOLDT'S NEW WORLD
ANDREA WULF

Vintage 2016
paperback, design
by Kelly Blair

MORE

- *The Genius of Birds* by Jennifer Ackerman
- *The Elephant Whisperer* by Lawrence Anthony
- *The Most Perfect Thing: Inside (and Outside) a Bird's Egg* by Tim Birkhead
- *Gorillas in the Mist* by Dian Fossey
- *Pilgrim at Tinker Creek* by Annie Dillard
- *Nature and Selected Essays* by Ralph Waldo Emerson
- *The Botany of Desire* by Michael Pollan
- *Beyond Words: What Animals Think and Feel* by Carl Safina
- *The Thing with Feathers* by Noah Strycker
- *Walden* by Henry David Thoreau

"and mine?"

"mine's the best, no?"

Gouldian
finch

Red-cheeked
cordonbleu
finch

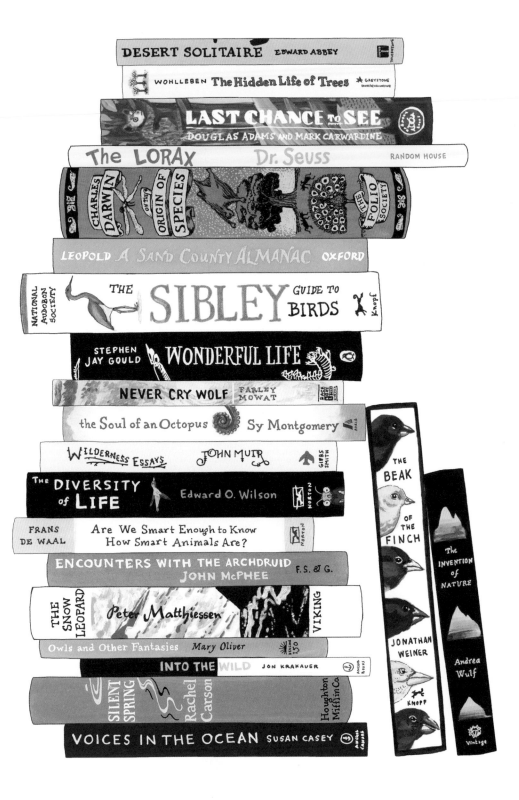

DESERT SOLITAIRE EDWARD ABBEY

WOHLLEBEN The Hidden Life of Trees GREYSTONE

LAST CHANCE TO SEE
DOUGLAS ADAMS AND MARK CARWARDINE

The LORAX Dr. Seuss RANDOM HOUSE

CHARLES DARWIN ON THE ORIGIN OF SPECIES THE FOLIO SOCIETY

LEOPOLD A SAND COUNTY ALMANAC OXFORD

THE SIBLEY GUIDE TO BIRDS
NATIONAL AUDUBON SOCIETY Knopf

STEPHEN JAY GOULD WONDERFUL LIFE

NEVER CRY WOLF FARLEY MOWAT

the Soul of an Octopus Sy Montgomery

WILDERNESS ESSAYS JOHN MUIR GIBBS SMITH

THE DIVERSITY of LIFE Edward O. Wilson NORTON

FRANS DE WAAL Are We Smart Enough to Know How Smart Animals Are? NORTON

ENCOUNTERS WITH THE ARCHDRUID
JOHN McPHEE F.S. & G.

THE SNOW LEOPARD Peter Matthiessen VIKING

Owls and Other Fantasies Mary Oliver

INTO THE WILD JON KRAKAUER

SILENT SPRING Rachel Carson Houghton Mifflin Co.

VOICES IN THE OCEAN SUSAN CASEY

THE BEAK OF THE FINCH JONATHAN WEINER Knopf

The INVENTION of NATURE Andrea Wulf Vintage

WRITERS' PETS

So many writers have pets. Perhaps it's because writing is such a solitary job and it's great to take a break with a furry (or feathered) friend?

PINKA

Virginia Woolf

Purebred cocker spaniel Pinka was given to Woolf as a gift by Vita Sackville-West, when her dog Pippin had a litter of puppies.

Miza

Mitou

Nicette

MITOU, MIZA & NICETTE

Edith Wharton

LIMPY

Flannery O'Connor

As a child, O'Connor collected chickens (including one that could walk backward, and one that wore a coat and lace collar) and then many other kinds of fowl. In her 1961 essay "The King of Birds," she recounts ordering a family of peacocks that arrived by train, and eventually having a large flock of them, including one named Limpy.

BASKET

Gertrude Stein & Alice B. Toklas

BOISE

Ernest Hemingway

Boise lived at Finca Vigía, Hemingway's home in Havana. He was one of Papa's first cats and a favorite, often sitting next to the writer at his desk, eating meals with him, and sleeping next to him. Boise was buried in a cat cemetery near the back terrace.

BAMBINO

Mark Twain

GRIP

Charles Dickens

Grip died in 1841, but he is preserved, standing on a log inside a glass case, in the Rare Books department of the Philadelphia Free Library. He appeared as a character in Dickens's *Barnaby Rudge* and indirectly inspired Edgar Allan Poe's "The Raven."

CHARLEY

John Steinbeck

In 1960, Steinbeck and Charley, a standard poodle, traveled many thousands of miles around the US together in a pickup truck with a camper shell (which Steinbeck named Rocinante, after Don Quixote's horse). *Travels with Charley*, his account of the road trip and of a changing America, was published in 1962.

HERMAN

Maurice Sendak

Sendak named the German shepherd after Herman Melville.

TYKE

Jack Kerouac

Jack Kerouac loved cats, and especially Tyke. In *Big Sur*, he mourns the cat as if he were a "little brother."

GINGER

William S. Burroughs

Burroughs felt cats were "psychic companions" and wrote a book about them called *The Cat Inside*. He even subscribed to *Cat Fancy* for many years.

MITZ

Leonard Woolf

Mitz the marmoset often sat on Woolf's shoulder or in his pocket. In 2007, Sigrid Nunez published a novel about the little rescued primate, called *Mitz: The Marmoset of Bloomsbury*.

US AND THE UNIVERSE

From the bacteria inside us to the stars above, we try to understand everything. Yet we often change the world without full understanding and then must scramble to fix things before it's too late. The best science writers explain difficult ideas in easy ways, and make us curious enough to do a better job.

Asked if the research for *A Short History of Nearly Everything* made him an optimist or a pessimist, Bill Bryson replied, "I don't know. It's hard not to be kind of pessimistic about human beings generally, because we do tend to mess things up. . . . But being a pessimist is just such a gloomy way of looking at things, so I have to hope for the best—life wouldn't be worth living if we didn't have hope."

The naturalist Diane Ackerman has written many books of both prose and poetry, often about animals, including humans. She considers a city to be as much a wilderness as a forest or the sea, and says that "Nature includes everything."

Ackerman has a molecule named after her: dianeackerone. It's a pheromone given off by crocodilians.

Astrophysicist (and captain of his high school wrestling team) Neil deGrasse Tyson decided to study the universe after visiting New York's Hayden Planetarium as a kid. A few decades later he became the Planetarium's director. Tyson writes for everyone and refutes science-deniers with humor and grace, in books, on radio and television, and, most pithily, on Twitter.

Tyson's "Astrophysics for People in a Hurry" is a clear and concise guide to the universe.

Norton 2017 hardcover, design by Pete Garceau

Mark O'Connell opens *To Be a Machine* with a Ralph Waldo Emerson quote: "A man is a god in ruins." He explores how transhumanists are trying to repair, upgrade, or replace the ruins so we can be immortal gods after all.

Doubleday 2017 hardcover, design by Pete Garceau

Walt Whitman wrote, "I am large, I contain multitudes." Ed Yong counters that we *are* multitudes. Research suggests that more than half of our cells are bacteria. They affect our behavior and perhaps even our thoughts and emotions, and they decompose us when we die. So really, we are never alone in the universe.

we are with you!

MORE

- *How Emotions Are Made* by Lisa Feldman Barrett
- *The Big Picture* by Sean Carroll
- *Collapse* by Jared Diamond
- *The Coming Plague* by Laurie Garrett
- *Chaos* by James Gleick
- *The Singularity Is Near* by Ray Kurzweil
- *The Accidental Universe* by Alan Lightman
- *How the Mind Works* by Steven Pinker
- *Cosmos* by Carl Sagan
- *Behave* by Robert M. Sapolsky

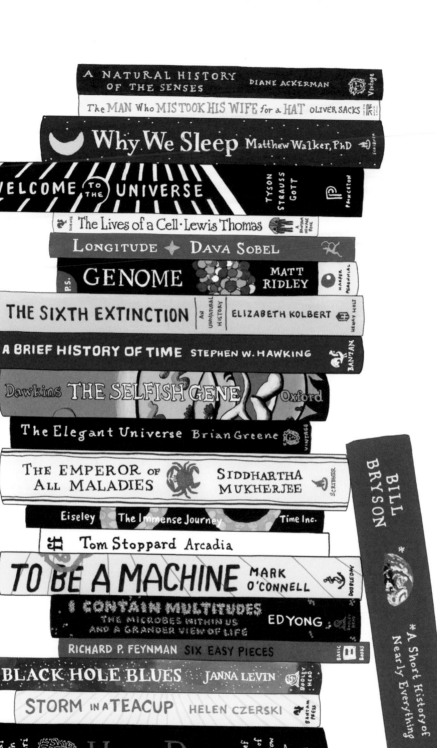

A NATURAL HISTORY OF THE SENSES · DIANE ACKERMAN · Vintage

The MAN Who MISTOOK HIS WIFE for a HAT · OLIVER SACKS

Why We Sleep · Matthew Walker, PhD · Scribner

WELCOME TO THE UNIVERSE · TYSON STRAUSS GOTT · Princeton

The Lives of a Cell · Lewis Thomas · A Bantam New Age Book

LONGITUDE · DAVA SOBEL

GENOME · MATT RIDLEY · Harper Perennial · P.S.

THE SIXTH EXTINCTION · An Unnatural History · ELIZABETH KOLBERT · Henry Holt

A BRIEF HISTORY OF TIME · STEPHEN W. HAWKING · BANTAM

Dawkins · THE SELFISH GENE · Oxford

The Elegant Universe · Brian Greene · Vintage

THE EMPEROR of ALL MALADIES · SIDDHARTHA MUKHERJEE · Scribner

Eiseley · The Immense Journey · Time Inc.

Tom Stoppard Arcadia

TO BE A MACHINE · MARK O'CONNELL · Doubleday

I CONTAIN MULTITUDES · THE MICROBES WITHIN US AND A GRANDER VIEW OF LIFE · ED YONG

RICHARD P. FEYNMAN · SIX EASY PIECES · Basic Books

BLACK HOLE BLUES · JANNA LEVIN · Bodley Head

STORM IN A TEACUP · HELEN CZERSKI · Bantam Press

Yuval Noah Harari · Homo Deus · A Brief History of Tomorrow · Harvill Secker

BILL BRYSON · *A Short History of Nearly Everything · Black Swan

BELOVED BOOKSTORES

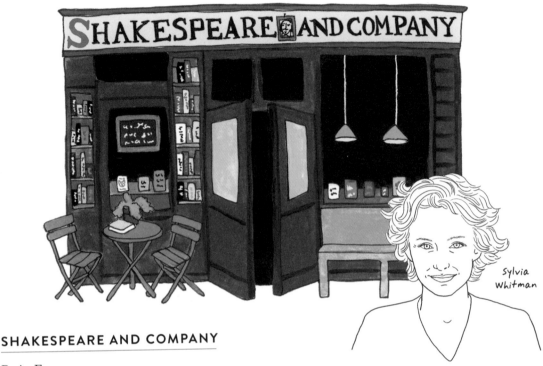

Sylvia Whitman

SHAKESPEARE AND COMPANY

Paris, France

The Shakespeare and Company that lives on Paris's Left Bank today is a tribute to Sylvia Beach's bookstore that came and went before. Beach was a champion of modernism, and Shakespeare and Company was famous for publishing *Ulysses* (and smuggling copies into the US), and for hosting writers like F. Scott Fitzgerald, Gertrude Stein, Ernest Hemingway, Djuna Barnes, and, of course, James Joyce. The store also lent out books for a small fee. As the story's told, Beach shut down the store and stashed all her books in an upstairs apartment during World War II. An American, she was forced to spend six months in an internment camp in Vittel. Hemingway is said to have "liberated" the bookstore himself two years later, but it didn't reopen.

George Whitman opened the current incarnation of Shakespeare and Company in 1951 under the name Le Mistral. He eventually changed the name, in homage to Beach and on the 400th anniversary of William Shakespeare's birth, and elevated the store's status to utopia. Writers Allen Ginsberg, William Burroughs, Anaïs Nin, Julio Cortázar, Henry Miller, William Saroyan, Lawrence Durrell, and James Baldwin were all early visitors. At least 30,000 writers and artists, including Ethan Hawke, Jeet Thayil, Darren Aronofsky, Geoffrey Rush, and David Rakoff, have slept on benches-cum-beds tucked into the store's aisles. Whitman called these visitors Tumbleweeds and let them come and go so long as they read a book a day, helped out at the shop, and wrote a one-page autobiography.

As Whitman aged, he transferred the store over to his daughter Sylvia, who brought it up to date with credit card readers, computers, a literary prize, and a tamed version of the Tumbleweeds. George died in 2011, but it's rumored he haunts the store, occasionally tossing books off high shelves.

BEST BOOKS & RICH TREASURES

Tampa, Florida, USA

Tampa's Ybor City neighborhood had gone at least 10 years without a bookstore until Best Books & Rich Treasures opened its doors. Ever since, the veteran-owned business has served the military and civilian communities. Now located close to MacDill Air Force Base, the store had a previous location in Virginia Beach, Virginia. BB & RT specializes in African diaspora books but offers new, used, and rare books on a variety of topics.

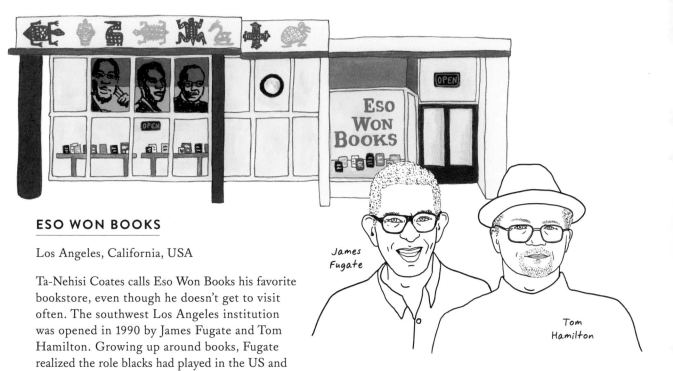

James Fugate

Tom Hamilton

ESO WON BOOKS

Los Angeles, California, USA

Ta-Nehisi Coates calls Eso Won Books his favorite bookstore, even though he doesn't get to visit often. The southwest Los Angeles institution was opened in 1990 by James Fugate and Tom Hamilton. Growing up around books, Fugate realized the role blacks had played in the US and around the world and wanted to be sure others knew that history, too. Through its decades of service, Eso Won has survived civil unrest, several relocations, recessions, and, of course, Amazon. It has survived because it is embedded in and essential to its community; one customer described it as a barbershop where no one cuts hair.

A SENSE OF PLACE

Some books evoke a place so strongly that after you've read them, you aren't quite sure whether you have or haven't been there. Often these are travel journals or memoirs, written by visitors or expats, but sometimes they're novels, by locals, set in locations that become characters themselves.

Paul Bowles was born in New York, but he lived in Tangier for the last 52 years of his life. In *The Sheltering Sky* he writes of two Americans in Algeria who think of themselves as enlightened travelers seeing the "real" world, but ultimately are never satisfied with their lives in any location.

1949 John Lehmann hardcover, design by Fred Uhlman

In *Looking for Transwonderland*, Noo Saro-Wiwa, raised in England, returns to Nigeria, the country of her birth. She had visited often as a child, but rarely during the decade since her activist father was murdered there. The time away gave her, as she puts it, "the innocence of the outsider."

Karen Christence Dinesen, born in Denmark, moved with her husband to Kenya. They started a coffee plantation, but he preferred big game hunting, so she ran the farm. He gave her syphilis in their first year of marriage (and she would suffer resulting spinal pain her whole life). After they divorced, she fell in love with Denys Finch Hatton, another game hunter. The farm failed, her lover died in a plane crash, and she returned to Denmark, unhappy to leave the country she felt to be her true home. She began to write, eventually to much success, under the pseudonym Isak Dinesen. Her best-known work, *Out of Africa* (about her colonialist life in Kenya), was made into an Oscar-winning movie in 1985.

In her later years, Dinesen always wore turbans and consumed very little other than oysters and champagne. She eventually died of malnutrition.

Orhan Pamuk's *A Strangeness in My Mind* tells the tale of Melvut, a boza seller in Istanbul. Boza is a thick, slightly alcoholic Turkish drink made from fermented wheat and topped with cinnamon and roasted chickpeas.

Joshua Foer and Dylan Thuras founded the *Atlas Obscura* website in 2009 as a massive cabinet of curiosities from around the globe. While it often feels like everything has been seen and done and you can drink Starbucks anywhere, Thuras says, "the world is still this huge, bizarre, vast place filled with astounding stuff. And if you sort of tilt your view a little bit and start looking for it, you start finding it everywhere." One of their website's most popular stories is about Tashirojima, the island in Japan where cats outnumber people.

NO DOGS ALLOWED.

MORE

- *City of Djinns* by William Dalrymple
- *Paris to the Moon* by Adam Gopnik
- *Video Night in Kathmandu* by Pico Iyer
- *A Year in Provence* by Peter Mayle
- *Coming into the Country* by John McPhee
- *Last Places* by Lawrence Millman
- *Perseus in the Wind* by Freya Stark
- *The Great Railway Bazaar* by Paul Theroux
- *Life on the Mississippi* by Mark Twain
- *Black Lamb and Grey Falcon* by Rebecca West

THE SHELTERING SKY Bowles

SARA MIDDA'S SOUTH OF FRANCE A SKETCH BOOK

IN A SUNBURNED COUNTRY BILL BRYSON

OUT OF AFRICA ISAK DINESEN RANDOM HOUSE

forster • a room with a view Vintage

MOCKETT Where the Dead Pause, and the Japanese Say Goodbye

ORHAN PAMUK
A STRANGENESS IN MY MIND

HEINRICH HARRER Seven Years in Tibet HART-DAVIS

George Orwell HOMAGE TO CATALONIA Harcourt, Brace & Co

A Small Place JAMAICA KINCAID FSG

The Inheritance of Loss KIRAN DESAI

IN PATAGONIA Bruce Chatwin

SHANTARAM GREGORY DAVID ROBERTS

ALEX GARLAND THE BEACH

ERIC NEWBY A Short Walk in the Hindu Kush FOLIO

eat pray love ELIZABETH GILBERT

THE WHITE TIGER ARAVIND ADIGA fp

NOO SARO-WIWA LOOKING FOR TRANSWONDERLAND

Independent People HALLDÓR LAXNESS Alfred A. Knopf

Frances Mayes Under the Tuscan Sun

FOER THUAAS MORTON

Atlas Obscura AN EXPLORER'S GUIDE TO THE WORLD'S HIDDEN WONDERS workman

日本の1年 a year in Japan Kate T. Williamson

Judith Schalansky ATLAS OF REMOTE ISLANDS Fifty Islands I Have Never Set Foot On and Never Will Penguin

BELOVED BOOKSTORES

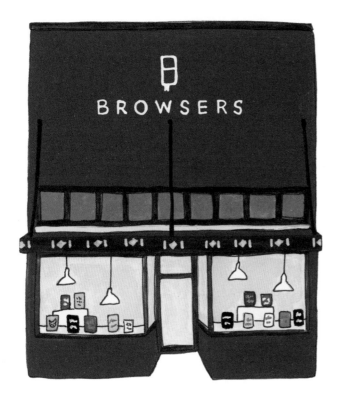

BROWSERS BOOKSHOP

Olympia, Washington, USA

Browsers Bookshop was founded by Anna Blom in 1935, in Aberdeen, Washington. The town was then a coastal shipping hub home to sawmills and salmon canneries, nicknamed "The Hellhole of the Pacific" and "The Port of Missing Men" because of its high murder rate. A well-read, self-educated, Russian Jewish immigrant, Blom moved her store to Olympia, the state's capital, on the advice of Washington Supreme Court judge Walter Beals, who thought the larger city might better support a bookstore through the Great Depression. Since then, Browsers Bookshop has been owned and operated by three more generations of women.

Current owner Andrea Griffith cleaned up and remodeled the store and is introducing more and more new books to the store inventory. Although the store was initially known as a place for used books, Griffith's goal is to offer equal stacks of new and used tomes.

Griffith recommends:
Middlemarch by George Eliot

"I recently convinced one of my favorite customers to buy this, one of my take-to-the-island books. This customer is a retired attorney and a great reader. He came back a few weeks later saying he loved the novel so much that he read each sentence three times: twice to himself and once out loud to his wife. George Eliot is an endlessly gifted and lively observer of the small, quotidian details of life but also wrestles with the big questions—the complexity of love and what constitutes a meaningful, moral life. Also, *Middlemarch* is really funny. This is one of those great novels that meets the reader in all stages of life."

Penguin Classics
2015 paperback,
design by Kelly Blair

OCTAVIA BOOKS

New Orleans, Louisiana, USA

One of the things that makes indie booksellers successful is their understanding and support of their local community. New Orleans's Octavia Books is no exception. Located in uptown NOLA, the indie bookseller reopened just five weeks after Hurricane Katrina hit, flooding 80% of the city, in August 2006. While the majority of the store's 15,000 books are not from local authors or about local subjects, the majority of the store's best sellers in the weeks following the hurricane were. Store owner Tom Lowenburg said readers were either trying to understand what happened or trying to escape it.

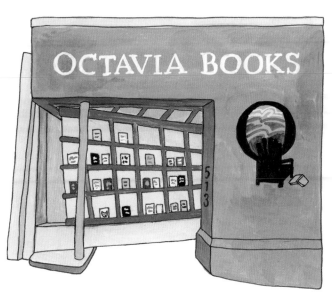

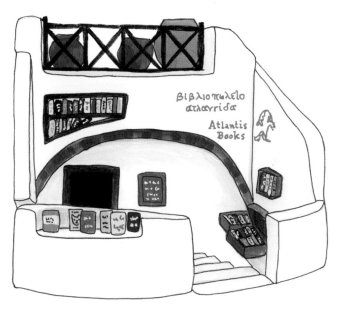

ATLANTIS BOOKS

Santorini, Greece

If opening a bookstore doesn't already sound romantic enough, imagine opening one on the Greek island of Santorini, modeling it after Shakespeare and Company, employing and housing itinerant travelers and writers, and all the while daydreaming about the days when your children will run it. That's exactly what a few American and European university friends decided to do in the spring of 2002.

By 2004, the bookstore that Craig Walzer, Chris Bloomfield, Oliver Wise, Will Brady, Tim Vincent-Smith, and Maria Papagapiou envisioned began to take shape—a snail shape. The team built spiraling bookshelves that moved with them to a new, subterranean location in 2005. On the store's domed ceiling, the spiral repeats: The first names of everyone who's ever worked at the shop are handwritten on the ceiling, circling out. The spiral will hopefully keep growing, but the store's future fate is subject to the whims of the real estate market (of course, unfortunately).

The Odyssey Homer — Penguin Classics

wild Cheryl Strayed — FROM LOST TO FOUND ON THE PACIFIC CREST TRAIL — Vintage

SENDAK — WHERE THE WILD THINGS ARE — HARPER COLLINS

Lansing — ENDURANCE — BASIC BOOKS

VOLTAIRE — CANDIDE

KON-TIKI — HEYERDAHL — RAND McNALLY

FLaMiNG IGUANAS — ERiKa LOPEZ

HEART OF DARKNESS — JOSEPH CONRAD

I MARRIED ADVENTURE — OSA JOHNSON — LIPPINCOTT

William Least Heat-Moon — Blue Highways

THE LOST CITY OF Z — A TALE OF DEADLY OBSESSION IN THE AMAZON — David Grann — VINTAGE

The Incredible Journey — SHEILA BURNFORD — Atlantic Little, Brown

Adrift — Seventy-six days lost at sea — THE NATIONAL BESTSELLER — Steven Callahan

Tracks — Robyn Davidson

INTO THIN AIR — Jon Krakauer — ANCHOR BOOKS

The Call of the Wild — JACK LONDON

APSLEY CHERRY-GARRARD — THE WORST JOURNEY IN THE WORLD — FS

The Mosquito Coast — PAUL THEROUX — AVON

JOHN STEINBECK — TRAVELS WITH CHARLEY

GULLIVER'S TRAVELS — JONATHAN SWIFT — JUNIOR DELUXE EDITIONS

MARKHAM — West with the Night — H.M.Co.

JOURNEYS & ADVENTURES

The *Odyssey* is the second-oldest surviving work of Western literature (after the *Iliad*). It has influenced almost every piece of writing since. Odysseus's 10-year journey home and all of the tales of adventure that came after it are, as they say, not about the destination.

Beryl Markham was a bush pilot in Kenya, the first woman to fly nonstop east to west across the Atlantic, and the first person to fly from England to North America nonstop (in a Percival Vega Gull named the *Messenger*). There has been debate (mostly instigated by men, for what it's worth) on how much her writer husband, Raoul Schumacher, or her writer lover, Thomas Baker, helped with her memoir *West with the Night*. Regardless, the events are real, and as Ernest Hemingway said, it is "a bloody wonderful book."

William Least Heat-Moon stuck to back roads on his cross-country journey, the ones drawn in blue ink in the Rand McNally *Road Atlas*. He judged the quality of the food in roadside cafés by the number of calendars (left by traveling salesmen) that hung on the wall behind the counter. One calendar meant it was crappy packaged food shipped in from New Jersey, while four meant you shouldn't miss the pie.

Maurice Sendak once received a drawing from a young *Where the Wild Things Are* fan, and sent him a thank-you note with a picture of a Wild Thing. The boy's mother wrote back that he loved the note so much he ate it. Sendak felt that was one of the highest compliments he'd ever received.

I'm a wild thing!

The "things" were meant to be wild horses, until Sendak realized he couldn't draw a horse.

Apsley Cherry-Garrard was the assistant zoologist on the ship *Terra Nova* for the doomed 1910–1913 British Antarctic Expedition, led by Robert Falcon Scott. Cherry-Garrard and two other men nearly died in a blizzard at −76°F (−60°C) while retrieving Emperor penguin eggs. (His teeth chattered so much, most shattered.) Later, the expedition tried to be the first to reach the South Pole. They reached it, but Roald Amundsen beat them to it. On the return trip, the five men in the "pole team," including Scott, froze to death. *The Worst Journey in the World*, written nine years later, is a meditation on heroism, sacrifice, and suffering.

Where is my egg?

Cheryl Strayed brought Adrienne Rich's *The Dream of a Common Language* along on the 1,100-mile hike of the Pacific Crest Trail she recounts in *Wild*, and writes that it was "a consolation, an old friend."

Norton 2013 paperback

MORE

- *A Cook's Tour* by Anthony Bourdain
- *A Walk in the Woods* by Bill Bryson
- *The Journals of Captain Cook* by James Cook
- *Travels with Myself and Another* by Martha Gelhorn
- *The Motorcycle Diaries* by Ernesto Che Guevara
- *No Hurry to Get Home* by Emily Hahn
- *The Perfect Storm* by Sebastian Junger
- *Wild by Nature* by Sarah Marquis
- *Between a Rock and a Hard Place* by Aron Ralston
- *The Electric Kool-Aid Acid Test* by Tom Wolfe

READ AROUND
THE WORLD

GREENLAND
"Crimson"
by Niviaq Korneliussen

ICELAND
"The Blue Fox"
by Sjón

CANADA
"Indian Horse"
by Richard Wagamese

UNITED STATES
"The Grapes of Wrath"
by John Steinbeck

CUBA
"Farewell
to the Sea"
by Reinaldo Arenas

MEXICO
"Like Water for
Chocolate"
by Laura Esquivel

DOMINICAN REPUBLIC
"In the Time of the Butterflies"
by Julia Alvarez

HAITI
"Brother, I'm Dying"
by Edwidge Danticat

GUATEMALA
"The President"
by Miguel Angel Asturias

VENEZUELA
"Doña Barbara"
by Rómulo Gallegos

COLOMBIA
"The Sound of Things Falling"
by Juan Gabriel Vásquez

SAMOA
"Leaves of the Banyan Tree"
by Albert Wendt

SURINAME
"The Cost of Sugar"
by Cynthia McLeod

ECUADOR
"The Villagers"
by Jorge Icaza

PERU
"Conversation in
the Cathedral"
by Mario Vargas Llosa

BRAZIL
"The Head of the Saint"
by Socorro Acioli

FIJI
"Kava in the Blood"
by Peter Thomson

BOLIVIA
"Turing's Delirium"
by Edmundo Paz Soldan

URUGUAY
"Solitaire of Love"
by Cristina Peri Rossi

ARGENTINA
"The Lizard's Tail"
by Luisa Valenzuela

CHILE
"My Tender Matador"
by Pedro Lemebel

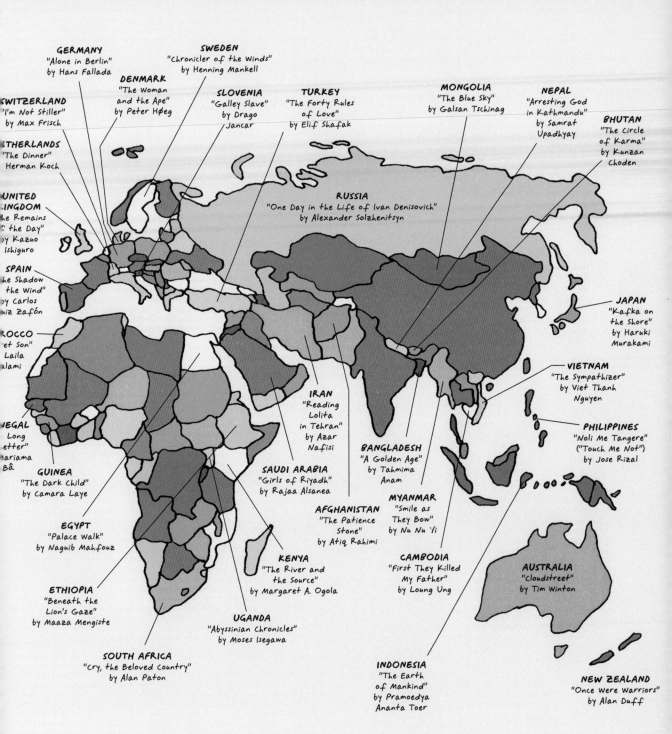

GERMANY
"Alone in Berlin"
by Hans Fallada

SWEDEN
"Chronicler of the Winds"
by Henning Mankell

DENMARK
"The Woman
and the Ape"
by Peter Høeg

SLOVENIA
"Galley Slave"
by Drago
Jancar

TURKEY
"The Forty Rules
of Love"
by Elif Shafak

MONGOLIA
"The Blue Sky"
by Galsan Tschinag

NEPAL
"Arresting God
in Kathmandu"
by Samrat
Upadhyay

SWITZERLAND
"I'm Not Stiller"
by Max Frisch

BHUTAN
"The Circle
of Karma"
by Kunzan
Choden

NETHERLANDS
"The Dinner"
Herman Koch

**UNITED
KINGDOM**
The Remains
f the Day"
by Kazuo
Ishiguro

RUSSIA
"One Day in the Life of Ivan Denisovich"
by Alexander Solzhenitsyn

SPAIN
he Shadow
the Wind"
by Carlos
uiz Zafón

JAPAN
"Kafka on
the Shore"
by Haruki
Murakami

ROCCO
et Son"
Laila
alami

IRAN
"Reading
Lolita
in Tehran"
by Azar
Nafisi

VIETNAM
"The Sympathizer"
by Viet Thanh
Nguyen

EGAL
Long
etter"
ariama
Bâ

BANGLADESH
"A Golden Age"
by Tahmima
Anam

PHILIPPINES
"Noli Me Tangere"
("Touch Me Not")
by Jose Rizal

GUINEA
"The Dark Child"
by Camara Laye

SAUDI ARABIA
"Girls of Riyadh"
by Rajaa Alsanea

AFGHANISTAN
"The Patience
Stone"
by Atiq Rahimi

MYANMAR
"Smile as
They Bow"
by Nu Nu Yi

EGYPT
"Palace Walk"
by Naguib Mahfouz

CAMBODIA
"First They Killed
My Father"
by Loung Ung

AUSTRALIA
"Cloudstreet"
by Tim Winton

KENYA
"The River and
the Source"
by Margaret A. Ogola

ETHIOPIA
"Beneath the
Lion's Gaze"
by Maaza Mengiste

UGANDA
"Abyssinian Chronicles"
by Moses Isegawa

SOUTH AFRICA
"Cry, the Beloved Country"
by Alan Paton

INDONESIA
"The Earth
of Mankind"
by Pramoedya
Ananta Toer

NEW ZEALAND
"Once Were Warriors"
by Alan Duff

REGIONAL COOKING

Spin the globe and stick a fork in it, and there is probably an amazing cookbook for that region's cuisine. Some of these books are particularly authentic and thorough, aiming to be encyclopedias of a cuisine. Others, by chefs who are locally legendary, don't always stick to tradition, but always retain their sense of place.

In 1961, Julia Child created one of the very first American cookbooks about another region's cuisine, *Mastering the Art of French Cooking*. The birth of the book is covered in her fascinating autobiography (cowritten with her husband's grandnephew, Alex Prud'homme), *My Life in France*, which tells the story of a late bloomer discovering all the things she would come to love most: her husband, France, and the "many pleasures of cooking and eating."

Julia Child also created one of the very first cooking TV shows, "The French Chef," in 1963. In one of the most memorable episodes, she names a flock of naked raw chickens by size. (She never did drop one on the floor, though; that is a myth.)

Yotam Ottolenghi and Sami Tamimi were both born (in 1968) and raised in Jerusalem— Ottolenghi in the Jewish West and Tamimi in the Arab East. They both moved to Tel Aviv, then to London. There they finally met, when Ottolenghi walked into the bakery where Tamimi worked and was hired as a pastry chef. They've since opened four restaurants together

Yotam Ottolenghi

Sami Tamimi

and cowritten two cookbooks (*Ottolenghi* and *Jerusalem*). In combination with Ottolenghi's *Plenty*, the books have collectively sold over a million copies in just five years (most cookbooks sell fewer than 35,000 copies).

Born in England to Ugandan Indian parents, Meera Sodha was inspired to learn to cook over a crappy meal with friends at a Brick Lane curry house. She wanted to introduce them to the lighter, brighter, and more flavorful food she grew up on instead. She asked her mom to teach her Gujarati cuisine, collected her family's recipes, and traveled extensively in India before producing *Made in India*.

This is Sodha's mom's worn wooden spoon, which she passed down to her daughter on Sodha's 30th birthday.

MORE

- *Persiana* by Sabrina Ghayour
- *Around My French Table* by Dorie Greenspan
- *The Art of Mexican Cooking* by Diana Kennedy
- *My Paris Kitchen* by David Lebovitz
- *King Solomon's Table* by Joan Nathan
- *Into the Vietnamese Kitchen* by Andrea Nguyen
- *Gran Cocina Latina* by Maricel E. Presilla
- *Bangkok* by Leela Punyaratabandhu
- *The New Book of Middle Eastern Food* by Claudia Roden
- *Yucatán* by David Sterling

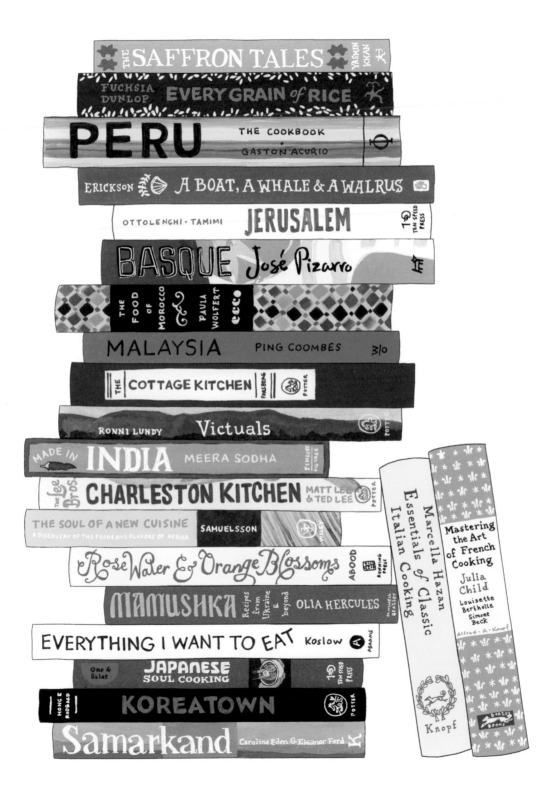

THE SAFFRON TALES · YASMIN KHAN

FUCHSIA DUNLOP · EVERY GRAIN of RICE

PERU · THE COOKBOOK · GASTON ACURIO

ERICKSON · A BOAT, A WHALE & A WALRUS

OTTOLENGHI · TAMIMI · JERUSALEM · TEN SPEED PRESS

BASQUE · José Pizarro

THE FOOD of MOROCCO · PAULA WOLFERT · ecco

MALAYSIA · PING COOMBES · 3/0

THE COTTAGE KITCHEN · FINSBENS · POTTER

RONNI LUNDY · Victuals · POTTER

MADE IN INDIA · MEERA SODHA · PENGUIN FIG TREE

THE Lee Bros. · CHARLESTON KITCHEN · MATT LEE & TED LEE · POTTER

THE SOUL of A NEW CUISINE · SAMUELSSON · A DISCOVERY OF THE FOODS AND FLAVORS OF AFRICA · WILEY

Rose Water & Orange Blossoms · ABOOD · RUNNING PRESS

MAMUSHKA · Recipes from Ukraine & beyond · OLIA HERCULES · MITCHELL BEAZLEY

EVERYTHING I WANT TO EAT · Koslow · ABRAMS

Ono & Salat · JAPANESE Soul Cooking · TEN SPEED PRESS

HONG & RIGDBAD · KOREATOWN · POTTER

Samarkand · Caroline Eden & Eleanor Ford

Marcella Hazan · Essentials of Classic Italian Cooking · Knopf

Mastering the Art of French Cooking · Julia Child · Louisette Bertholle · Simone Beck · Alfred · A · Knopf · DRAGON BOOKS

BELOVED BOOKSTORES

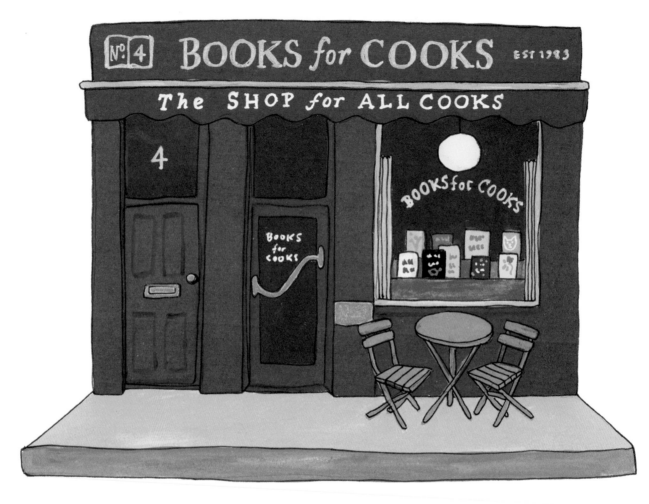

BOOKS FOR COOKS

London, UK

Books for Cooks was founded in 1983 by Heidi Lascelles, when London was still an improbable food destination. In 1992, Lascelles hired Rosie Kindersley, and a year later Kindersley met her husband, Eric Treuille, when he walked into the shop.

Books for Cooks has become an institution for hungry fans, and when Lascelles retired, Kindersley and Treuille took over. She manages the books and he runs the upstairs test kitchen, preparing recipes from a chosen title and serving lunch daily to 40 or so other enthusiastic foodies. It's a match made in foodie heaven.

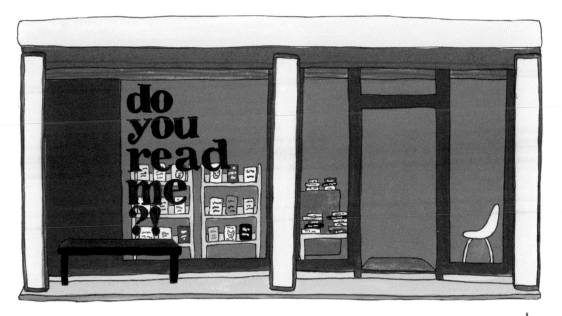

DO YOU READ ME?!

Berlin, Germany

Stationed in Berlin's Mitte neighborhood, Do You Read Me?! is a store for omnivorous, cultured consumers of independent print media about fashion, photography, art, architecture, interior design, culture, and society. Visitors find more magazines than books. Narrow custom shelves are neatly stacked with best sellers like *Apartamento* and *The Gentlewoman*, as well as more niche publications like *Toilet Paper Magazine* and *mono.kultur*.

LA CENTRAL DEL RAVAL

Barcelona, Spain

Residing in a former chapel, La Central del Raval initially specialized in the humanities. The store now offers books on anthropology, architecture and design, art and film, photography, and poetry. It also boasts plenty of foreign-language novels, including a variety of titles in English, making it a sanctuary for expats.

Mitte—home of the famous Fernsehturm (TV Tower)—was part of East Germany before the Berlin Wall fell in 1989, and is now full of cool shops and galleries.

Fernsehturm ↗

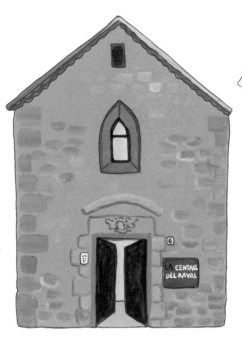

REFERENCE COOKBOOKS

These cookbooks sit closest to the stove. Their pages are stained and their spines cracked. They fall right open to the recipes we love the most, or the ones we just can't keep in our heads (was it one stick of butter in that flaky pie crust, or two?). They teach us to approach cooking as a system (hackable once mastered) and as a way to endlessly riff within a framework. Most importantly, they take the fear out of cooking and replace it with confidence.

During an emotionally and financially tough time after her husband's suicide, Irma S. Rombauer wrote and self-published *The Joy of Cooking*. It's been in print continuously since publisher Bobbs-Merrill picked it up, selling over 18 million copies through eight editions and four generations. The original 1931 edition was illustrated by Irma's daughter Marion Rombauer Becker; the cover depicts Saint Martha of Bethany, the patron saint of cooks and homemakers, defeating the kitchen dragon.

Samin Nosrat can break her technique down to just four words: *SALT FAT ACID HEAT*. If you master balancing them, everything will be DELICIOUS.

Nosrat's book is full of delicious drawings by ← Wendy MacNaughton.

Simon & Schuster 2017 hardcover, design by Alvaro Villanueva

Inspired by his childhood hero, Don Herbert of the everyday-science TV show *Mr. Wizard's World*, J. Kenji López-Alt obsessively tested, tinkered, retested, observed, and tasted to master the techniques in *The Food Lab*. If it isn't in there, then you don't really need to know it.

Mark Bittman spent over four years perfecting the recipes in *How to Cook Everything*, cutting many that weren't basic enough and adding in standards like grilled cheese. His publisher almost decided not to publish it, but the first run of 50,000 copies sold out immediately. It is so useful for learning the basics and quickly looking up details that, before long, you might need to buy a second (clean) copy, or maybe the app.

MORE

- *How to Cook Without a Book* by Pam Anderson
- *James Beard's American Cookery* by James Beard
- *CookWise* by Shirley O. Corriher
- *The Professional Chef* by the Culinary Institute of America
- *The River Cottage Meat Book* by Hugh Fearnley-Whittingstall
- *Larousse Gastronomique* by Librairie Larousse
- *On Food and Cooking* by Harold McGee
- *Jacques Pepin's Complete Techniques* by Jacques Pepin
- *The Gourmet Cookbook* by Ruth Reichl
- *My Master Recipes* by Patricia Wells

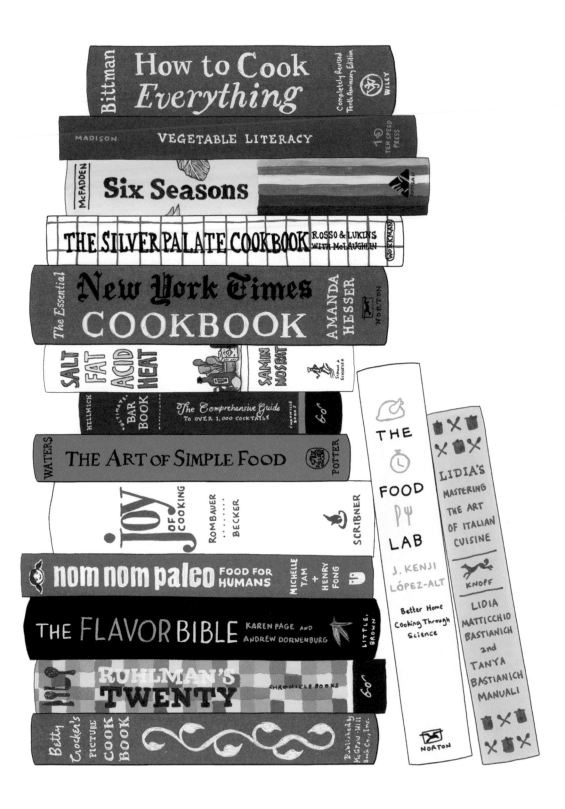

NOVEL FOOD

Name the book that features the dish.

1) Perfect Key lime pie for throwing at an ex-husband

2) Irresistible Turkish delight

3) Not enough gruel

4) Mom's madeleines and tea

5) Pasta puttanesca hated by Count Olaf

6) Buttered yams from a Harlem street vendor

7) Butterbeer and Bertie Bott's Every Flavor Beans

8) Liverwurst and cream-cheese sandwiches with hot cocoa made by Charles Wallace

9) The treasured roasted pig tail

10) Avocado with crab salad (and food poisoning)

11) Unlucky crab missing a leg

12) Nipples of Venus

13) Yet another apple pie with ice cream

14) Quail in rose petal sauce (and love)

EVERYDAY FOOD INSPIRATION

Flip through any of these books and you'll see a dozen things you want to make tonight. These are the ones you really use, not the ones sitting on the shelf gathering that weird kitchen-grease dust.

Edna Lewis introduced Southern cooking to the world. She was born in a Virginia town founded by freed slaves, later moved to New York to become a famous chef and the co-owner at 1950s hotspot Café Nicholson, and eventually returned to the South. She published *The Taste of Country Cooking* in 1976, but it feels new, organized by seasonal menus, focused on respecting ingredients, and capped off with understated stories of country life. In a 1989 interview Lewis said, "As a child in Virginia, I thought all food tasted delicious. After growing up, I didn't think food tasted the same, so it has been my lifelong effort to try and recapture those good flavors of the past."

Truman Capote adored Lewis's buttermilk biscuits and would sneak into the kitchen at Café Nicholson to ask for some.

Paltrow for *It's All Good*, Jessamyn W. Rodriguez for *Hot Bread Kitchen*, and Mario Batali for *Spain: A Culinary Road Trip*, to list just a few. *Small Victories* is her first solo venture, designed for beginners and folks a bit intimidated by the kitchen.

Beet + Just-Barely-Pickled Cucumber Salad from "Small Victories"

Edward Lee was born in Brooklyn to Korean parents, but fell in love with the South and moved to Louisville after visiting for the Kentucky Derby in 2001. He now owns three restaurants there and one in Washington, DC. His dishes (and his cookbook *Smoke & Pickles*) often combine the best of Korean and Southern food.

The Moosewood Cookbook sprang from a vegetarian restaurant run by a collective in Ithaca, New York, in 1974. It was originally self-published; Mollie Katzen hand wrote the recipes and drew the illustrations. Now published by Ten Speed Press, it's one of the *New York Times*'s top 10 best-selling cookbooks of all time.

Julia Turshen made her name as a cookbook collaborator with Jody Williams for *Buvette*, Gwyneth

MORE

- *Olives, Lemons & Za'atar* by Rawia Bishara
- *A Good Food Day* by Marco Canora
- *Flavorwalla* by Floyd Cardoz
- *The Kitchn Cookbook* by Sara Kate Gillingham & Faith Durand
- *Canal House Cooks Every Day* by Melissa Hamilton & Christopher Hirsheimer
- *Milk Street* by Christopher Kimball
- *Leon* by Allegra McEvedy
- *Food52 Genius Recipes* by Kristen Miglore
- *Dining In* by Alison Roman

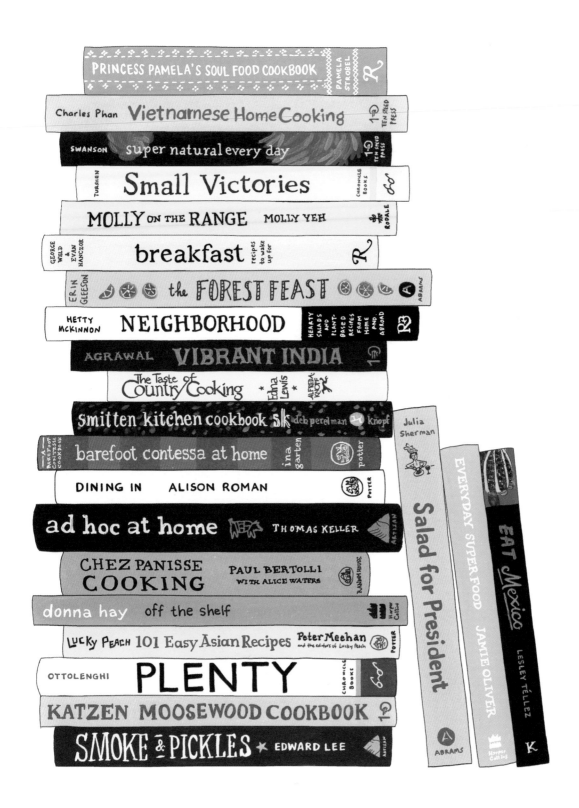

PRINCESS PAMELA'S SOUL FOOD COOKBOOK — PAMELA STROBEL — R

Charles Phan — Vietnamese Home Cooking — Ten Speed Press

SWANSON — super natural every day — Ten Speed Press

Small Victories — TVASHEN — CHRONICLE BOOKS

MOLLY on the RANGE — MOLLY YEH — RODALE

breakfast — recipes to wake up for — GEORGE WELD & EVAN HANCZOR — R

the FOREST FEAST — ERIN GLEESON — ABRAMS

NEIGHBORHOOD — HETTY MCKINNON — HEARTY SALADS AND PLANT-BASED RECIPES FROM HOME AND ABROAD — PB

VIBRANT INDIA — AGRAWAL

The Taste of Country Cooking — Edna Lewis — ALFRED A KNOPF

smitten kitchen cookbook sk — deb perelman — Knopf

barefoot contessa at home — ina garten — potter

DINING IN — ALISON ROMAN — Potter

ad hoc at home — THOMAS KELLER — ARTISAN

CHEZ PANISSE COOKING — PAUL BERTOLLI WITH ALICE WATERS — RANDOM HOUSE

donna hay — off the shelf — Harper Collins

Lucky Peach 101 Easy Asian Recipes — Peter Meehan and the editors of Lucky Peach — Potter

OTTOLENGHI — PLENTY — CHRONICLE BOOKS

KATZEN MOOSEWOOD COOKBOOK

SMOKE & PICKLES ★ EDWARD LEE — ARTISAN

Julia Sherman — Salad for President — ABRAMS

EVERYDAY SUPER FOOD — JAMIE OLIVER

EAT Mexico — LESLEY TÉLLEZ — K

BELOVED BOOKSTORES

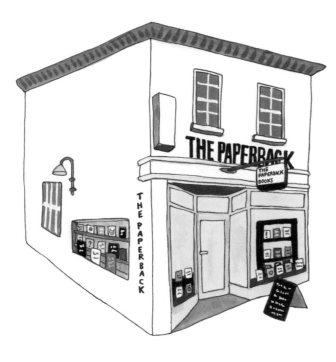

PAPERBACK BOOKSHOP

Melbourne, Victoria, Australia

A Melbourne mainstay, Paperback Bookshop has been around since the 1960s, when it gained a reputation for stocking books that were banned or otherwise not easily available. The shop now also sells hardbacks, but it stays true to its roots with plenty of uncommon tomes and a hearty selection of Australian fiction and nonfiction. It is known and loved by night owls for keeping late hours.

LIBRERIA

London, UK

Cleverly named and designed in honor of Jorge Luis Borges's short story "Library of Babel," London's Libreria Books is a long, narrow space that appears to extend eternally (a mirror panels the back wall, you see). In an approach inspired by Borges's narrator, who's struck by the notion that too much information is useless rather than useful, the store is an internet-free space. As a result, readers can turn their full attention to carefully attended shelves. Books at Libreria are arranged in cross-pollinating categories like "The Sea and the Sky" and "Enchantment for the Disenchanted," so that readers may serendipitously discover new titles and genres.

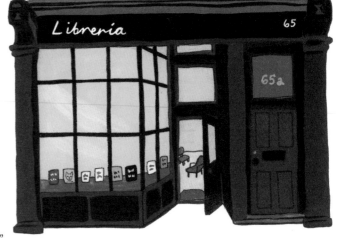

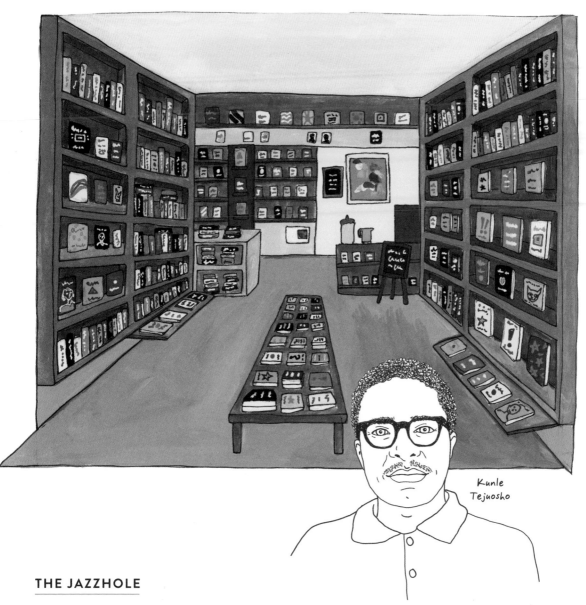

Kunle
Tejuosho

THE JAZZHOLE

Lagos, Nigeria

Nearly hidden on a busy street in Lagos, The Jazzhole lives up to its name as an intimate home for not only music, but also books and art. A fan of John Coltrane and John Lee Hooker, Kunle Tejuosho wanted to create a home for contemporary global black culture, especially music and books. Tejuosho grew his store as an offshoot of Glendora, the legendary bookstore chain founded by his mother. At times, Tejuosho self-published records under a namesake imprint and a literary journal called *The Glendora Review.* He now offers what may be the best collection of African artifacts in all of Africa. Among the people who come in: writer Chimamanda Ngozi Adichie, who calls the store her favorite.

Ottolenghi & Goh SWEET

LEWIS & POLIAFITO BAKED NEW FRONTIERS IN BAKING Stewart Tabori & Chang

PRUEITT/ROBINSON TARTINE CHRONICLE BOOKS

JIM LAHEY WITH RICK FLASTE my bread THE REVOLUTIONARY NO-WORK, NO-KNEAD METHOD NORTON

COOKIE LOVE

CURL CANDY IS MAGIC

WEISS CLASSIC GERMAN BAKING

GEMIGNANI The Pizza BIBLE TEN SPEED PRESS

HOW TO BE A DOMESTIC GODDESS BAKING AND THE ART OF COMFORT COOKING NIGELLA LAWSON

BIG GAY ICE CREAM Petroff and Quint POTTER

Maida Heatter's BOOK OF GREAT AMERICAN DESSERTS Knopf

MILK BAR LIFE Christina Tosi

jeni's SPLENDID ICE CREAMS AT HOME • JENI BRITTON BAUER

THE CAKE BIBLE ROSE LEVY BERANBAUM MORROW

BOUCHON • BAKERY THOMAS KELLER ARTISAN

BRAVETART ICONIC AMERICAN DESSERTS STELLA PARKS NORTON

Betty Crocker's COOKY BOOK GOLDEN PRESS

Wilson JOY THE BAKER Homemade Decadence POTTER

Lebovitz Ready for Dessert TEN SPEED PRESS

BAKING & DESSERTS

Candy is magic. So is ice cream, and so are cupcakes. Life gets tough at times, and small sweets can make it (at least temporarily) better. And when things are good, nothing says "celebration" like a cake. Or a pizza party.

Elisabeth Prueitt and her husband, Chad Robertson, opened Tartine Bakery in the Mission neighborhood of San Francisco in 2002. He focused on artisanal bread and she on everything else, and the world fell in love. They've since published three cookbooks and opened the much larger Tartine Manufactory.

The first *Tartine* cookbook highlights Prueitt's amazing pastries and desserts, including the best morning buns ever (pictured) and a ridiculous coconut cream pie. She perfects all these treats even though she's gluten intolerant, and Tartine now offers many wheat-free items, too.

At her Portland store Quin (named after those round sprinkles that look like confetti), Jami Curl uses fresh Oregon fruit, locally roasted coffee beans, and (of course) magic to make lollipops, gumdrops, caramels, and more—no fake flavorings allowed. Before Curl made candy, she made cupcakes. And before that she was a marketer for the State Bar, trying to "convince the people of Oregon that lawyers are not bad."

Jim Lahey's No-Knead Bread really is the easiest crusty bread recipe, ever.

Matt Lewis and Renato Poliafito's Baked Brownies really are the best brownies, ever.

Bryan Petroff and Doug Quint debuted their Big Gay Ice Cream truck in New York City in 2009, "as a lark." After a few summers they opened a shop in Manhattan's East Village and now have a couple of other locations, including one in Philadelphia.

Doug Quint

Bryan Petroff

One of their best-selling cones is the Bea Arthur: vanilla soft-serve swirled with dulce de leche and coated in crushed Nilla Wafers.

MORE

- *Hello, My Name Is Ice Cream* by Dana Cree
- *Flour Water Salt Yeast* by Ken Forkish
- *Cookies* by Dorie Greenspan
- *Sugar Rush* by Johnny Iuzzini & Wes Martin
- *King Arthur Flour Baker's Companion* by King Arthur Flour
- *The Perfect Scoop* by David Lebovitz
- *The Art of French Pastry* by Jacquy Pfeiffer & Martha Rose Shulman
- *The Bread Baker's Apprentice* by Peter Reinhart & Ron Manville
- *Real Sweet* by Shauna Sever
- *Bread Toast Crumbs* by Alexandra Stafford

BOOKISH PEOPLE RECOMMEND

NANCY PEARL

Librarian and author
of *George & Lizzie*
and the Book Lust series

In the Company of the Courtesan
by Sarah Dunant

Random House 2006 hardcover,
design by Allison Saltzman, art by Titian

"The time is 1527; the beautiful and seductive
courtesan Fiammetta Bianchini and her busi-
ness manager and best friend, the dwarf Bucino,
flee Rome and end up in Venice, the city of
Fiammetta's birth. There, the two embark on the
difficult task of regaining both their fortunes and
their social positions. Dunant's writing is rich with
period details; all of her characters pulse with
life. Any fan of historical fiction—indeed, anyone
who's drawn to well-written prose—will find
Sarah Dunant's *In the Company of the Courtesan* a
real treat."

Spooner
by Pete Dexter

"Pete Dexter's autobiographical
novel *Spooner* is both funny and
heartbreaking, frequently at the
same time. It's peopled with
unforgettable characters, includ-
ing Spooner's stepfather, Calmer,
his friend Harry (a would-be box-
ing champion who follows Spooner
where common sense shouldn't
take either of them), and a series of dogs
who share Spooner's life. I found myself thinking
about the characters long after I'd finished the

Grand Central
2008 hardcover,
design by Flag,
photo by
Serge Bloch

novel. *Spooner* is the unforgettable story of a boy
from Milledgeville, Georgia, as he grows to man-
hood, and that man learning how best to accom-
modate himself to the vagaries of the world."

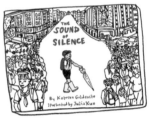

Little, Brown Books
for Young Readers
2016 hardcover

MATTHEW C. WINNER

School librarian
and *All the Wonders*
podcast host

The Sound of Silence
by Katrina Goldsaito,
illustrated by Julia Kuo

"*Ma.* Silence. The most beautiful sound. A young
boy named Yoshio asks a musician if he has a
favorite sound, and the musician replies that
the most beautiful sound is the sound of silence.
This sets in motion Yoshio's quest to explore the
sounds and locations he encounters throughout
the day in search of ma. Katrina Goldsaito's
text in *The Sound of Silence* hops along with the
umbrella-wielding child as he encounters sounds
throughout his walk in Tokyo. Julia Kuo brings a
sense of texture and acoustical depth to the illus-
trations, and the resulting effect is one that took
up residence inside my head after first reading the
story. *The Sound of Silence* is a story I return to
again and again, in part, because it's a story with
room for its readers to live for a time. The text is
practical and precise, using only what words are
needed to convey the story and nothing more.
And yet the book holds within it a trick, because
it does not end with its text or its illustrations. It
ends with the reader and it ends in ma until the
reader closes the cover."

ANNE BOGEL

Founder of *Modern Mrs. Darcy* & host of *What Should I Read Next?*

Crossing to Safety
by Wallace Stegner

"I've read this gorgeous, graceful novel more times than I can count, because I discover something new each time I pick it up. Stegner's writing is deliberate and steady, but never boring. He draws heavily on his own history to weave a riveting story out of four seemingly ordinary lives and the extraordinary, life-changing friendship that binds them together over a span of 40 years. His wise, wistful tone has me hanging on every word as he tackles big themes like love, marriage, duty, and vocation."

Modern Library 2002 paperback, design by Emily Mahon, art by Darren Booth

You Learn by Living: Eleven Keys for a More Fulfilling Life
by Eleanor Roosevelt

"Confession: I used to think of Eleanor Roosevelt as a dry, dusty, and frankly boring woman from the history books. But then I picked up her memoir, only because I felt like I should know more about important women of history, and was flabbergasted by the woman I discovered in its pages. She was smart, entertaining, and plucky—someone I'd like to chat with for hours over coffee. Roosevelt penned this book—part memoir, part advice manual—in 1960, when she was 76 years old, yet it's striking how fresh, wise, and relatable her insights seem today. This work has something for everyone: She offers an interesting perspective on history, unique insights into her life (which contained a surprising amount of personal tragedy), and a good bit of wisdom you might just apply to your own."

Harper Perennial 2016 paperback, design by Milan Bozic, art by June Park

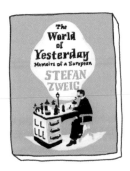

Pushkin Press 2014 hardcover, design by Nathan Burton Design

GAËL LELAMER

Buyer at Books & Books in Miami, Florida, USA

The World of Yesterday
by Stefan Zweig

"Completed in 1942, the day before his suicide, this memoir is Zweig's final cri de coeur. A heartbreaking historical document of Europe between the wars and an inspiring account of a life dedicated to the arts and overwhelmed by nostalgia. One of the finest memoirs I've ever read."

JENNA SHAFFER

Bookseller and buyer at Kepler's Books and Magazines in Menlo Park, California, USA

The Serpent King
by Jeff Zentner

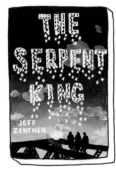

"This makes the list of my top three books of all time. I laughed, I cried, and I spent a lot of time contemplating this book and what it meant, and yet, I still can't quite articulate just how gorgeous and raw this book was. Captivating us from beginning to end, Zentner effortlessly weaves three very different stories of three best friends together to create an absolute masterpiece."

Crown Books for Young Readers 2015 hardcover, design by Alison Empey, photo by Rolf Brenner/ Getty Images

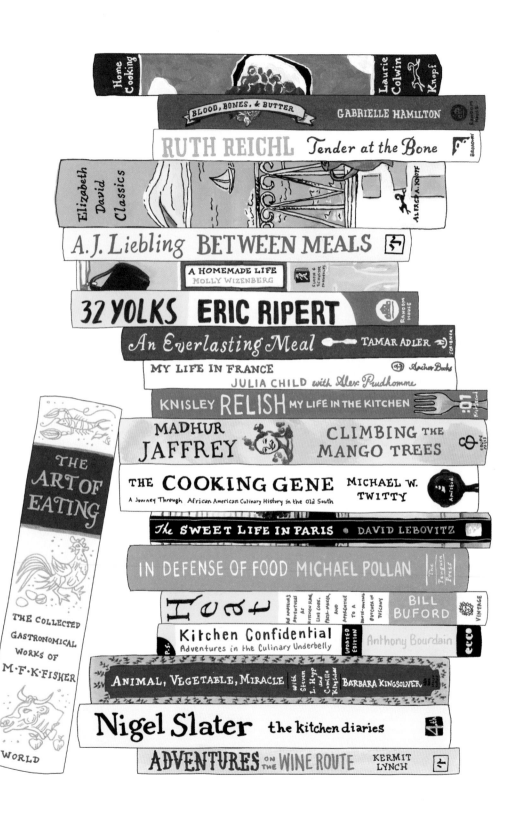

Home Cooking — Laurie Colwin — Knopf

Blood, Bones, & Butter — Gabrielle Hamilton

RUTH REICHL — Tender at the Bone

Elizabeth David Classics — Alfred A. Knopf

A. J. Liebling — BETWEEN MEALS

A HOMEMADE LIFE — MOLLY WIZENBERG — Simon & Schuster Paperbacks

32 YOLKS — ERIC RIPERT — Random House

An Everlasting Meal — TAMAR ADLER — Scribner

MY LIFE IN FRANCE — Anchor Books — JULIA CHILD with Alex Prudhomme

KNISLEY RELISH MY LIFE IN THE KITCHEN

MADHUR JAFFREY — CLIMBING the MANGO TREES

THE COOKING GENE — A Journey Through African American Culinary History in the Old South — MICHAEL W. TWITTY — Amistad

The SWEET LIFE IN PARIS • DAVID LEBOVITZ

IN DEFENSE OF FOOD MICHAEL POLLAN — The Penguin Press

Heat — An American's Adventures At Kitchen Slave, Line Cook, Pasta-maker, And Apprentice to a Dante-quoting Butcher in Tuscany — BILL BUFORD — VINTAGE

Kitchen Confidential — Adventures in the Culinary Underbelly — Updated Edition — Anthony Bourdain — ecco

ANIMAL, VEGETABLE, MIRACLE — with Steven L. Hopp and Camille Kingsolver — BARBARA KINGSOLVER

Nigel Slater — the kitchen diaries

ADVENTURES ON THE WINE ROUTE — KERMIT LYNCH

THE ART OF EATING — THE COLLECTED GASTRONOMICAL WORKS OF M·F·K·FISHER — WORLD

FOOD WRITING

We're obsessed with food—where it comes from, if it's the best, how to best prepare it—and reading about it is a matter of course. The internet is packed with food bloggers, and the amazing ones rise to the top like cream. But they might never have tested their first recipe if writers like M. F. K. Fisher, Laurie Colwin, Elizabeth David, and Ruth Reichl hadn't first set the oven at 350°F, buttered the pan, and boiled the water for them.

The Art of Eating (which Alice Waters says should be "required reading for every cook") combines five of Mary Frances Kennedy Fisher's books into one. In *The Gastronomical Me*, Fisher explains why she writes about food: "It seems to me that our three basic needs, for food and security and love, are so mixed and mingled and entwined that we cannot straightly think of one without the others. So it happens that when I write of hunger, I am really writing about love and the hunger for it, and warmth and the love of it and the hunger for it . . . and then the warmth and richness and fine reality of hunger satisfied . . . and it is all one."

Fisher's Half-and-Half cocktail from "How to Cook a Wolf," her World War II—era book on being thrifty in the kitchen, is half dry sherry and half dry vermouth, with lemon juice and a bit of rind.

Laurie Colwin's *Home Cooking* is a collection of food essays she wrote for *Gourmet* magazine in the 1980s. During the heyday of packaged meals and over-the-top dinners out, she focused on the delights of simple, nourishing (often organic, before that was even a thing) food made at home with loved ones. She included personal musings, written in a conversational style (often blog-like, before that

was even a thing). The result, according to food writer Ruth Reichl, is that "she is the best friend we all want." Colwin died in 1992 at age 48, so she never got to see the world become more like her.

Tomato Pie, from Colwin's "More Home Cooking" →

David Lebovitz cooked at Chez Panisse and other Bay Area restaurants for many years, mostly as a pastry chef, before focusing on writing and moving to Paris. He was one of the very first food bloggers, chronicling his adventures as an expat in the kitchen.

MORE

- *Born Round* by Frank Bruni
- *Shark's Fin & Sichuan Pepper* by Fuschia Dunlop
- *The Raw and the Cooked* by Jim Harrison
- *Julie & Julia* by Julie Powell
- *The Man Who Ate Everything* by Jeffrey Steingarten
- *A Tiger in the Kitchen* by Cheryl Lu-Lien Tan
- *Alice, Let's Eat* by Calvin Trillin
- *Licking the Spoon* by Candace Walsh
- *My Berlin Kitchen* by Luisa Weiss
- *Food and the City* by Ina Yalof

BELOVED BOOKSTORES

SUNDOG BOOKS

Seaside, Florida, USA

Sundog Books opened in 1986, in Seaside, Florida, in the heart of the town's walkable center. Seaside is a privately owned community, one of the first in the US designed around the principles of New Urbanism. It's also where the *The Truman Show* was filmed. The town's motto is "A simple, beautiful life," of which books, of course, are an essential part.

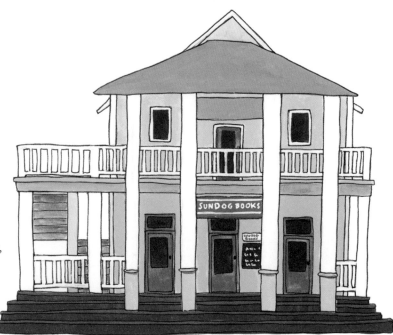

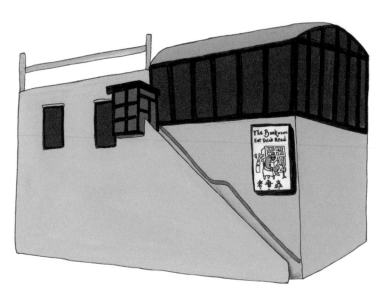

THE BOOKWORM

Beijing, China

A bookstore, library, café, and event space with locations in Beijing, Chengdu, and Suzhou, the Bookworm is an ever-brighter literary beacon. It started out as a small lending library in the early 1990s, when then-expat Alexandra Pearson saw how hard it was to get English-language books in China, beyond the tightly edited selection of classics offered in government-run stores.

Shelves are now stocked with thousands of volumes in both English and Chinese. The Bookworm also runs a popular but intimate annual festival that attracts international authors and a press that focuses on translating lesser-known Chinese authors.

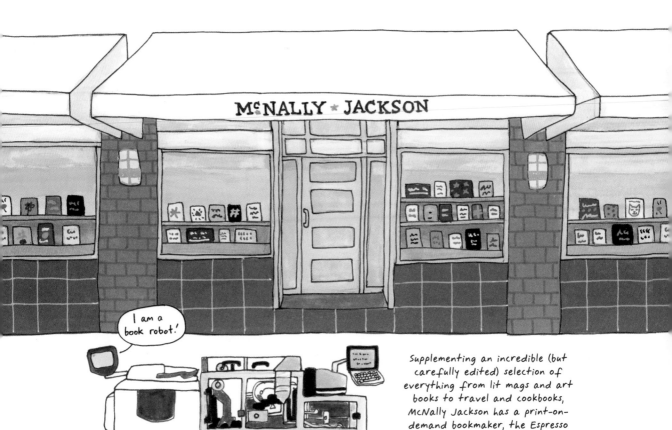

I am a book robot!

Supplementing an incredible (but carefully edited) selection of everything from lit mags and art books to travel and cookbooks, McNally Jackson has a print-on-demand bookmaker, the Espresso Book Machine. Readers can request perfect-bound copies of rare, out-of-print, or public domain titles. And writers can self-publish their own works with or without the help of a McNally Jackson consultant.

MCNALLY JACKSON

New York City, New York, USA

When it first opened in Lower Manhattan in 2004, McNally Jackson was called McNally Robinson, after the bookstores in Manitoba, Canada, founded by the parents of owner Sarah McNally. In 2008, McNally made the store her own, subbing in her husband's last name instead of Robinson. Other details are strictly hers, too—from the decision to organize the store's literature geographically to the wallpaper that decorates its café. The wallpaper is made from book pages scanned from her personal collection.

She intended for her notes and marginalia to be included on the wallpaper, too, only to have them mistakenly, painstakingly edited out by the paper's makers.

McNally Jackson has grown across Lower Manhattan and now includes Goods for the Study, which offers furniture, stationery, light fixtures, and art prints, and Picture Room, which sells artist prints and multiples.

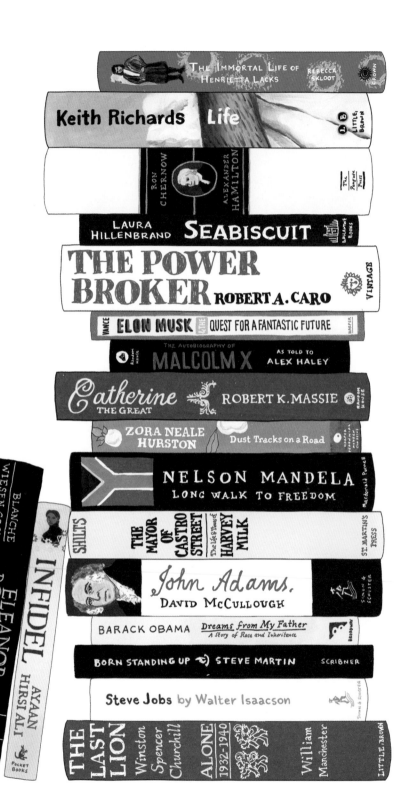

BIOGRAPHIES & AUTOBIOGRAPHIES

James Boswell's *The Life of Samuel Johnson, LLD*, published in 1791, is often called the first modern biography because it paints a full picture of its famous subject—how he looks, acts, and thinks—instead of just recounting his major accomplishments. And now we expect that full picture of our heroes; we want to know who they really are and how they got to where they are. We want to learn the secrets they know, the ones that will help us get there, too. We are always curious about others, even if they have four legs, or no body at all.

Laura Hillenbrand's *Seabiscuit* is the biography of a short racehorse, an unlikely champion who appeared when Americans needed inspiration, in the middle of the Great Depression. It's also the story of three other champions—his owner Charles Howard, his trainer Tom Smith, and his ex-boxer jockey "Red" Pollard—and how all four collaborated to win 33 races and set 16 track records.

Seabiscuit was a nervous and grumpy horse when Smith first met him, nipping at everyone, pacing his stall, and generally against the whole idea of training. Other animals often calm racehorses down, so Smith brought in an old yellow horse named Pumpkin and tore the wall down between their stalls. Later a stray dog named Pocatell wandered in, and eventually a spider monkey named Jo Jo joined the team.

Wanna be friends?

Ashlee Vance adapted his best-selling biography of billionaire inventor Elon Musk into a version for kids, so they can read about a real-life Tony Stark and get inspired to make the future fantastic.

Original Ecco 2015 hardcover, design by Allison Saltzman

Henrietta Lacks may never die, not completely. Her cervical cancer cells, known as HeLa, soldier on in labs around the world. They were the first human cells grown in culture. Since their collection in 1951, they have been used in innumerable experiments and discoveries, including Jonas Salk's development of the polio vaccine. But Lacks never consented to the collection of her cells, and her family only learned of it in 1975, 24 years after her death, and hasn't benefited from it. Rebecca Skloot's thoroughly researched 2010 book *The Immortal Life of Henrietta Lacks* was adapted into a 2017 film starring Oprah Winfrey as Henrietta's daughter, Deborah.

We are HeLa.

MORE

- *Knock Wood* by Candice Bergen
- *If Chins Could Kill* by Bruce Campbell
- *Hard Choices* by Hillary Rodham Clinton
- *The Kid Stays in the Picture* by Robert Evans
- *Bossypants* by Tina Fey
- *The Story of My Experiments with Truth* by Mahatma Gandhi
- *Empire State of Mind* by Zack O'Malley Greenburg
- *Charlotte Brontë: A Fiery Heart* by Claire Harman
- *The Story of My Life* by Helen Keller
- *King of the World* by David Remnick

WORLD-CHANGING BOOK PEOPLE

MARLEY DIAS

Books are incredibly powerful ways to help kids understand their place in the world. But what happens when kids don't see themselves in the books they read?

If you're Marley Dias, you do something about it. At age 11, Dias realized that most of the characters in the books she devoured were not like her (they were mostly boys and mostly white). And in fact, a 2015 analysis by the Cooperative Children's Book Center at the University of Wisconsin revealed that only 10% of children's books released that year had a black person as the main character. So Dias started #1000blackgirlbooks, hoping to collect 1,000 books about black girls. She ended up with more than 4,000 and counting. The hashtag has likewise grown into a movement, and Marley wrote her own book about social activism, inclusion, and education, called *Marley Dias Gets It Done: And So Can You!*

DOLLY PARTON

When Dolly Parton was born, her father, a subsistence farmer and construction worker who couldn't read or write, paid the doctor who delivered her with a bag of oatmeal. The fourth of 12 kids, she grew up in a one-room cabin in rural Tennessee. Parton went on to become the most honored female country performer of all time, writing more than 5,000 songs.

The title she might be most proud of is the Book Lady. In 1995, in honor of her father, Parton created the Imagination Library so that kids could know the magic of books, no matter their family's income. The nonprofit program mails new books to more than a million kids in the US, UK, and Canada every month.

ELLEN OH

Ellen Oh, writer of young adult fantasy fiction, is also the CEO and president of We Need Diverse Books. The mission of WNDB is simple but huge; they're working for "a world in which all children can see themselves in the pages of a book." Before starting We Need Diverse Books and a viral hashtag of the same name, Oh hatched *Flying Lessons & Other Stories*, a thought-provoking collection of stories for teenagers from a range of writers. All the stories inspire wonder, courage, and creativity during those oft-terrible middle-school years.

DAVID RISHER & COLIN MCELWEE

After working at Microsoft and Amazon (while he was the VP of product and store development, Amazon's revenue grew from $16 million to over $4 billion), David Risher partnered with Colin McElwee to found Worldreader.

Based in the US, Europe, and Africa, Worldreader provides kids in 50 developing countries with a curated library

David Risher

Colin McElwee

of relevant and engaging books by Indian and African authors—with a twist. Worldreader's library is entirely digital and optimized for increasingly ubiquitous mobile devices. Schools in need can get e-readers for their students through scholarships. Worldreader also provides on-the-ground training for teachers and for businesses that repair e-readers.

Worldreader has served 6,307,795 readers and 424 schools and libraries in 50 countries since 2010.

LAURA MOULTON

Laura Moulton is a writer, artist, professor, and street librarian. In 2011, she founded Street Books to bring books to people across Portland, Oregon, who live outside. Moulton and other street librarians distribute books by bike, using the old-school library pockets and cards to let people simply sign out books; no need for an address or ID. Moulton started her mission magnanimously, assuming that if someone lived outside, returning a book on time might not be their most pressing concern. But she reports that the rate of return is solid and when someone can't return a book, they often come back just to explain why. Street Books patrons have become Street Books librarians and board members.

RACHEL MCCORMACK

A professor of literacy education at Rhode Island's Roger Williams University, Rachel McCormack is dedicated to helping one of the most vulnerable populations affected by the refugee crisis: kids. McCormack runs the grassroots Books for Refugees. All donations to the organization go to buying and distributing high-quality children's books in Arabic. So far, she's served kids in Holland, Greece, and Turkey with at least a thousand books.

LEVAR BURTON

"Butterfly in the sky, I can go twice as high. . . ." If you're singing the end of this line, you already know LeVar Burton. For 23 years, from 1983 to 2006, Burton hosted the iconic PBS TV show *Reading Rainbow*. After the show was canceled, Burton and his company RRKidz built an app to keep the show's mission alive: to get kids excited about reading books. The app lets kids read unlimited numbers of books and, thanks to a wildly successful Kickstarter campaign, was given to 13,000 underserved classrooms.

Burton also has a podcast, *LeVar Burton Reads*, which is billed as a *Reading Rainbow* for adults.

DAVE EGGERS & NÍNIVE CALEGARI

Dave Eggers

Nínive Calegari

826 Valencia, a nonprofit dedicated to helping students develop writing skills and to helping teachers inspire their students to write, originally opened up as a pirate supply store, with a publishing and tutoring center in the back. Zoning regulations required the space be used for retail, so Eggers and his friends ran with it—offering eye patches and spyglasses alongside periodicals, and installing a fish-tank theater and a booby-trapped ceiling—not realizing it would scare off potential students. After no students showed up for weeks, Eggers recruited educator Nínive Calegari, who worked with schools and teachers to bring students into the space. This gave Eggers time to address his next problem: The space had a single bathroom for the dozens of students.

826 Valencia has grown into 826 National, with chapters in Brooklyn, Los Angeles, Chicago, Michigan, Boston, and Washington, DC. The Brooklyn chapter is hidden behind the Superhero

Supply Co., and the LA chapter is inside the Echo Park Time Travel Mart. It sounds like fun and games, but as one LA student says, "art is such a powerful thing. It can be used to fight against oppression, racism, and sexism—the pollution of our society."

MEREDITH ALEXANDER

Meredith Alexander's adorably named nonprofit Milk+Bookies started informally as a biannual children's birthday party at her local bookstore. She invited all her friends with kids. Then she asked each child to choose a book they'd like to give to another kid in their town who didn't have a book of their own, inscribe a note in it, and donate it. The tradition resonated with other parents, and her LA-based organization was born. Now a national charity, with support from celebrities like Lena Dunham, Jennifer Garner, and Dave Grohl, Milk+Bookies also organizes book drives and book fairs to benefit underserved schools and their students.

DINESH SHRESTHA, JOHN WOOD & ERIN GANJU

While traveling in Nepal, John Wood loved how warm and energetic classrooms there were, but also noticed how much they lacked in resources. He quit his job at Microsoft and cofounded Room to Read with Dinesh Shrestha and Erin Ganju, to improve literacy and gender equality in developing countries around the world.

John Wood

Erin Ganju

Dinesh Shrestha

Room to Read collaborates with local communities, organizations, and governments to foster literacy skills and reading habits in primary school children, and support girls in completing secondary school with the life skills needed for success. So far, they have served 11.6 million kids around the world.

GENEVIEVE PITURRO

The Pajama Program's Good Night Bill of Rights says that all kids have the right to a have a sense of stability and security, to feel loved and cared for at bedtime, to wear clean pajamas and enjoy a bedtime story, to feel valued and validated as a human being, and to have a good night and a good day.

Genevieve Piturro started the nonprofit in 2001 to help secure these rights for kids who don't have a stable home life or a home at all. The Pajama Program has since donated 2,974,431 pairs of pajamas and 2,230,442 books, transforming bedtime rituals across the country.

MAYA NUSSBAUM

Upon graduating from Columbia University, Maya Nussbaum recognized that the literary world she was about to enter was full of white men. She wanted to create a community and support network for young women writers. In 1998, she founded Girls Write Now to do just that.

Since then, the organization has matched underserved high school girls (over 90% high need and 95% girls of color) throughout NYC with professional women writers and media makers as their mentors. The organization has been recognized by the White House as one of the nation's top afterschool programs—not once but three times, so far.

MUSKAAN AHIRWAR

Every day after school, Muskaan Ahirwar sets up a library in the poor neighborhood where she lives in Bhopal, India. Room to Read, a nonprofit NGO, gave Ahirwar 50 books to start the library after she volunteered to run it. Ahirwar uses a register to track the more than 200 books she has in her growing inventory and quizzes other kids when they return books, to make sure they've read them.

At nine years old, Ahirwar was the youngest ever recipient of the National Institution for Transforming India's Thought Leader award.

KYLE ZIMMER

While volunteering at a soup kitchen in Washington, DC, in 1992, Kyle Zimmer realized the kids she was working with didn't have books in their lives. Since then, the organization she founded, First Book, has put more than 170 million books into the hands of children from low-income or military families or in Title I–eligible schools in 30 countries.

Zimmer is known as an innovator and an advocate for social entrepreneurship, educational equity, and the importance of literacy. She was awarded the National Book Foundation's Literarian Award in 2014 and the Peggy Charren/Free to Be You and Me Award from the Ms. Foundation for Women in 2016, among many other honors.

TOM MASCHLER & QUENTIN BLAKE

Buses embellished with drawings by Quentin Blake bring libraries packed with books and volunteer storytellers to

more than 100,000 children in Zambia, Malawi, and Ecuador. The Book Bus was founded in 2006 by Tom Maschler, a former publisher at Jonathan Cape. Long a fan of kids' literature, Maschler had brought Roald Dahl to Jonathan Cape and paired him with Blake, much to the delight (and horror!) of young children everywhere, who gobbled up Dahl's books. Blake decided to join Maschler in this next venture in 2009, contributing his artwork and design to brighten the buses.

SIDNEY KEYS III

Inspired by a visit to EyeSeeMe, a St. Louis–area bookstore that specializes in African American books for kids, Sidney Keys III, then 11 years old, started Books N Bros. It's a book club for all boys his age, of any background, dedicated to reading African American literature, such as *Hidden Figures* and *Danny Dollar Millionaire Extraordinaire: The Lemonade Escapade*.

Tom Maschler

Quentin Blake

MEMOIRS

In an autobiography, the writer covers their entire life to that point, while in a memoir they focus on just one period or aspect of it. Frank Conroy's 1967 *Stop-time*—about his coming of age—is generally thought to be the genre's first, or the first to be called a memoir. Tobias Wolff and Mary Karr really made memoirs a thing.

Penguin Classics
Deluxe Edition 2015
paperback, art by
Brian Rea

Lena Dunham wrote that she figured most memoirs written since the publication of Mary Karr's *The Liars' Club* were by fans who thought, "Hey, I can do that." In 2015 Karr published *The Art of the Memoir*, explaining her own process.

Graphic memoirs first appeared right about the same time as text-only ones. One of the best is Marjane Satrapi's *Persepolis*, a brilliant account of her childhood in Iran during the Islamic Revolution, first published in France.

Pantheon
2003 hardcover

Ecco 2010 hardcover,
design by Allison Saltzman

age 20, both fiercely creative and ambitious in New York City. She has said she wrote the book to fulfill a promise she made to him on his deathbed.

In her short life, Amy Krouse Rosenthal wrote 30 books (28 awesome ones for children and two memoirs) and one of the most beautiful essays ever written about love and the end of life ("You May Want to Marry My Husband," in the *New York Times*). Her *Encyclopedia of an Ordinary Life* is just that, filled with all the little alphabetized bits that make a person.

Puffin 2016 paperback, design
by Theresa Evangelista

Jacqueline Woodson wrote *Brown Girl Dreaming* for young adults, in free verse. She discovered the wonder of poetry while reading Langston Hughes in elementary school. Before that she assumed it was "some code that older white people used to speak to each other."

In *Just Kids* the musician and poet Patti Smith recounts her formative, passionate friendship with photographer Robert Mapplethorpe. They met at

MORE

- *Before Night Falls* by Reinaldo Arenas
- *Hunger Makes Me a Modern Girl* by Carrie Brownstein
- *Boy Erased* by Garrard Conley
- *My Family and Other Animals* by Gerald Durrell
- *Happiness* by Heather Harpham
- *Girl, Interrupted* by Susanna Kaysen
- *Let's Pretend This Never Happened* by Jenny Lawson
- *The Color of Water* by James McBride
- *Everything Is Perfect When You're a Liar* by Kelly Oxford
- *The Rings of Saturn* by W. G. Sebald

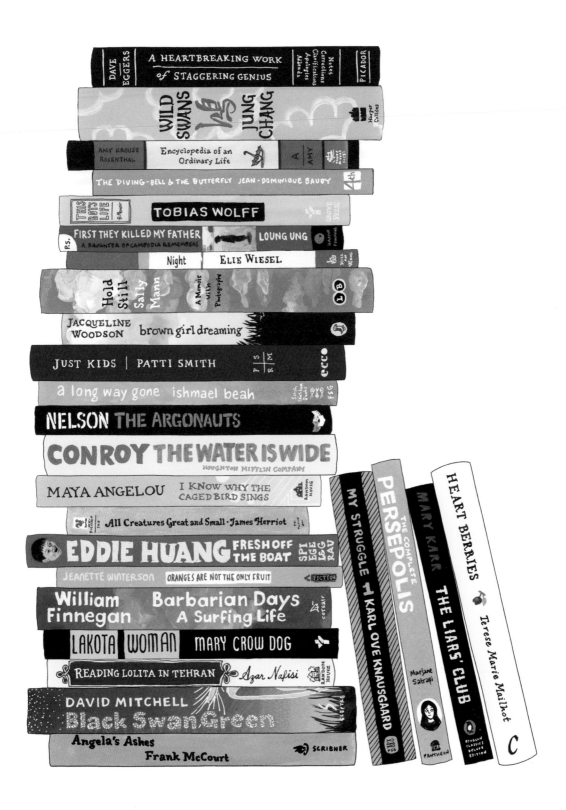

DAVE EGGERS · A HEARTBREAKING WORK of STAGGERING GENIUS · Notes Corrections Clarifications Apologies Addenda · Picador

WILD SWANS · JUNG CHANG · Harper Collins

AMY KROUSE ROSENTHAL · Encyclopedia of an Ordinary Life · A AMY

THE DIVING-BELL & THE BUTTERFLY · JEAN-DOMINIQUE BAUBY

THIS BOY'S LIFE A Memoir · TOBIAS WOLFF · GROVE PRESS

P.S. · FIRST THEY KILLED MY FATHER · A Daughter of Cambodia Remembers · LOUNG UNG · Harper Perennial

Night · ELIE WIESEL · Hill & Wang

Hold Still · Sally Mann · A Memoir with Photographs · LB

JACQUELINE WOODSON · brown girl dreaming

JUST KIDS | PATTI SMITH · P S R M · ecco

a long way gone · ishmael beah · FSG

NELSON THE ARGONAUTS

CONROY THE WATER IS WIDE · HOUGHTON MIFFLIN COMPANY

MAYA ANGELOU · I KNOW WHY THE CAGED BIRD SINGS · Random House

All Creatures Great and Small · James Herriot

EDDIE HUANG · FRESH OFF THE BOAT · SPI EGE L&G RAU

Jeanette Winterson · ORANGES ARE NOT THE ONLY FRUIT · FICTION

William Finnegan · Barbarian Days A Surfing Life · Corsair

LAKOTA WOMAN · MARY CROW DOG

READING LOLITA IN TEHRAN · Azar Nafisi · RANDOM HOUSE

DAVID MITCHELL · Black Swan Green · SCEPTRE

Angela's Ashes · Frank McCourt · SCRIBNER

MY STRUGGLE 1 · KARL OVE KNAUSGAARD

THE COMPLETE PERSEPOLIS · Marjane Satrapi · PANTHEON

MARY KARR · THE LIARS' CLUB · Penguin Classics Deluxe Edition

HEART BERRIES · Terese Marie Mailhot · C

BELOVED BOOKSTORES

The seventh most populous city in India, Pune is considered the state of Maharashtra's cultural capital. Pune brims with the energy of scholars; the city hosts several well-known universities and half of the country's international students.

Vishal & Neha Pipraiya

PAGDANDI

Pune, India

Now husband and wife, Vishal and Neha Pipraiya met after quitting their jobs and setting out to travel. Together they opened Pagdandi in Pune, India, in 2013. There they nourish like-minded hearts and souls with a wide collection of literature, wholesome foods, and warm chai, all in an inviting space. The two had found not only each other but also their own *pagdandi*, a less traveled but more fulfilling path, and hope to help others find theirs, too. They'll even help you plan the trip and find the books to get you there.

AVID BOOKSHOP

Athens, Georgia, USA

A cheeky sign above Avid Bookshop's Prince Avenue location declares "Anti-Established 2011." Janet Geddis's shop is anti-established in two Athens, Georgia, locations. As she's met success, Geddis has been frank about the struggles of opening and owning a bookstore and cites other indie stores—WORD Brooklyn; Greenlight Bookstore, also in Brooklyn; Little Shop of Stories in Decatur, Georgia; Over the Moon Bookstore & Artisan Gallery in Crozet, Virginia; Books & Books in Miami; and many more—as sources of insight and inspiration.

Geddis recommends:

I Am, I Am, I Am: Seventeen Brushes with Death
by Maggie O'Farrell

"Maggie O'Farrell is one of my favorite writers. *I Am, I Am, I Am* is a searing and gorgeous memoir, an exploration of 17 times death has come blisteringly close to the author. While reading her stories, told in vignettes, one can't help but be hyperaware of the fact that we are all living so near the veil. O'Farrell's skill for evocative imagery is almost unparalleled: It's not uncommon for me to gasp as I read her sentences, astonished at the ways in which her language so aptly captures the human experience."

Tinder Press
2017 hardcover,
design by
Yeti Lambregts

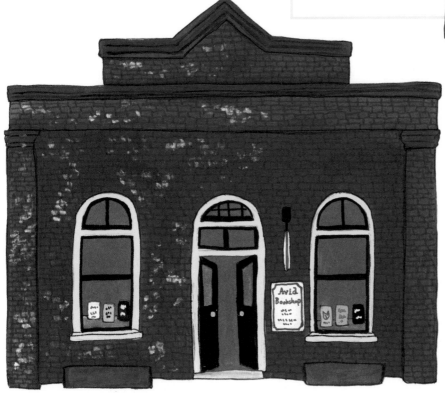

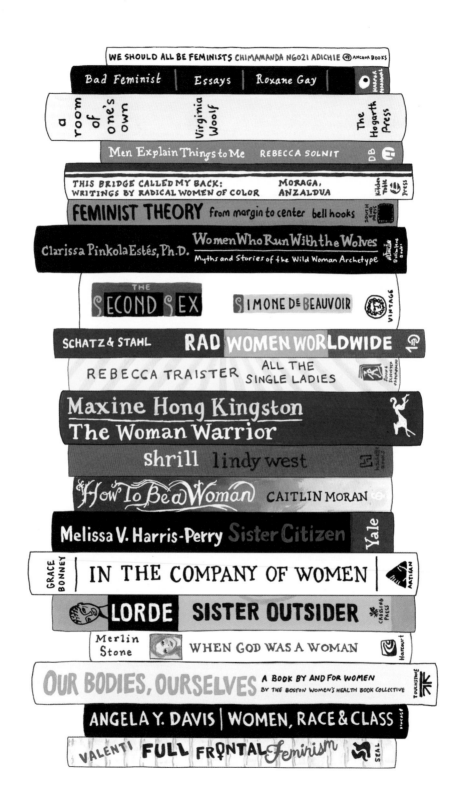

FEMINISM

It's hard to believe feminism can still be polarizing. Everyone has slightly different associations with the word and interpretations of its meaning. But at its core, feminism is about equality for the sexes, which is something we should all be able to get behind.

CHIMAMANDA NGOZI ADICHIE

WE SHOULD ALL BE FEMINISTS

Anchor Books 2015 paperback, design by Joan Wong

Beyonce's 2013 track "***Flawless" samples Chimamanda Ngozi Adichie's TED Talk "We Should All Be Feminists," which was also the basis for this book. In 2015, the Swedish government gave a copy of the book to every 16-year-old student in the country. Finland followed suit in 2017, giving it to all 15-year-olds.

on growing up as the child of immigrant parents and dealing with sexism and racism in her new land and her parents' old one. Kingston didn't love the final title because she is a pacifist.

THIS BRIDGE CALLED MY BACK

WRITINGS BY RADICAL WOMEN OF COLOR

edited by CHERRÍE MORAGA GLORIA ANZALDÚA

foreword by TONI CADE BAMBARA

Persephone Press 1981 hardcover, art by Johnetta Tinker, design by Maria von Brincken.

In the preface to the seminal 1981 anthology *This Bridge Called My Back*, editors Cherríe Moraga and Gloria E. Anzaldúa explain that with the included essays, poems, and artworks they want to expand the term "feminist" to include women of color.

In 2009, the percentage of US women who were married dropped below 50 for the first time. Rebecca Traister's *All the Single Ladies* studies how the world has changed now that women have more choices, now that we don't all have to follow "a single highway toward early heterosexual marriage and motherhood."

MORE

- *Feminist Fight Club* by Jessica Bennett
- *Gender Trouble* by Judith Butler
- *Gyn/Ecology* by Mary Daly
- *The Feminine Mystique* by Betty Friedan
- *Fear of Flying* by Erica Jong
- *The Gutsy Girl* by Caroline Paul
- *The Women Who Made New York* by Julie Scelfo & Hallie Heald
- *Outrageous Acts and Everyday Rebellions* by Gloria Steinem
- *The Beauty Myth* by Naomi Wolf
- *A Vindication of the Rights of Women* by Mary Wollstonecraft

Roxane Gay admits to loving the Sweet Valley High books, saying all reading is reading and you shouldn't be ashamed about your choices, unless of course you're reading *Mein Kampf*. Her essays in *Bad Feminist* explain how it is to be a woman in the current world, but also how it is to be a person, with all our beautiful imperfections.

In *The Woman Warrior*, Maxine Hong Kingston mixes memoir with Chinese folktales. She reflects

Maxine Hong Kingston

The Woman Warrior

Memoirs of a girlhood among ghosts

Knopf 1976 hardcover, art by Elias Dominguez, design by Lidia Ferrara

WRITING ROOMS

ROALD DAHL

When Roald Dahl and his family were living in Gipsy House in Great Missenden, Buckinghamshire, UK, he realized his kids were so noisy that he needed his own writing space. After seeing Dylan Thomas's shed in Wales, he built a shed of his own in his garden.

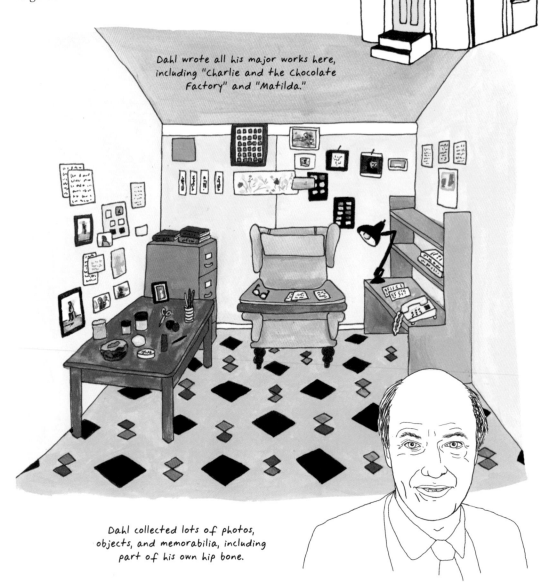

Dahl wrote all his major works here, including "Charlie and the Chocolate Factory" and "Matilda."

Dahl collected lots of photos, objects, and memorabilia, including part of his own hip bone.

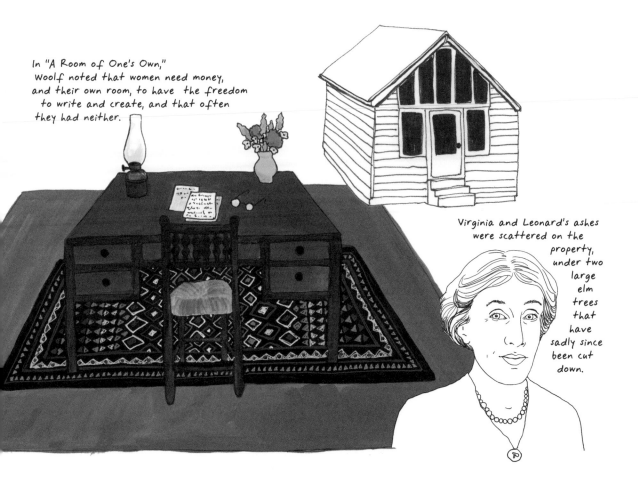

In "A Room of One's Own," Woolf noted that women need money, and their own room, to have the freedom to write and create, and that often they had neither.

Virginia and Leonard's ashes were scattered on the property, under two large elm trees that have sadly since been cut down.

VIRGINIA WOOLF

Virginia Woolf and her husband, Leonard, bought Monk's House in 1919 and visited frequently. They moved in full time in 1940, when their Bloomsbury, London, flat was damaged in an air raid. The Woolfs loved the property for its lush, informal grounds, including an Italian garden, a dew pond, a terrace, and an orchard. The main house was decorated with the help of Woolf's sister, the painter and decorator Vanessa Bell, who lived six miles away. Many of Bell's paintings still hang on the walls.

The couple hosted members of the Bloomsbury Group—influential English writers, philosophers, and artists—at their new home. E. M. Forster was photographed happily pruning trees alongside Leonard. Visitors also enjoyed rigorous games of lawn bowling.

Woolf wrote parts of all her major works in a converted toolshed she called her "writing lodge," where she had views of Mount Caburn, one of the highest points in East Sussex. The shed was also where she wrote her farewell letter to Leonard on March 28, 1941, before heading to the River Ouse with pockets full of stones.

WE'RE ALL HUMAN

Writers and thinkers remind us that we humans are pretty powerful. Large groups of us can destroy or create, be a source of sorrow or hope. The way to more creation and hope, and less destruction and sorrow, is understanding each other better. As Neil Gaiman said, a book is a "little empathy machine," and it is "very hard to hate people of a certain kind when you've just read a book by one of those people."

Claudia Rankine's award-winning *Citizen* is a collection of poems, essays, and artworks. It's a cultural critique on racism in America, referencing Serena Williams's tennis matches, Barack Obama's inauguration, and police shootings of unarmed black men.

The cover features a sculpture titled "In the Hood," created by David Hammons in 1993. It is the hood of a hoodie, hung on the wall like a hunting trophy.

Graywolf Press 2014 paperback, design by John Lucas

A Pakistani who's lived in New York, California, and London, Mohsin Hamid describes himself as a "hybridized mongrel," and also notes that "we're all mongrels." He attributes bigotry and xenophobia to a longing for the past that we need to move on from, writing that "stories have the power to liberate us from the tyranny of what was and is."

In 1998, at the Central Park Zoo, two male penguins named Roy and Silo fell in love. They called to each other and entwined necks, and eventually built a nest together and put a rock in it as if it were their egg. When the charmed zoo staff gave them an extra egg from a heterosexual penguin couple, Roy and Silo took turns sitting on it until their daughter Tango was born. Husbands Justin Richardson and Peter Parnell turned their story into a delightful book for kids, one that they hoped would help parents discuss homosexuality. The American Library Association, which tracks requests to remove books and helps librarians counter them, recorded *And Tango Makes Three* as the most challenged book in 2006, 2007, 2008, and 2010.

Simon & Schuster Books for Young Readers hardcover, art by Henry Cole

Kamala Khan debuted as Ms. Marvel in 2014. This 16-year-old millennial Muslim superhero from New Jersey was created by editors Sana Amanat and Stephen Wacker, written by G. Willow Wilson, and drawn by Adrian Alphona.

MORE

- *The New Jim Crow* by Michelle Alexander
- *Notes of a Native Son* by James Baldwin
- *The Sellout* by Paul Beatty
- *Invisible Man* by Ralph Ellison
- *Random Family* by Adrian Nicole LeBlanc
- *The Making of Asian America* by Erika Lee
- *The Better Angels of Our Nature* by Steven Pinker
- *Behave* by Robert M. Sapolsky
- *The Warmth of Other Suns* by Isabel Wilkerson
- *The Spirit Level: Why Greater Equality Makes Societies Stronger* by Richard Wilkinson & Kate Pickett

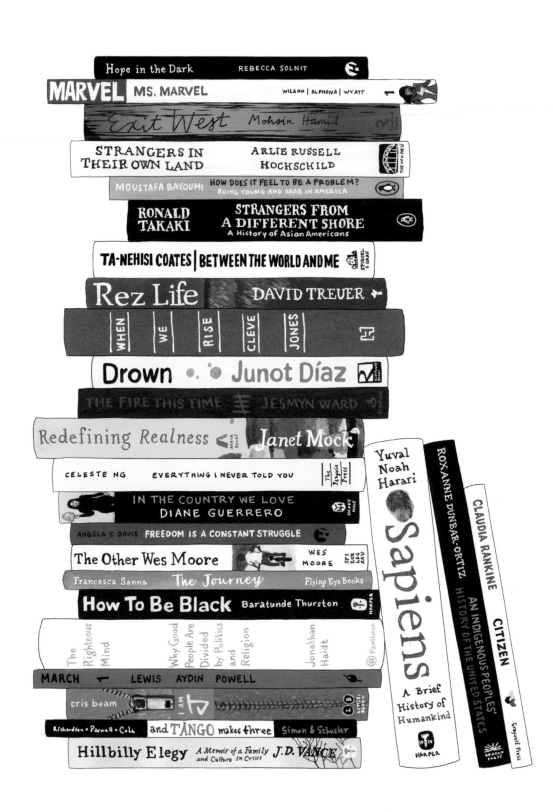

LITTLE FREE LIBRARIES

As of 2016 there were more than 50,000 registered Little Free Libraries!

SCHOOLHOUSE LITTLE FREE LIBRARY

Hudson, Wisconsin, USA

This is the very first Little Free Library, designed and filled with books by Todd Bol in 2009 as a tribute to his mother, Esther, a teacher. His neighbors loved visiting his yard to "take a book/leave a book." He and his friend Richard Brooks, inspired by the philanthropist Andrew Carnegie's building of libraries at the beginning of the 20th century, made many more and gave them away, starting a worldwide movement.

BÜCHER TAUSCHBAUM

Freudenstadt, Germany

Trees turn into paper into books and then go back into a tree again!

VICKMORR LITTLE FREE LIBRARY

Salt Lake City, Utah, USA

This is a very well-organized tiny library; it even has themes and events! →

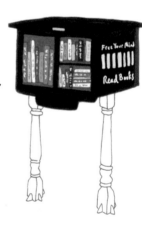

MUSHROOM LIBRARY

Kyoto Botanical Gardens, Kyoto, Japan

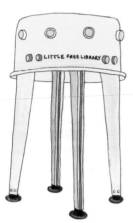

THINK TANK

New York,
New York, USA

The Architectural League of New York and PEN World Voices Festival held a Little Free Library competition, and 10 designers were chosen to each create a library. This one, usually found in Manhattan's Nolita neighborhood, was created by Stereotank, based on the concept of immersing oneself in a book.

The books surround the interior of the yellow doughnut and the borrower stands in the center with their head inside.

PAY PHONE LITTLE FREE LIBRARY

Spokane,
Washington, USA

Such an excellent use of an outdated pay phone!

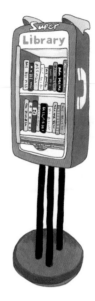

LOG CABIN LITTLE FREE LIBRARY

Lakeville,
Minnesota, USA

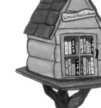

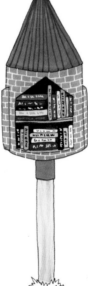

MEDIEVAL TOWER LITTLE FREE LIBRARY

Barkhamsted,
Connecticut, USA

It looks a little like a tower and a little like a rocket ship, but is filled with great stories either way.

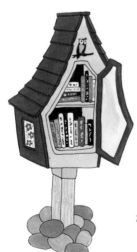

CARTOON LITTLE FREE LIBRARY

St. Paul, Minnesota,
USA

TARDIS LITTLE FREE LIBRARY

Macon, Georgia, USA

This life-size replica of Dr. Who's TARDIS, a time and space machine, was made by Christopher Marney and Jen Look. Like the TARDIS, books are bigger on the inside!

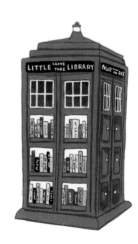

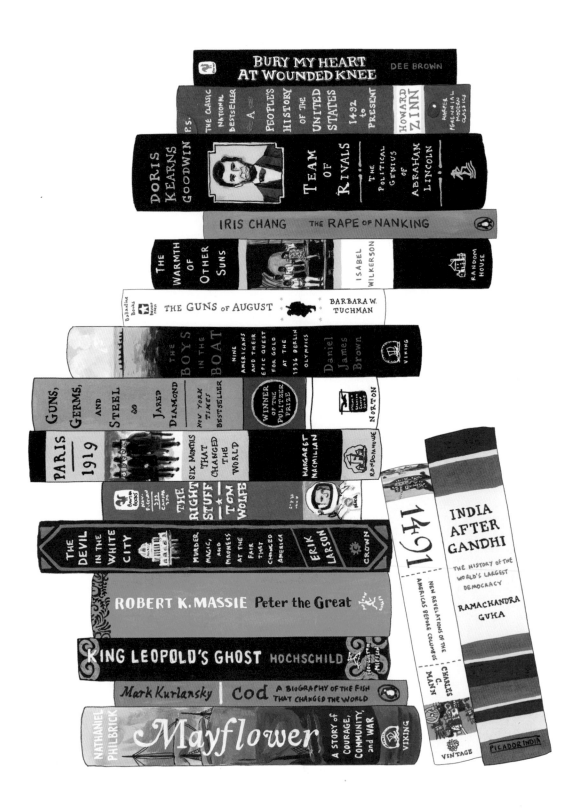

HISTORY

I changed the world.

Does reading history free us from repeating the worst of it and enable us to repeat the best? Maybe or maybe not, but it does reveal human nature and why we did what we did (hindsight is 20/20). If we look closely enough, we might also see what we will probably do in the future; here's hoping we plan accordingly.

Vintage Books 2006 paperback, design by Abby Weintraub

Among the revelations in Charles C. Mann's *1491*: In that year, the Americas were as populated as Europe, and indigenous technology was on a par with, if not superior to, European technology. For example, Spaniards wouldn't cross indigenous suspension bridges because they couldn't see what held them up. And in battle, Spaniards discarded their metal armor because it was so inferior to the Incas' densely woven cotton clothing for the location and climate.

Barbara Tuchman, winner of two Pulitzer Prizes, had no advanced degree in history, but saw that as an advantage for writing a narrative that would keep readers turning pages. Reflecting on her chosen subject, she saw "good and bad always coexisting and inextricably mixed. . . ."

Macmillan 1962 hardcover, design by Ellen Raskin

Tuchman's thorough research and skillful dramatization of the diplomatic errors that led to the escalation of World War I provided President John F. Kennedy with a history lesson he (actually) heeded to avoid a potential World War III. *The Guns of August* is widely credited for influencing how JFK diffused the Cuban Missile Crisis. He was so taken with the book that he gave it to his aides and visiting dignitaries alike.

When Tom Wolfe sent a copy of *The Right Stuff* to the astronauts he interviewed for it, John Glenn (whom Wolfe hallows as a national hero) was one of very few to reply. Glenn had a correction for the next edition: He did not drive a four-cylinder Peugeot, but an even smaller car, a two-cylinder NSU Prinz. While the other astronauts favored Corvettes, Glenn commuted in the Prinz

Farrar Straus & Giroux 1979 hardcover, design by Kiyoshi Kanai

because its 30–45 MPG helped him save money for his kids' college educations.

MORE

- *Undaunted Courage* by Stephen E. Ambrose
- *Stalingrad: The Fateful Siege, 1942–1943* by Anthony Beevor
- *The Path to Power* by Robert Caro
- *Wild Swans: Three Daughters of China* by Jung Chang
- *Return of a King: The Battle for Afghanistan, 1839–42* by William Dalrymple
- *The Decline and Fall of the Roman Empire* by Edward Gibbon
- *1776* by David McCullough
- *The Rise of Theodore Roosevelt* by Edmund Morris
- *The Rise and Fall of the Third Reich* by William L. Shirer
- *Genghis Khan and the Making of the Modern World* by Jack Weatherford

BELOVED BOOKSTORES

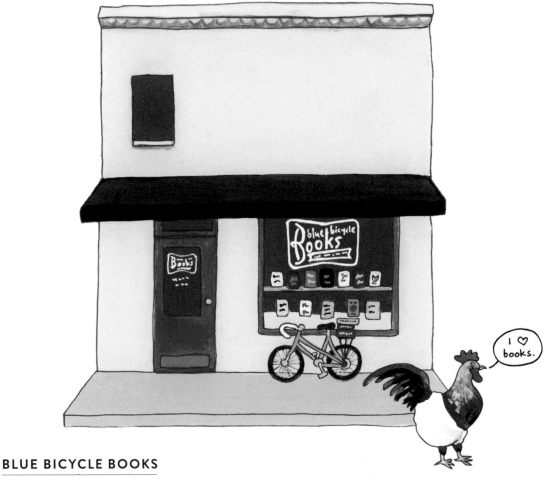

BLUE BICYCLE BOOKS

Charleston, South Carolina, USA

Charleston's Blue Bicycle Books is named after the trusty steed that owner Jonathan Sanchez rides to work, with books stacked high over the rear wheel.

The store, originally the home of a book printer, then an ophthalmologist's office, has enough books to make a stack 1,565 feet tall. It is chock-full of half-off trade paperback fiction, beautiful classics, modern firsts (signed by William Faulkner, Harper Lee, and Margaret Mitchell), military

history, almost every new and used Charleston book ever written, plus lots of new books, including children's books and cookbooks.

Of many memorable encounters in the store, Sanchez recounts a few: Bill Murray doing a Dustin Hoffman impression (*"I'm not fucking Robert Redford!"*); a marriage proposal almost gone awry due to a bout of dehydration; and a visitor toting a diaper-wearing rooster.

TATTERED COVER

Denver, Colorado, USA

Two of the several buildings at the 60-acre ranch.

Tattered Cover in Denver, Colorado, is one of the largest independent bookstores in the US. The first store opened in 1971, and now there are four branches all around the city, with a total of over half a million books. In their words, "We are a Denver institution, a community gathering place, and an experience you can't download."

Two longtime Tattered Cover employees, Ann Martin and Jeff Lee, personally collected more than 32,000 books about the land, history, and people of the West to create the Rocky Mountain Land Library. Thanks in part to a hugely successful Kickstarter campaign and the support of an enthusiastic community, the library has an evolving home at Buffalo Peaks Ranch in South Park, Colorado—a literary dream come true.

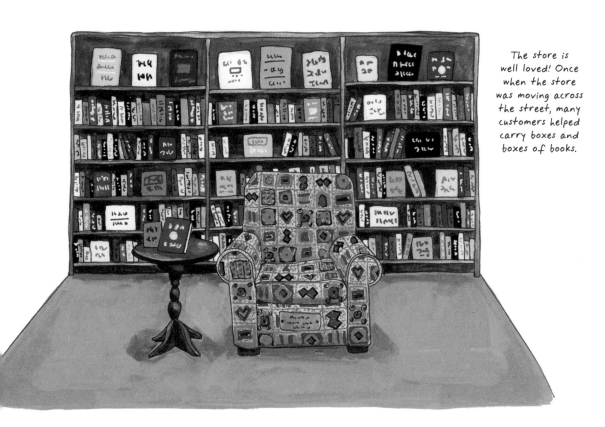

The store is well loved! Once when the store was moving across the street, many customers helped carry boxes and boxes of books.

WAR

The hope is that reading about war will reduce the frequency of it. Right? These books at least let us see not only the glory of a proud warrior on the battlefield and the genius of political strategies, but also soldiers' often inglorious deaths and war's effects on everyday citizens.

Tim O'Brien fought in the Army's 23rd Infantry Division in the Vietnam War. His short-story collection *The Things They Carried* mixes real events and people with fake names and details to arrive at truths. While he acknowledges that "war is hell," he also writes that it is confusing and contradictory, that it is "mystery and terror and adventure and courage and discovery and holiness and pity and despair and longing and love."

The title of Joseph Heller's classic 1961 satire, *Catch-22*, refers to the unsolvable dilemma of war-weary airmen: If you were insane you no longer had to fly missions, but if you applied to stop flying, showing a rational concern for your safety, you must therefore be sane and were required to fly. The book was almost called *Catch-18*, but editor Robert Gottlieb didn't want it to be confused with Leon Uris's *Mila 18*, published the same year.

Simon & Schuster 1961 hardcover, design by Paul Bacon

In 2007, journalist David Finkel embedded with a US Army Infantry Battalion in Baghdad. In 2008, he published *The Good Soldiers*, about Lieutenant Colonel Ralph Kauzlarich, his soldiers, and their experience of war. *Thank You for Your Service* was his follow-up

five years later, chronicling the soldiers' struggles as they returned home to the US and to "the after-war."

Joe Haldeman got a B.S. in physics and astronomy and was promptly drafted into the Vietnam War. Upon returning he wrote *The Forever War*, published in 1974. It follows a soldier named William Mandella, part of an elite group sent into space in 1997 to fight an alien race. After a two-year battle, thanks to time dilation, he returns home in 2024 and feels full future shock. He returns to the war, which continues for a thousand Earth years, and gets increasingly disillusioned and detached from the drastically changing culture at home.

St. Martin's Press 1974 hardcover

MORE

- *Empire of the Sun* by J. G. Ballard
- *Regeneration* by Pat Barker
- *Restless* by William Boyd
- *A Rumor of War* by Philip Caputo
- *The Rape of Nanking* by Iris Chang
- *The Red Badge of Courage* by Stephen Crane
- *Dispatches* by Michael Herr
- *Seven Pillars of Wisdom* by T. E. Lawrence
- *We Were Soldiers Once . . . and Young* by Lt. Gen. Harold G. Moore & Joseph L. Galloway
- *The First Salute* by Barbara W. Tuchman

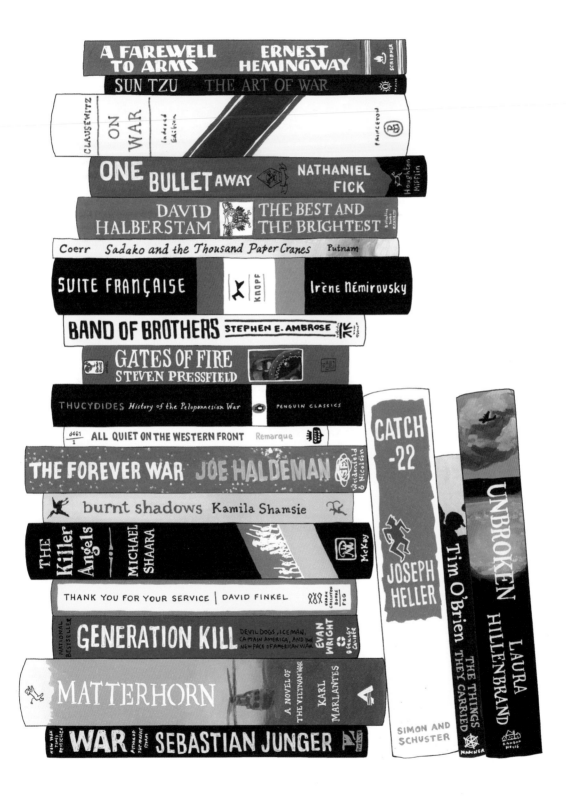

BOOKS MADE INTO GREAT TV

A SONG OF ICE AND FIRE

by George R. R. Martin

Game of Thrones, HBO series, 2011–

Bantam 1996 hardcover, design by David Stevenson, art by Larry Rostant

THE HANDMAID'S TALE

by Margaret Atwood

The Handmaid's Tale, Hulu series, 2017–

Houghton Mifflin Harcourt 2017 hardcover, design by Patrik Svensson

ROOTS

by Alex Haley

Roots, ABC miniseries, 1977

Doubleday 1976 hardcover, design by Al Nagy

AMERICAN GODS

by Neil Gaiman

American Gods, Starz series, 2017–

William Morrow 2016 paperback, art by Robert E. McGinnis, lettering by Todd Klein

Sherlock Holmes has been adapted for the screen many times, including in over 200 films and the CBS television series "Elementary."

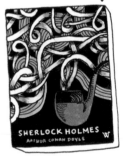

TREASURE ISLAND

by Robert Louis Stevenson

Black Sails, Starz series, 2014–2017

Puffin 2008 paperback, art by Matt Jones

This series is actually a prequel to the events in the book, portraying many of the same characters (but not the young Jim Hawkins) and telling the origin story of Long John Silver.

THE MAGICIANS

by Lev Grossman

The Magicians, SyFy series, 2015–

Viking 2009 hardcover, design by Jaya Miceli, art by Didier Massard

SHERLOCK HOLMES

by Sir Arthur Conan Doyle

Sherlock, BBC One series, 2010–

White's Books 2010 hardcover, design by Michael Kirkham

BIG LITTLE LIES

by Liane Moriarty

Big Little Lies,
HBO series, 2017–

G. P. Putnam's Sons
2014 hardcover, art by
Yamanda Taro/Image
Bank/Getty Images

OUTLANDER

by Diana Gabaldon

Outlander,
Starz series, 2014–

Bantam 1992 paper-
back, design by Marietta
Anastassatos, art by Diana
Gabaldon & Running
Changes, Inc.

THE LITTLE HOUSE BOOKS

by Laura Ingalls Wilder

Little House on the Prairie,
NBC series, 1974–1983

Harper 1953 hardcover,
art by Garth Williams

FRIDAY NIGHT LIGHTS

by H. G. Bissinger

Friday Night Lights,
NBC series, 2006–2011

Da Capo 2000 paperback,
design by Alex Camlin,
photo by Robert Clark

LONESOME DOVE

by Larry McMurtry

Lonesome Dove,
CBS miniseries, 1989

Simon & Schuster
2010 paperback,
design by Rodrigo
Corral Design, art
by Bonnie Clas

McMurtry is also a
screenwriter and won an
Academy Award for Best Adapted Screenplay
for "Brokeback Mountain." His novels "The Last
Picture Show" and "Terms of Endearment" were
also both adapted into award-winning films.

THE SOOKIE STACKHOUSE NOVELS

by Charlaine Harris

True Blood,
HBO series, 2008–2014

Ace 2001 hardcover,
art by Lisa Desimini

ORANGE IS THE NEW BLACK

by Piper Kerman

Orange Is the New Black,
Netflix series, 2013–

Spiegel & Grau 2011 paperback,
design by Christopher Sergio,
art by Bertram Glenn Moshier

I LOVE DICK

by Chris Kraus

I Love Dick,
Amazon Video
series, 2016–

Tuskar Rock 2015 hardcover,
design by Peter Dyer

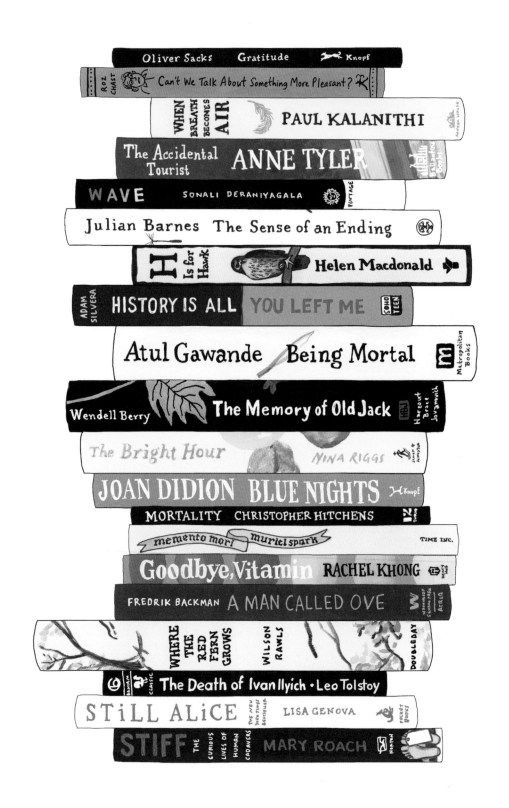

MORTALITY

We all die. Most of us get old first. Almost all of us slam up against the death of a loved one at least once, if not many times. Some brave souls write to try and guide us, in preparation for those days, like Charon on the River Styx.

Oliver Sacks's many books all help us better understand our humanity. He wrote his last one while dying from cancer. It's titled *Gratitude* because that was his foremost feeling, for loving and being loved, and for being "a sentient being, a thinking animal, on this beautiful planet."

Many of us first learn to grieve, as kids, through a heartbreaking book. Just try to think about the coonhounds Old Dan and Little Ann in Wilson Rawls's *Where the Red Fern Grows* without tearing up.

Dr. Atul Gawande's *Being Mortal* is both the personal tale of his father's battle with cancer and a public call for a better health care philosophy and system, one that should "enable well-being" above all else, even survival, and allow us each to die a humane death when the time comes. In addition to being a writer and surgeon, Gawande is a professor and public health researcher. He worked on Al Gore and Bill Clinton's presidential campaigns, and later was a senior adviser on the Clinton Health Care Task Force.

When Helen Macdonald's father died, she poured herself into taming and training a murderous bird, a wild goshawk she named Mabel after the Latin *amabilis*, meaning "lovable". *H Is for Hawk* is part Macdonald's memoir, part nature writing, and part shadow biography of T. H. White.

FOREWORD BY ABRAHAM VERGHESE
WHEN BREATH BECOMES air
PAUL KALANITHI

Random House 2016 hardcover, design by Rachel Ake

Paul Kalanithi died from lung cancer before he finished *When Breath Becomes Air* and after asking his wife Lucy to see it published. She wrote an epilogue, helped design the cover, and did the book tour. She said that the book's success has kindled a fantasy in which she can meet him again, even if only for a few seconds, and give him a "copy of the book with the award nominations printed on the cover."

MORE

- *Tuesdays with Morrie* by Mitch Albom
- *The Sweet Hereafter* by Russell Banks
- *Why Survive? Being Old in America* by Dr. Robert N. Butler
- *Looking for Alaska* by John Green
- *To Dance with the White Dog* by Terry Kay
- *A Separate Peace* by John Knowles
- *On Death & Dying* by Dr. Elisabeth Kübler-Ross
- *A Grief Observed* by C. S. Lewis
- *How We Die* by Sherwin Nuland
- *The Thing About Life Is That One Day You'll Be Dead* by David Shields

STRIKING LIBRARIES

THE RADCLIFFE CAMERA, BODLEIAN LIBRARY, OXFORD UNIVERSITY

Oxford, UK

Designed by James Gibbs

Opened in 1749

This was originally a science library but now houses English, history, and theology books on Oxford University reading lists, plus a lot of room for reading them.

SEATTLE CENTRAL LIBRARY

Seattle, Washington, USA

Designed by Joshua Prince-Ramus and Rem Koolhaas of OMA and LMN Architects

Opened in 2004

As with many public buildings, there was a competition among architects for this project. OMA and LMN's winning design acknowledges that, while lending books is very important, libraries have several other functions and need various spaces, particularly social ones. They divided the functional spaces into vertical sections, stacked on each other like a messy pile of books, and covered it all with a glass skin.

The library can hold 1.5 million books, and over two million people visited it in its first year open.

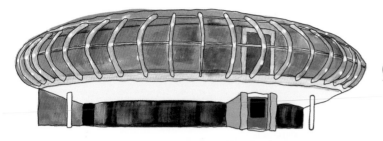

BIBLIOTECA SANDRO PENNA
(THE SANDRO PENNA LIBRARY)

Perugia, Italy

Designed by Studio Italo Rota

Opened in 2004

It glows at night and is named after a poet from Perugia.

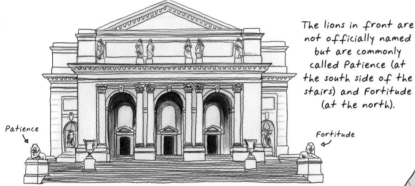

The lions in front are not officially named but are commonly called Patience (at the south side of the stairs) and Fortitude (at the north).

Patience →

Fortitude →

STEPHEN A. SCHWARZMAN BUILDING, THE NEW YORK PUBLIC LIBRARY

Manhattan, New York, USA

Designed by Carrère & Hastings

Opened in 1911

This is perhaps the most famous library in the world, right in the heart of New York City. It's an excellent example of Beaux-Arts architecture. The design was based on a quick sketch by the first library director, Dr. John Shaw Billings. Inside there are more than 15 million books and other items, and the beautiful Rose Main Reading Room.

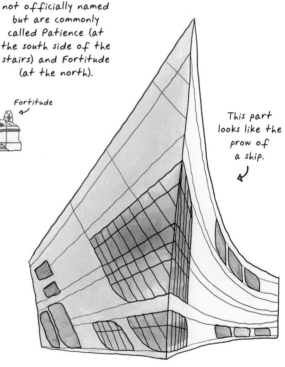

This part looks like the prow of a ship.

THE SURREY CITY CENTRE LIBRARY

Surrey, British Columbia, Canada

Designed by Bing Thom Architects

Opened in 2011

The library is meant to house books, of course, but the priority was creating "a space for reading, studying, and above all, gathering as a community," according to the architects.

FINDING MEANING

We try so hard to figure out why we're here in the universe and how we should best live while we are. While one person's woo-woo is the next person's shining ray of hope, all of us fall into a shitty place at some point, and we must try every possible path to happiness, to being better people with more love for ourselves and each other.

Rider 2011 hardcover, design by Two Associates

As an Auschwitz concentration camp inmate, Viktor Frankl was also a psychiatrist for other inmates. His book about the experience, *Man's Search for Meaning*, has sold over 10 million copies and been translated into 24 languages. It holds many jewels of knowledge about the human condition. An especially brilliant insight was that everything can be taken from a person, except one's ability "to choose one's attitude in any given set of circumstances, to choose one's own way."

Brené Brown has spent many years studying and writing about vulnerability, courage, and how happy and successful people get back up after difficulties and failures. Her TED Talk "The Power of Vulnerability" has been viewed more than 20 million times. "We are the authors of our lives," she declares in her book *Rising Strong*. "We write our own daring endings."

TarcherPerigee 2016 paperback

One active and productive way to figure yourself out is to write or draw in workbooks or guided journals, like the clever *Pick Me Up* by artist Adam J. Kurtz. He explained, "It's like if a jaded New Yorker did his own take on 'mindfulness' (because that's exactly what it is)."

When asked what she changed in order to live the life she wanted, musician, life coach, and badass Jen Sincero says that now "instead of running away from the big, awesome, terrifying idea that pops into my head, I run towards it." She also notes that self-doubt is totally normal, and "the only people who don't have moments of doubt are liars."

Chronicle Books 2016 hardcover

Artist Susan O'Malley asked a hundred people, of all ages and backgrounds, how their 80-year-old selves would advise their current selves. The resulting book is beautiful and piercingly clear; we know what we need to do to be happy, we just need to do it. O'Malley died suddenly, at the age of 38 and while pregnant with twins, before the book was published, making the messages within it all the more vivid.

MORE

- *The Universe Has Your Back* by Gabrielle Bernstein
- *The Alchemist* by Paulo Coelho
- *The Bonobo and the Atheist* by Frans de Waal
- *Love Warrior* by Glennon Doyle
- *Four Quartets* by T. S. Eliot
- *Siddhartha* by Hermann Hesse
- *Memories, Dreams, Reflections* by C. G. Jung
- *Think on These Things* by Jiddu Krishnamurti
- *Mere Christianity* by C. S. Lewis
- *The Gospel of Sri Ramakrishna* by Sri Ramakrishna

Lao Tzu TAO TEH CHING Shambhala

RISING STRONG Brené Brown Ph.D. LMSW Random House

FRANKL MAN'S SEARCH FOR MEANING BEACON

kondo the life-changing magic of tidying up Ten Speed Press

Krista Tippett Becoming Wise

O'Malley ADVICE FROM MY 80-YEAR OLD SELF chronicle books

THE HAPPINESS PROJECT GRETCHEN RUBIN Collins
Or, Why I Spent a Year Trying to Sing in The Morning, Clean My Closets, Fight Right, Read Aristotle, and Generally Have More Fun

WHY ZEBRAS DON'T GET ULCERS The Acclaimed Guide to Stress-Related Diseases, and Coping THIRD EDITION
ROBERT M. SAPOLSKY

Eckhart Tolle ～ THE POWER OF NOW Namaste Publishing NEW WORLD LIBRARY

THE SEAT OF THE SOUL GARY ZUKAV FIRESIDE Simon & Schuster

INSTANT HAPPINESS ON EVERY PAGE the POSITIVITY KIT LISA CURRIE

PEACE IS EVERY STEP Thich Nhat Hanh BANTAM

HOW TO BE HAPPY (OR AT LEAST LESS SAD) LEE CRUTCHLEY

THERE IS NO GOOD CARD FOR THIS: KELSEY CROWE, Ph.D. and EMILY McDOWELL HarperOne
WHAT TO SAY and DO WHEN LIFE is SCARY, AWFUL, and UNFAIR to PEOPLE YOU LOVE

BE HERE NOW BE NOW HERE

THE LITTLE BOOK OF HYGGE MEIK WIKING LIFE

Benjamin Hoff The Tao of Pooh

INNER ENGINEERING SPI EGE L&G RAU SADHGURU

MARK MANSON THE SUBTLE ART OF NOT GIVING A F*CK HarperOne

CHOPRA The SEVEN SPIRITUAL LAWS of SUCCESS New World Library

CHÖDRÖN WHEN THINGS FALL APART HEART ADVICE for DIFFICULT TIMES SHAMBHALA

The Happiness Hypothesis Finding Modern Truth in Ancient Wisdom HAIDT BASIC BOOKS

YOU ARE A BADASS SINCERO

PICK ME UP * ADAM J. KURTZ tp RUNNING PRESS

The Book of JOY His Holiness the DALAI LAMA Archbishop DESMOND TUTU with DOUGLAS ABRAMS AVERY

BELOVED BOOKSTORES

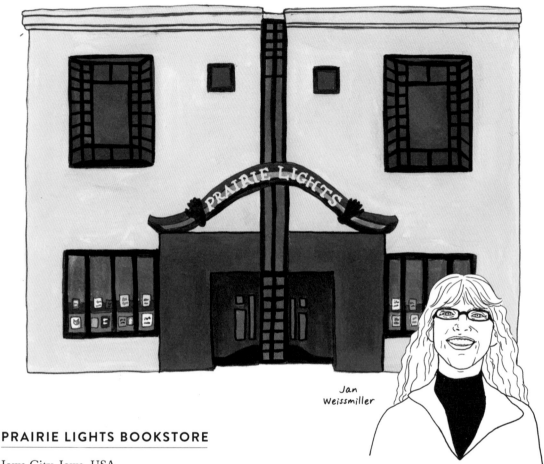

Jan
Weissmiller

PRAIRIE LIGHTS BOOKSTORE

Iowa City, Iowa, USA

Prairie Lights is nestled in the same town as the Iowa Writers' Workshop. The proximity makes Prairie Lights glitter, helping to attract many celebrated writers for readings.

The bookstore opened in an intimate space in 1978 and grew over time, eventually overtaking the former home of a literary society that hosted Carl Sandburg, Robert Frost, Sherwood Anderson, Langston Hughes, e e cummings, and more.

Prairie Lights' owners, Jan Weissmiller and Jane Mead, are both poets. While Mead manages her

family ranch in Northern California, Weissmiller, formerly a store employee, runs the day-to-day business, and wishes she still had the time to shelve the books of poetry.

Part of Prairie Lights' success over the years has been in diversifying the business. In 2010, the bookstore took over a café that was leasing space inside it, and which now accounts for 10% of revenue. And in 2013, the bookstore partnered with the University of Iowa Press to start publishing its own books.

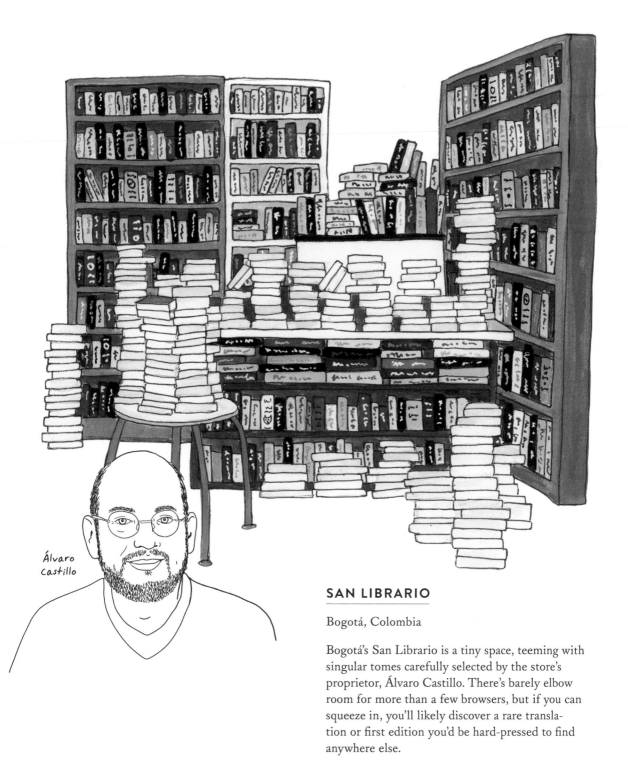

Álvaro
Castillo

SAN LIBRARIO

Bogotá, Colombia

Bogotá's San Librario is a tiny space, teeming with singular tomes carefully selected by the store's proprietor, Álvaro Castillo. There's barely elbow room for more than a few browsers, but if you can squeeze in, you'll likely discover a rare translation or first edition you'd be hard-pressed to find anywhere else.

THE WRITING LIFE ANNIE DILLARD HARPER & ROW

RAY BRADBURY ZEN IN THE ART OF WRITING NONFICTION

ON MORAL FICTION JOHN GARDNER Basic Books

On Writing Well 30TH ANNIVERSARY EDITION William Zinsser Collins

Eats, Shoots & Leaves LYNNE TRUSS GOTHAM BOOKS

IF YOU WANT TO WRITE BRENDA UELAND

THE ART OF MEMOIR | MARY KARR HARPER PERENNIAL

RAINER MARIA RILKE LETTERS TO A YOUNG POET VINTAGE

Anne Lamott bird by bird Some Instructions on Writing and Life ANCHOR Books

ERNEST HEMINGWAY on WRITING EDITED BY LARRY W. PHILLIPS

STEPHEN KING On Writing SCRIBNER

THE ELEMENTS OF STYLE • STRUNK/WHITE/KALMAN The Penguin Press

READING LIKE A WRITER Francine Prose

Goldberg Writing Down the Bones Shambhala

EUDORA WELTY ON WRITING INTRODUCTION BY Richard Bausch

The Chicago Manual of Style The University of Chicago Press

BROWNE & KING SELF-EDITING FOR FICTION WRITERS

How Fiction Works JAMES WOOD FSG

Stein on Writing SOL STEIN

HOW TO WRITE

Have a burning desire to write your own book? These can help! As can reading every other book listed anywhere in this one. When asked about his writing routine, Nobel Prize–winning writer José Saramago said, "I write two pages. And then I read and read and read."

Writing is usually not easy, of course; even the great Kurt Vonnegut admitted, "When I write, I feel like an armless, legless man with a crayon in his mouth." If you need a good kick-start, join National Novel Writing Month at NaNoWriMo .org. Each November over 400,000 people write 50,000-word novels in just 30 days, inspired by mentor pep talks and egging each other on with daily word counts. Novels drafted during past NaNoWriMos include *The Night Circus* by Erin Morgenstern, *Water for Elephants* by Sara Gruen, *Wool* by Hugh Howey, and *Fangirl* by Rainbow Rowell.

Vintage Classics 2016 paperback, art by Kate Forrester

interesting and in some way universal, so "you must risk placing real emotion at the center of your work," and even "risk being unliked."

When you've got a draft done, remember what Vladimir Nabokov said: "I have rewritten—often several times—every word I have ever published. My pencils outlast their erasers." So start editing, and make *The Elements of Style* your new best friend (preferably the version illustrated by Maira Kalman).

Penguin 2007 paperback, design by Darren Haggar

Stephen King also believes you must read in order to write; and though he claims to be a slow reader, he manages 70 to 80 books a year. His helpful, honest, and insightful *On Writing* will get you started (whether you love his novels or not). He feels you cannot wait for inspiration to strike but must get to work anyway, even if you feel like "all you're managing is to shovel shit from a sitting position."

MORE

- *The Writing Life: Writers on How They Think and Work* by Marie Arana
- *On Literature* by Umberto Eco
- *Aspects of the Novel* by E. M. Forster
- *Write Away* by Elizabeth George
- *The Situation and the Story* by Vivian Gornick
- *The Forest for the Trees* by Betsy Lerner
- *Story* by Robert McKee
- *Why I Write* by George Orwell
- *The Writer's Journey* by Christopher Vogler
- *A Writer's Diary* by Virginia Woolf

Anne Lamott's *Bird by Bird* will teach you to reach the core of what you want to say. She feels that if something is real or true it is very likely to be

Anchor 1995 paperback, design by Marjorie Anderson

THE PHYSICAL BOOK

Ever wonder what all the parts of a book are called?

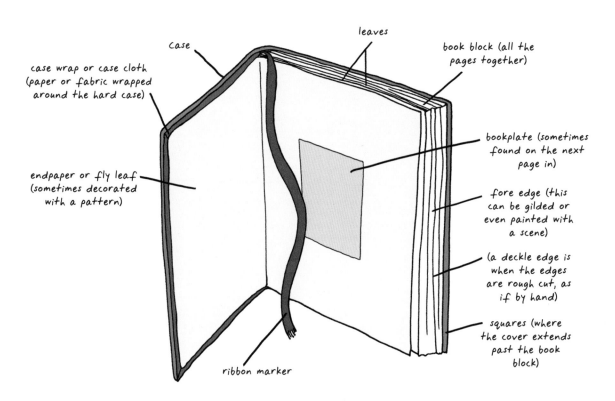

case

leaves

book block (all the pages together)

case wrap or case cloth (paper or fabric wrapped around the hard case)

bookplate (sometimes found on the next page in)

endpaper or fly leaf (sometimes decorated with a pattern)

fore edge (this can be gilded or even painted with a scene)

(a deckle edge is when the edges are rough cut, as if by hand)

squares (where the cover extends past the book block)

ribbon marker

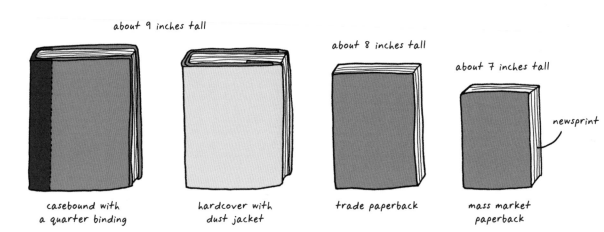

about 9 inches tall

about 8 inches tall

about 7 inches tall

newsprint

casebound with a quarter binding

hardcover with dust jacket

trade paperback

mass market paperback

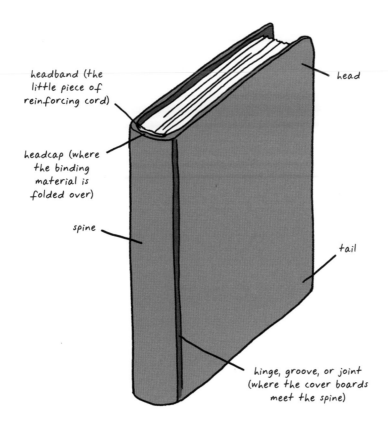

headband (the little piece of reinforcing cord)

headcap (where the binding material is folded over)

spine

head

tail

hinge, groove, or joint (where the cover boards meet the spine)

gutter

title

author

colophon or imprint

(if there is an illustration here, it's called a frontispiece)

A Book

A Writer

A Publisher

CREATIVITY & THE PURSUIT OF HAPPINESS

"Love what you do and do what you love." Variations of this mantra, popular among creatives, have been attributed to all kinds of smart people. Our world highly values creative thinking and the Next Big Idea. And making new things really does make many of us happy. But even creative work is never that easy. Lots of it isn't at all lucrative (see the long list of now-revered artists who died totally broke), or takes years to get to the financial tipping point (and might be something very different once it gets there). All along the way there will be periods of haze, self-doubt, and panic. Just. Keep. Going.

When Betty Edwards published *Drawing on the Right Side of the Brain* in 1979, her method was revolutionary. It consists of drawing what you actually *see*, not what you *think* you see. The effective and evergreen book, full of exercises to teach your brain to make that switch, is now in its fourth edition.

TarcherPerigee 2012 paperback, design by Joe Molloy

magazine. After the huge success of her memoir, she jokes that people treated her like she was doomed, asking her, "Aren't you afraid you're never going to be able to top that?" Her answer, in her book *Big Magic*, is that fear happens, of course, and tries to stifle creativity, but you must "choose curiosity over fear."

Prolific poet/performance artist/singer-songwriter/Twitter-master Amanda Palmer began her career as a solid white, eight-foot-tall, living statue bride in Harvard Square, giving out flowers to passersby.

In *The Shape of Content,* a collection of lectures he gave at Harvard in the 1950s, artist Ben Shahn wrote, "Intuition in art is actually the result of . . . prolonged tuition." In other words, get to work learning, and just keep going.

Vintage Books 1960 paperback

Chris Guillebeau (who visited 193 countries before his 35th birthday) reminds us that life-changing creative "quests" come in many forms: travel, adventure, activism, philanthropy, or artistic activities.

Harmony 2014 hardcover, design by Michael Nagin

If anyone knows the quirks of creative life, it's Elizabeth Gilbert. Before writing the best-selling *Eat, Pray, Love*, she was a lesser-known but accomplished journalist and short-story writer—the first since Norman Mailer to debut in *Esquire*

MORE

- *Art & Fear* by David Bayles
- *Sketch!* by France Belleville-Van Stone
- *Pivot* by Jenny Blake
- *Designing Your Life* by Bill Burnett & Dave Evans
- *Art Before Breakfast* by Danny Gregory
- *The Act of Creation* by Arthur Koestler
- *Creative Pep Talk* by Andy J. Miller
- *Drawing Your Life* by Michael Nobbs
- *Year of Yes* by Shonda Rhimes
- *The Art of Possibility* by Rosamunde Stone Zander & Benjamin Zander

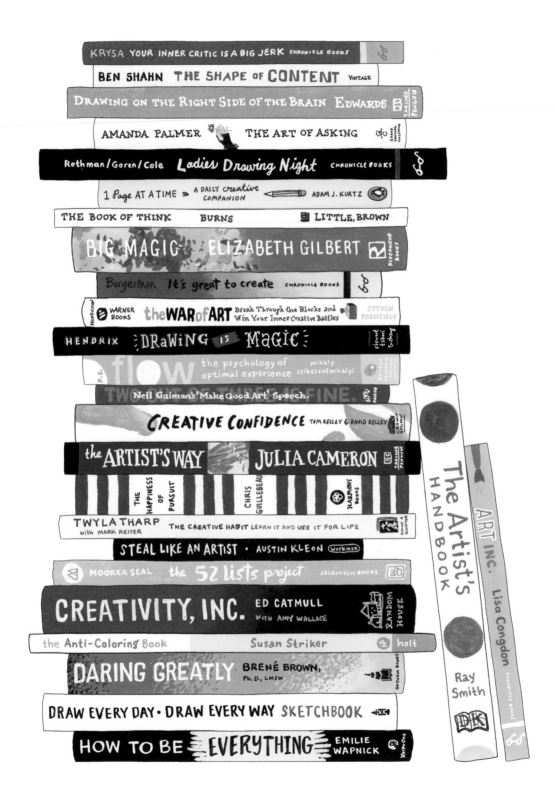

KRYSA YOUR INNER CRITIC IS A BIG JERK CHRONICLE BOOKS

BEN SHAHN THE SHAPE of CONTENT VINTAGE

DRAWING ON THE RIGHT SIDE OF THE BRAIN EDWARDS TARCHER PENGUIN

AMANDA PALMER THE ART OF ASKING

Rothman/Goren/Cole Ladies Drawing Night CHRONICLE BOOKS

1 Page AT A TIME A DAILY creative COMPANION ADAM J. KURTZ

THE BOOK OF THINK BURNS LITTLE, BROWN

BIG MAGIC ELIZABETH GILBERT RIVERHEAD BOOKS

Burgerman It's great to create CHRONICLE BOOKS

WARNER BOOKS the WAR of ART Break Through the Blocks and Win Your Inner Creative Battles STEVEN PRESSFIELD

HENDRIX DRAWING IS MAGIC

flow the psychology of optimal experience mihaly csikszentmihalyi

Neil Gaiman's 'Make Good Art' Speech.

CREATIVE CONFIDENCE Tom Kelley & David Kelley

the ARTIST'S WAY JULIA CAMERON TARCHER PENGUIN

THE HAPPINESS OF PURSUIT CHRIS GUILLEBEAU HARMONY BOOKS

TWYLA THARP with MARK REITER THE CREATIVE HABIT LEARN IT AND USE IT FOR LIFE

STEAL LIKE AN ARTIST · AUSTIN KLEON Workman

MOOREA SEAL the 52 lists project SASQUATCH BOOKS

CREATIVITY, INC. ED CATMULL With AMY WALLACE RANDOM HOUSE

the Anti-Coloring Book Susan Striker holt

DARING GREATLY BRENÉ BROWN, Ph.D., LMSW GOTHAM BOOKS

DRAW EVERY DAY · DRAW EVERY WAY SKETCHBOOK

HOW TO BE EVERYTHING EMILIE WAPNICK KNOPF ONE

The Artist's Handbook Ray Smith DK

ART INC. Lisa Congdon CHRONICLE BOOKS

WRITING ROOMS

GEORGE BERNARD SHAW

George Bernard Shaw's 8' x 8' writing shed sits at the edge of the garden at Shaw's Corner. These 3.5 acres also hold Shaw's 1902 Edwardian Arts and Crafts–influenced home and are located in the small village of Ayot St. Lawrence, in Hertfordshire, England. From here, the Irish-born playwright wrote *Pygmalion* (1912) and *Saint Joan* (1923), for which he won the Nobel Prize in Literature.

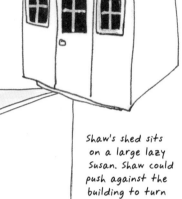

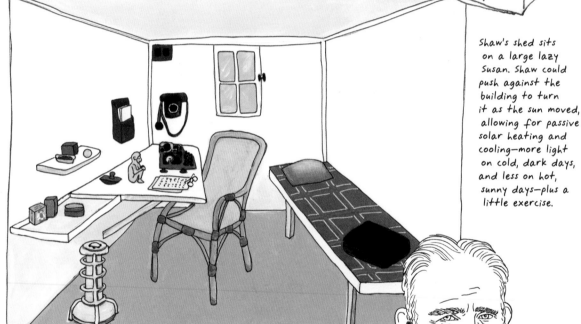

Shaw's shed sits on a large lazy Susan. Shaw could push against the building to turn it as the sun moved, allowing for passive solar heating and cooling—more light on cold, dark days, and less on hot, sunny days—plus a little exercise.

Shaw nicknamed his writing space "London" so his wife could tell friends and visitors he was away at the capital and he could be left alone. (The Shaws did in fact keep a second home in Fitzroy Square.)

THE BRONTËS

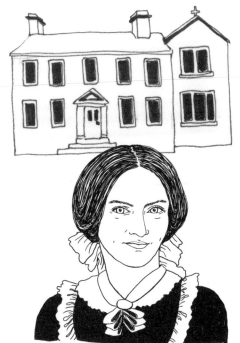

Charlotte, Emily, and Anne Brontë moved into the Haworth Parsonage in West Yorkshire when their father Patrick, a priest and poet, was appointed there in 1820.

When Patrick Brontë died (he outlived all of his children) in 1861, the contents of the family home were auctioned off. Decades later, in 1893, at a librarian's insistence that the artifacts be collected and preserved, the Brontë Society was founded and began gathering Brontë treasures.

Even though the Brontë sisters grew up seeing their name on book spines at home (Patrick was a published poet), they published their first work together, a collection of poems, under the (male) pseudonyms of Currer (Charlotte), Ellis (Emily), and Acton (Anne) Bell. Three copies of the book were sold.

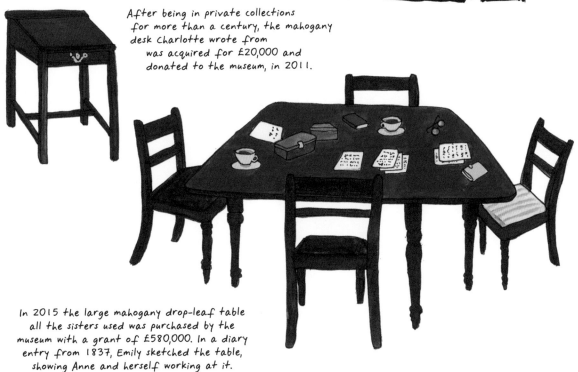

After being in private collections for more than a century, the mahogany desk Charlotte wrote from was acquired for £20,000 and donated to the museum, in 2011.

In 2015 the large mahogany drop-leaf table all the sisters used was purchased by the museum with a grant of £580,000. In a diary entry from 1837, Emily sketched the table, showing Anne and herself working at it.

BOOKISH PEOPLE RECOMMEND

Penguin Classics
2012 paperback,
design by Coralie
Bickford-Smith

MARGARET WILLISON & SOPHIE BROOKOVER

Librarians and editors of the
Two Bossy Dames newsletter

Wives and Daughters
by Elizabeth Gaskell

"Given the reverence in which
our institutions of higher
learning hold British novelists
from the 19th century, Elizabeth
Gaskell remains almost criminally under-read
and under-celebrated. With the warmth, wit, and
keen eye for social dynamics of Jane Austen; the
provincial scope and moral complexity of George
Eliot; and the satisfying serial plotting of Charles
Dickens (whose weekly journal *Household Words*
serialized many of her best-known novels); she
is a delight to read, and deserves to be as well-
known as any of those three. While each of her
novels has much to recommend it, none is better
than her final novel, *Wives and Daughters*, a love
story on par with Austen's best and a medita-
tion on just how much can go wrong even when
everyone is fundamentally decent and trying hard
to do their best."

Bellweather Rhapsody
by Kate Racculia

"In our career as culture
witches, few recommendations
have been met with more
universal delight than ours of Kate
Racculia's *Bellweather Rhapsody*,
a mystery/suspense/coming-of-
age story that falls at the perfect
midway point between Ellen

Houghton Mifflin
Harcourt 2014
hardcover, design &
art by Laserghost

Raskin's *The Westing Game* and Stephen King's
The Shining. It's the rare piece of art that manages
to be both brilliantly referential—Agatha Christie!
Weezer! David Bowie! Fame!—and entirely its
own delightful and unique self. Fifteen years from
now, we will be able to begin books and say, 'Oh,
this person loved *Bellweather Rhapsody*, too,' the
same way we can tell Racculia loved Raskin—its
flavor is that distinct and that enticing."

LACY SIMONS

Owner and operator of
hello hello books in
Rockland, Maine, USA

Black Swan Green
by David Mitchell

"Before reading *Black Swan
Green*, I hadn't claimed a favor-
ite book since I was a teenager;
there were too many. After
reading it, I knew I'd found the

Hodder & Stoughton
2006 paperback, design
by Kai and Sunny

one. It's an October-y book, and for five years I
actually reread it every October (after I opened up
a bookstore, that turned into every two or three).
The book is magic in three major ways: It cap-
tures the inventiveness, unselfconsciousness, and
eloquence of the human interior world; it builds
story in a realistic, empathetic, and incredibly
familiar way; and the awkward, fraught, beauti-
ful, heartbreaking, necessary divide between the
interior and exterior world of the main character
creates some of the most genius writing I've ever
been lucky enough to read. Seriously. Why are
you even reading the rest of this blurb? Just go get
the book. Get it."

ALLISON K. HILL

President/CEO of Vroman's
Bookstore in Pasadena
and Book Soup in West
Hollywood, California, USA

The Paper Bag Princess
by Robert Munsch

"This charming children's book is one of my favorites. Author Robert Munsch's stories are exuberant, and his writing begs to be read out loud. Michael Martchenko's drawings perfectly illustrate this quirky adventure story. But it's the book's feminist message that inspires me to recommend it to children, parents, and women looking for an empowerment boost. When a dragon destroys her castle, burns her clothes, and kidnaps her prince, Princess Elizabeth dons a paper bag and sets out to find them. She outsmarts the dragon and rescues Prince Ronald only to discover that Ronald is a jerk—in response to her daring rescue he criticizes her for smelling like ash and wearing a dirty paper bag. Still, the book has a happy ending: Princess Elizabeth lives happily after, just not with Prince Ronald. She stands up to the prince, then proceeds to dance off into the sunset, solo."

BETSY BIRD

Librarian at Evanston
Public Library and editor
of *Funny Girl: Funniest.
Stories. Ever.*

A Face Like Glass
by Frances Hardinge

"I find that the books I love most are often the ones that are capable of turning my brain completely inside out so that black is white, night is day, and in is out. Only Hardinge could conjure up an underground world where only the rich can afford multiple facial expressions, cheese is deadly,

revolution is in the air, and the most dangerous girl in the world is the one who shows how she feels at all times. I don't use the word 'delicious' enough to describe books, but that's what this novel is. A succulent, sumptuous, somewhat perverse feast."

The Year of the Dog
by Grace Lin

"I am a cursed woman. I know this because more than once I have found myself in the most torturous situation a devious mind could conceive. I'll be on a plane, sitting on the tarmac, far from any kind of delicious edibles, and inevitably I will start to read a Grace Lin book. The descriptions of Taiwanese food are overwhelming, particularly when Lin couches them in such beautiful, simple storytelling. Bridging that difficult area between early chapter books and middle-grade fiction, her simple stories of growing up in New England, making friends, and figuring out where she excels tap into a kind of writing people often yearn for. Looking for something along the lines of Maud Hart Lovelace or Sydney Taylor? Look no further. I got yer 21st-century-classic series right here."

SPORTS

Sports have been an essential part of the human experience since at least 2000 BCE. Sports can make both participants and spectators think about everything from ethics and integrity, to politics, technology, and beauty. In his essay on the glory of Roger Federer's tennis game, David Foster Wallace writes that sports remind us of the beauty of having and using a human body, and help reconcile us to the rest (pain, illness, and ultimately, death).

After surviving childhood sexual abuse, many box jellyfish stings, and four failed attempts over 34 years, Diana Nyad swam 110 miles through shark-infested waters from Cuba to Florida, becoming the first human to do so, at the age of 64.

Nyad is a lifelong fan of lay astrophysics: the writings of Carl Sagan, Stephen Hawking, et al. She is enthralled with the poetry of Mary Oliver, citing "The Summer Day" as a favorite.

When Jim Bouton's *Ball Four* came out in 1970—revealing details that may now seem quaint about athletes' drug use, sexual language, and among other things, a kissing game—Bowie Kuhn called it "detrimental to baseball." Pete Rose started yelling, "Fuck you, Shakespeare!" whenever Bouton pitched. Dick Young called Bouton a social leper, and many players said they would never speak to him again. Mickey Mantle later forgave Bouton, in a voicemail message that Bouton is saving for his grandkids.

When chewing tobacco was making baseball players ill, Bouton and his Portland Mavericks teammate Rob Nelson wished for something that looked like chew but tasted good—like gum. Bouton pitched the idea to Wrigley, which has since sold over 750 million packages of Big League Chew.

Steph Davis was the first woman to free-climb the Salathé Wall on El Capitan, to free-solo the

Diamond on Longs Peak, and to summit Patagonia's Torre Egger. She lived on climbing sponsorships until her then husband, Dean Potter, controversially climbed Utah's Delicate Arch. The decision cost both Potter and Davis their sponsorships and eventually their marriage. Davis took up skydiving and BASE jumping. Potter eventually did, too, and died in a wingsuit flying accident, as did Davis's second husband, Mario Richard.

Golfer Harvey Penick's *Little Red Book*, published when he was 87, has sold over 1.3 million copies. When Penick was ill and bedridden at 90, his longtime student Ben Crenshaw came by to say hello. Penick gave him a lesson right there from his bed, watching Crenshaw putt across the carpet. A week later, Crenshaw was a pallbearer at Penick's funeral. A week after that, Crenshaw won the 1995 Masters.

Simon & Schuster 2012 hardcover, design by Janet Perr

MORE

- *Open* by Andre Agassi
- *Eight Men Out* by Eliot Asinof
- *Courage to Soar* by Simone Biles
- *Among the Thugs* by Bill Buford
- *The Game* by Ken Dryden
- *Eat and Run* by Scott Jurek
- *Shoeless Joe* by W. P. Kinsella
- *Levels of the Game* by John McPhee
- *Loose Balls* by Terry Pluto
- *The Golf Omnibus* by P. G. Wodehouse

We are often deadly.

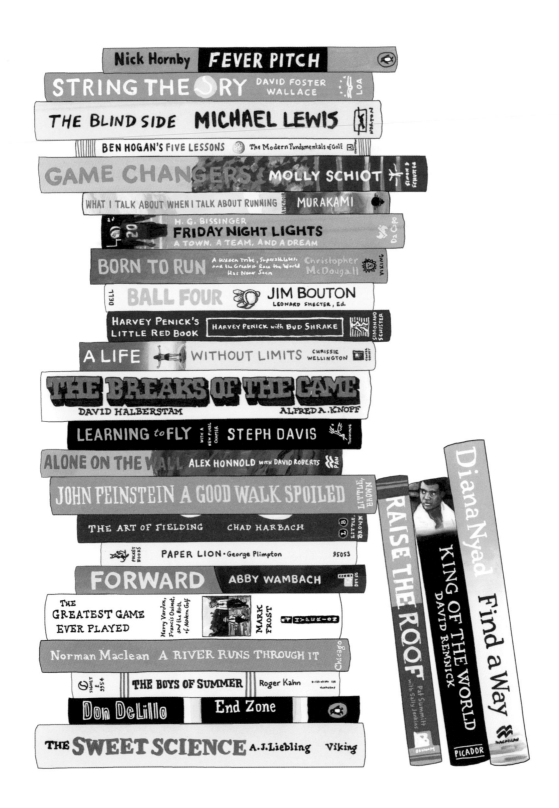

STRIKING LIBRARIES

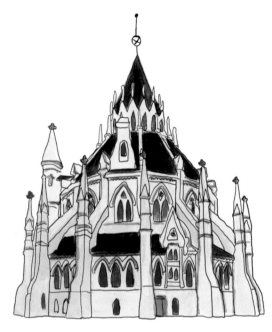

LIBRARY OF PARLIAMENT

Ottawa, Ontario, Canada

Designed by Thomas Fuller and Chilion Jones

Opened in 1876

This library is the research hub for Canada's Parliament and houses over 600,000 historical texts and other items.

A picture of it appears on the back of the Canadian 10-dollar bill.

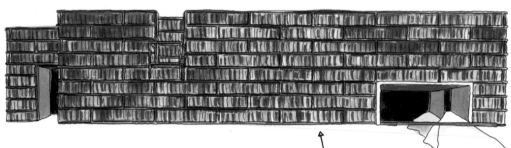

LIYUAN LIBRARY

Liyuan, China

Designed by Li Xiaodong

Opened in 2011

This is a small library in a small village just outside Beijing. The glass exterior is covered with a steel framework, filled in with sticks.

Yes, those are sticks, from trees! The architect was inspired by piles of similar sticks locals keep outside their houses for firewood.

ATLANTA FULTON
PUBLIC LIBRARY

Atlanta, Georgia, USA

Designed by Marcel Breuer

Opened in 1980

This library was modernist architect Marcel Breuer's last work and is similar to his Whitney Museum building (now the Met Breuer) in New York.

This is the main branch of the public library system in Atlanta, where I grew up. I spent many hours here researching for high school term papers.

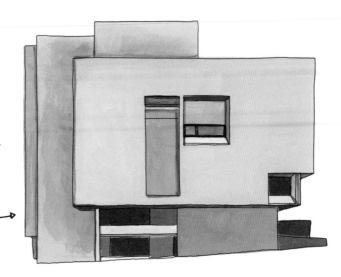

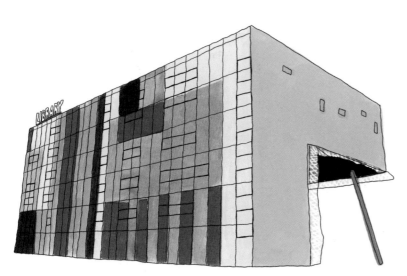

PECKHAM LIBRARY

London, UK

Designed by Alsop & Störmer

Opened in 2000

Brightly colored glass covers the back of the building, letting in tinted light, and copper panels cover the rest.

INNOVATION & BUSINESS

As the old adage goes, "Give a man a fish and you feed him for a day; teach him how to fish, you feed him for a lifetime." But these books go well beyond teaching others how to fish. They cover everything from innovation to conservation, from productivity to meditation, from teamwork, mentorship, and coaching to self-care. Basically, if you've got a job to do, one of these will help you do it better.

In 1981, Tracy Kidder's *The Soul of a New Machine* illuminated the computer industry as it was first blossoming, foreshadowing the decades of technological innovation to come. He followed a team of passionate engineers working obsessively in two groups— the Hardy Boys focused on hardware and the Microkids focused on code—to build a magic machine, all under a driven and charismatic leader, Tom West.

Back Bay Books 2000 paperback, design by John Fulbrook III

The machine being built in the book, a Data General Eclipse MV8000 32-bit CPU, circa 1984 →

I've got soul, baby.

In his riveting memoir *Shoe Dog*, Phil Knight, the cofounder of Nike, reveals that when founding his company he told himself it didn't matter how crazy anyone thought his idea was or where he might end up, he had to "just keep going."

Scribner 2016 hardcover, design by Jaya Miceli and Jonathan Bush

This is one of the first Nike shoes worn in competition, by Mark Covert at the 1972 Olympic Trials. Knight's partner (and former high school track coach) Bill Bowerman made the first version of the rubber sole with the family waffle iron. Bowerman, referring to his ancestors forging the Oregon Trail, often said, "The cowards never started, and the weak died along the way—that leaves us."

St. Martin's Press 2017 hardcover, design by James Iacobelli

Kim Scott's experiences working at Google (where Sheryl Sandberg was her boss) and coaching managers at Twitter, Shyp, and other tech startups led her to write *Radical Candor*. She believes that if you really care about your employees' growth, you must be willing to praise them on successes and challenge them on mistakes, in a helpful, humble, and impersonal way.

MORE

- *Predictably Irrational* by Dan Ariely
- *Making Ideas Happen* by Scott Belsky
- *Contagious* by Jonah Berger
- *Losing My Virginity* by Richard Branson
- *The 7 Habits of Highly Effective People* by Stephen Covey
- *Emotional Agility* by Susan David
- *Tribes* by Seth Godin
- *The Ten Faces of Innovation* by Tom Kelley
- *Orbiting the Giant Hairball* by Gordon MacKenzie
- *To Engineer Is Human* by Harry Petroski

ALL-TIME BEST SELLERS

These are the top 10 best-selling books of all time (so far), in order of number of copies sold, based on reliable, independent sources. Religious books (like the Bible and the Qur'an) and ideological ones (like Chairman Mao's *Little Red Book*) are excluded, because their numbers are high but very difficult to pin down.

Nº 1

Don Quixote
by Miguel de Cervantes

Over 500 million copies sold

First published in Spanish (as *El ingenioso hidalgo don Quijote de la Mancha*) in 1612

Modern Library 1950 hardcover, translated by Peter Motteux and revised by John Ozell, design by E. McKnight Kauffer

Nº 2

A Tale of Two Cities
by Charles Dickens

Over 200 million copies sold

First published in English in 1859

Washington Square Press 1963 paperback, art by Leo & Diane Dillon

Nº 3

The Alchemist
by Paulo Coelho

Over 150 million copies sold

First published in Portuguese (as *O Alquimista*) in 1988

HarperSanFrancisco 1993 paperback, translated by Alan R. Clarke, design by Michele Wetherbee, art by Stefano Vitale

Saint-Exupéry drew this cover art himself!

Nº 4

The Little Prince
by Antoine de Saint-Exupéry

Over 140 million copies sold

First published in French (as *Le Petit Prince*) in 1943

Reynal & Hitchcock 1943 hardcover

All together, the seven books in the series have sold over 450 million copies, in 74 languages!

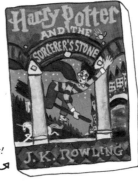

Nº 5

Harry Potter and the Sorcerer's Stone
by J. K. Rowling

Over 107 million copies sold

First published in English in the UK (as *Harry Potter and the Philosopher's Stone*) in 1997

Scholastic 1998 hardcover, art by Mary GrandPré

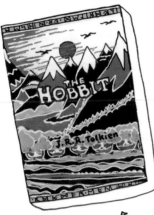

N°. 6

The Hobbit
by J. R. R. Tolkien

Over 100 million
copies sold

First published in
English in 1937

George Allen & Unwin
1937 hardcover

Tolkien drew this
cover art himself!

N°. 7

*And Then There Were
None*

by Agatha Christie

Over 100 million
copies sold

First published in
English in 1939

Dodd, Mead
1940 hardcover

N°. 8

The Dream of the Red Chamber
by Tsao Hsueh-Chin

Over 100 million copies sold

First published in Mandarin
Chinese in 1791

Doubleday Anchor 1958 paper-
back, translated by Chi-Chen
Wang, art by Seong Moy

This beautiful version
was illustrated by
Anna Rifle Bond, of
Rifle Paper Co. fame.

N°. 9

*Alice's Adventures
in Wonderland*
by Lewis Carroll

Over 100 million
copies sold

First published in
English in 1865

Puffin 2015
hardcover

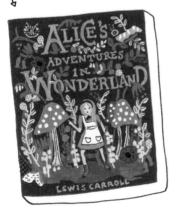

N°. 10

*The Lion, the Witch,
and the Wardrobe*

by C. S. Lewis

Over 85 million
copies sold

First published in
English in 1950

Geoffrey Bles
1950 hardcover

This is the first edition,
illustrated by Pauline Baynes,
who also illustrated some
of J. R. R. Tolkien's books.

DESIGN

Design is the melding of beauty and function to solve a problem. When it's done well, you might not notice it, but you can always sense it (and you'll probably notice when it's not, as on a poorly laid-out remote control). Design influences virtually every aspect of our lives, or as designer Erik Adigard puts it, "Design is in everything we make, but it is also between those things. It's a mix of craft, science, storytelling, propaganda, and philosophy."

Professor Edward Tufte sees data visualization as a matter of life and death. In an essay, Tufte shows how critical information got lost and distorted when NASA engineers forced it into bulleted lists in a PowerPoint slide, ultimately leading to the *Columbia* disaster in which seven died.

Things I Have Learned in My Life So Far started as a running list about the pursuit of happiness in Stefan Sagmeister's diary during a sabbatical year.

Harry N. Abrams 2008 paperback, design by Stefan Sagmeister and Matthias Ernstberger

In her book *In Progress,* designer and famed letterer Jessica Hische details her creative process, complete with hundreds of images. Though her work ends up in a digital format, she always starts a project with drawing sketches by hand in a notebook. She believes "procrastiwork"—the work you do when you should be doing something else—is the key to finding your creative calling.

Ilse Crawford was the first editor of *Elle Decoration*. She grew disillusioned seeing so many spaces that didn't center around the humans using them, and left to start her own design firm, Studio Ilse. It focuses first on watching and asking questions, and then creates spaces that truly enhance life.

IKEA Sinnerlig pitcher by Studio Ilse, 2015

MORE

- *Picture This* by Molly Bang
- *The Elements of Typographic Style* by Robert Bringhurst
- *Classic Penguin: Cover to Cover* by Paul Buckley
- *The Art of Looking Sideways* by Alan Fletcher
- *Tibor Kalman, Perverse Optimist* by Peter Hall & Michael Bierut
- *The Field Guide to Human-Centered Design* by IDEO.org
- *Towards a New Architecture* by Le Corbusier
- *Sunday Sketching* by Christoph Niemann
- *A Humument* by Tom Philips
- *Make It Bigger* by Paula Scher

Picasso called designer Bruno Munari "the new Leonardo." In his 1971 book *Design as Art*, Munari professed his belief that art is a necessary part of life and should be accessible to everyone, and that good design of everyday things embodies that philosophy.

Penguin Modern Classics 2008 paperback, design by YES

DESIGNERS' PICKS

Cover designers must translate text into an image that both encapsulates and attracts. Here 10 designers each pick a cover they created and explain the process.

KELLY BLAIR

Against Everything
by Mark Greif

"Essays are always an interesting puzzle, because the design needs to be broad, but also express a point of view. When I first started working on this cover I got it all wrong. I was working with big red X's. I was interpreting "against" too literally. The author isn't expressing contrary views necessarily; rather, he is examining things closely. The final design, with a graphic sense of turning something inside out and pushing up to the edges, worked much better."

*Pantheon 2016
hardcover*

JAMES PAUL JONES

The Good Immigrant,
edited by Nikesh Shukla

"On publication, this was a timely book over in the UK, and the cover received a lot of coverage. Initially the 'design fear' hit me when I found out they wanted to incorporate all 21 contributors' names on the front. I decided to turn this problem into one of the cover's main features, and I quickly hit on the idea of going purely typographic, as if it was a gig poster traveling around the UK. There are 21 stars for each of the contributors, and the framing device was an added touch to really draw the viewer in."

*Unbound
2016 hardcover*

HENRY SENE YEE

Picador Modern Classics
Series 02

"Series 01 of the Picador Modern Classics collected four timeless works of fiction. Part of the challenge in packaging Series 02, four classic works of nonfiction, was to distinguish them, yet connect the two series. Since Series 01 was packaged like candy with colorful, patterned backgrounds, I decided that for Series 02 I would use black-and-white, and focus on illustrating author portraits rather than patterns. One of my type solutions was a box that happened to go across the author's mouth. She was a woman, and it looked like we were symbolically silencing her. It was then that I realized all the authors were women. The Women's March had just happened, and it inspired me to focus on finding a female illustrator. Cecilia Carlstedt's work has fullness in black-and-white with an energetic use of accent colors."

*Picador 2017
paperbacks,
art by Cecilia
Carlstedt*

*Pantheon 2014
hardcover*

LINDA HUANG

The Book of Heaven
by Patricia Storace

"This was one of the first jackets I designed that I actually liked, and it holds a special place in me. At the time, I only had a brief excerpt of the book, which actually helped focus the process. The paragraph that inspired the design was about there being multiple heavens and how there is always more of it than we see, tales that evolve endlessly into other tales."

KIMBERLY GLYDER

Fen
by Daisy Johnson

"*Fen* is a collection of short stories that moves between magical realism

*Graywolf Press
2017 paperback*

and raw reality. In my entire book design career, spanning over 15 years, I have never worked on a cover with a title comprising only three letters. Usually I'm battling long titles with words that are tough to fit legibly into typical trim sizes. Johnson's writing has a primal quality which instinctually made me want to pick up a wide brush to ink out the type. Ultimately, the letterforms are the driving imagery for the cover."

Ecco 2016
hardcover

ALLISON SALTZMAN

The Nest
by Cynthia D'Aprix Sweeney

"Ecco's publishing team wanted this book to be a huge success, which always promises a fraught cover design process. I explored countless directions: illustration, typography, photography; New York City setting, sibling rivalry, aspirational lifestyles, plays on the title; all were rejected. In what felt like my 27th round of research I came across a pair of velvet slippers, embroidered with a family crest . . . and the idea immediately felt right for the book. But even the crest designs went through many iterations, with Sara Wood joining in to help. In the end, I feel pretty vindicated by how successful the book has become, sales-wise."

JOAN WONG

All the Birds, Singing
by Evie Wyld

Pantheon 2014
hardcover, art
from Art Resource

"*All the Birds, Singing* is about Jake Whyte and her life off the coast of Britain, attending to a farm and trying to escape the darker past she left behind. I knew that these vintage animal illustrations set the right tone for the story. The process of this cover was all about showcasing the art to strike the balance between the vulnerability of the sheep and the ominous threat of the wolf. It creates the tension that is represented throughout the story of Jake trying to live

a tranquil lifestyle while her past is on the verge of spilling into her present."

Riverhead Books
2016 hardcover

RACHEL WILLEY

Boy Erased
by Garrard Conley

"I made quite a few failed attempts at this cover trying to graphically represent an extremely personal experience that the author is writing about. Finally, I sat down and asked myself what I *felt* the cover should look like instead of what I *thought* it should look like. I think that in the end the cover touches on some of the very heavy topics in the book, while still feeling hopeful. I made a collage in an attempt to give the cover a more personal look."

JENNIFER CARROW

I See You Made an Effort
by Annabelle Gurwitch

Blue Rider Press
2014 hardcover

"This collection of hilarious essays deserved an equally humorous jacket. The design process involved many embarrassing Google searches, shopping for granny panties, and photographing them on a black background for something unexpected."

JAYA MICELI

Zero K
by Don DeLillo

Scribner
2016 hardcover

"It was a great privilege to design a jacket for such an iconic American writer. It's a powerful book about the subject of cryogenics, love, and death, and I felt using an image of a female statue's face and her subtle gaze through the typography brought humanity to the cover."

BELOVED BOOKSTORES

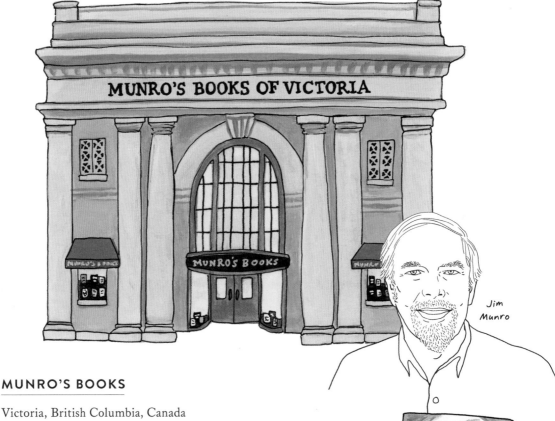

Jim Munro

MUNRO'S BOOKS

Victoria, British Columbia, Canada

Established in 1963, Munro's Books is a landmark in Victoria's Old Town. The neoclassical building was originally designed for the Royal Bank of Canada and harbors a 24-foot ceiling resembling the ceiling of the porch of the second-century CE Roman library of Ephesus. It was lovingly restored by Jim Munro and his then-wife, Alice. While the store has flourished, one of its great contributions may be inspiring Ms. Munro, who after reading through its stock figured she could write something better. She won the Nobel Prize for Literature in 2013.

Jim ran the store until 2014, when he retired and gave ownership over to four longtime employees. He said, "I've had a really good time. . . . Somehow I just feel this is the time to go." He passed away two years later and is fondly remembered by readers across Canada and the globe.

Vintage International 2013 paperback, design by Megan Wilson, art by Leanne Shapton based on a photo by Derek Shapton

NAPA BOOKMINE

Napa, California, USA

As the daughter of a used-book seller, Naomi Chamblin knows books and the business. She decided to open her own used book-store, named after her dad's store, Chamblin Bookmine, when she realized her new home-town of Napa didn't have one. Since opening in 2013, the store has expanded to also serve vora-cious readers at Napa's Oxbow Public Market.

Chamblin recommends:

Our Endless Numbered Days
by Claire Fuller

"This is a debut about a survivalist father obsessed with preparations for the end of the world who steals his young daughter from their family and travels deep into the woods of Europe. They find a small cabin, which sustains them for years after he announces that the rest of the world is no longer. This story kept me up until 3 a.m. with its disturb-ing twists, and it has never left the top of my recommended list."

Tin House Books 2015 paperback, design by Jakob Vala, art by Julianna Swaney

PICTURE BOOKS FOR GROWN-UPS

As Lewis Carroll's Alice thought in Wonderland, "What is the use of a book . . . without pictures or conversations?" Dickens's novels had pictures, and the best medieval manuscripts were illuminated. But sometime around the beginning of the 20th century, we collectively decided pictures were mainly for kids. Thankfully, illustrated books for adults are making a comeback. But also, FYI, it's always acceptable to buy and read kids' picture books, even if you don't have kids.

Maira Kalman's first picture book, *Stay Up Late*, was based on a song written by David Byrne for the Talking Heads album *Little Creatures*. It's officially for kids but feels like an adult book in disguise. Kalman has since written and illustrated over 30 more books,

Viking Juvenile 1987 hardcover

many about her favorite things, including shoes, cakes, and dogs.

Kalman says she approaches writing for children and adults in the same way, trying to use "the same kind of imagination, the same kind of whimsy, the same kind of love of language."

Edward Gorey, prodigy (by age five he had read *Dracula* and *Alice's Adventures in Wonderland,* both very influential to his work), poet, and illustrator of perfectly creepy, cross-hatched characters in over 100 books, was a lifelong animal lover (especially cats!). He left his estate to a charitable trust for the welfare of all living creatures.

Julia Rothman has created nine books and a whole bunch of other stuff, including wallpaper and temporary tattoos. *Hello NY* is a personal, enhanced guidebook, a love letter to her hometown.

Nick Bantock's *Griffin and Sabine* was a phenomenon, an illustrated epistolary romance that required the reader to pull letters out of envelopes. Collectively, the three-book series spent over 100 weeks on the *New York Times* Best Seller list and sold over three million copies.

Chronicle Books 1991 hardcover

← *Chronicle Books 2015 paperback*

Jason Polan is drawing every person in New York; this is volume one.

MORE

- *Adulthood Is a Myth* by Sarah Andersen
- *Sad Animal Facts* by Brooke Barker
- *Hark, a Vagrant* by Kate Beaton
- *Jane, the Fox, and Me* by Fanny Britt
- *The Joy of Swimming* by Lisa Congdon
- *Well-Read Women* by Samantha Hahn
- *Artists, Writers, Thinkers, Dreamers* by James Gulliver Hancock
- *All My Friends Are Dead* by Avery Monsen & Jory John
- *Raven Girl* by Audrey Niffenegger
- *The Little Prince* by Antoine de Saint-Exupéry

ACKNOWLEDGMENTS

Making this book has been one of the hardest things I've ever done. I often jump into projects and then figure out how exactly to do them, because, well, I like a challenge. The whole idea seemed huge and scary, and I knew I would feel ridiculously great after I finished it. If you're not challenging yourself, and not pushing to make the very best possible thing, then what's the point, really?

As I figured out exactly how to make this book (and in the process made mistakes, and therefore figured more stuff out, and then made some more mistakes), I scored the help of some truly brilliant people. Without the guidance of my awesome agent, Kate Woodrow, this book would never have even made it to the scary idea stage. My deepest, most intense thanks goes to the unflappable Sara Distin, who helped me research and write almost everything in it, and to Sharon Mount for even more excellent research. And to my Chronicle Books editors Mirabelle Korn and Christina Amini, designer Kristen Hewitt, and production manager Erin Thacker, who shared my vision, coached me through the process, and pulled it all together to be way better than I imagined. (I mean, way better! You all are amazing!)

Also, much gratitude to Kelly Talcott for his sound advice, and to Li Frei and Night Owls for helping hold down the Ideal Bookshelf fort. To everyone who so generously gave me input and recommendations to include in this book, and especially to Mary Laura Philpott and Kimberly Glyder. To all the writers, editors, and designers of books, to bookstores around the globe, and to all you beautiful bibliophiles, for making the world a better place. And finally, much love to Madison Mount, Charmaine Ehrhart, Sharon Mount, and Shannon McGarity, for always being there; to my cats Emmer and Kasha for letting me squeeze them during times of writing stress; and most especially of all, to Darko Karas for being my one, and always reminding me to Just. Keep. Going.

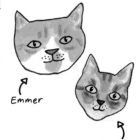

Emmer

Kasha

BIBLIOGRAPHY & CREDITS
(IN ORDER OF APPEARANCE)

L'Engle, Madeleine. "The Expanding Universe." 1963 Newbery Medal Acceptance Speech. https://www.madeleinelengle.com.

Comenius, Johann Amos, and Charles Hoole. *Orbis sensualium pictus*: London: John Sprint, 1705. Internet Archive, 2009. https://archive.org/details/johamoscommeniio00come.

Sendak, Maurice. *Caldecott & Co.: Notes on Books and Pictures*. New York: Noonday, 1990.

Brightly editors. "Meet the Illustrator: Christian Robinson." Brightly. Accessed December 1, 2017. http://www.readbrightly.com/meet-illustrator-christian-robinson.

Corrigan, Maureen. "How E.B. White Spun 'Charlotte's Web'." NPR: *Fresh Air*, July 5, 2011.

Juster, Norton. "My Accidental Masterpiece: The Phantom Tollbooth." NPR: *All Things Considered*, October 25, 2011.

Correal, Annie. "There Will Be a Quiz." *New York Times*, July 17, 2016.

"Test Your Book Smarts." *New York Times*, July 15, 2016. https://www.nytimes.com/interactive/2016/07/14/nyregion/strand-quiz.html.

Flood, Alison. "Study finds huge gender imbalance in children's literature." *Guardian*, May 6, 2011. https://www.theguardian.com/books/2011/may/06/gender-imbalance-children-s-literature.

Nyman, Karin. "The story behind Pippi Longstocking." Rabén & Sjögren. YouTube, 2015. https://www.youtube.com/watch?v=LVbnGk-iYTU.

"James Joyce." *Wikipedia: The Free Encyclopedia*. Wikimedia Foundation, Inc. Last modified December 12, 2017. https://en.wikipedia.org/wiki/James_Joyce.

Yoon, Nicola. Interview with Arun Rath. "The Glimmering Sheen of a Wide World Seen from Inside a Bubble: Interview with Nicola Yoon." NPR: *All Things Considered*, August 30, 2015.

Vlogbrothers. "Vlogbrothers: About." YouTube. Accessed December 10, 2017. https://www.youtube.com/user/vlogbrothers/about.

Mesure, Susie. "New YA sensation Angie Thomas: 'Publishing did something pretty terrible. They made the assumption that black kids don't read'." *Telegraph*, April 11, 2017. http://www.telegraph.co.uk/books/authors/meet-angie-thomas-author-new-ya-sensation-inspired-black-lives.

DeVito, Lee. "John King of John K. King Used & Rare Books." *Detroit Metro Times*, February 5, 2014. https://www.metrotimes.com/detroit/john-king-of-john-k-king-used-and-rare-books/Content?oid=2143899.

Roper, Caitlin. "Geek Love at 25: How a Freak Family Inspired Your Pop Culture Heroes." *Wired*, March 7, 2014. https://www.wired.com/2014/03/geek-love.

Vitello, Paul. "Robert M. Pirsig, Author of 'Zen and the Art of Motorcycle Maintenance,' Dies." *New York Times*, April 25, 2017.

"Pharrell Williams." *Oprah Prime*, Season 1, Episode 108. OWN, April 13, 2014.

Dickens, Charles. *A Tale of Two Cities*. London: Penguin, 2011.

Brontë, Charlotte. *Jane Eyre*. New York: Vintage, 2009.

Kakutani, Michiko. "English Modernism: A Big Weight to Hang on 1910." *New York Times*, November 29, 1996.

Walker, Alice. "Looking for Zora," *Ms.*, 1975.

"About Daikanyama T-Site." Daikanyama T-Site website. Accessed December 10, 2017. http://real.tsite.jp/daikanyama/english.

"About Us." Unity Books website. Accessed December 10, 2017. http://unitybooks.nz/about.

Ellison, Ralph. "National Book Awards Acceptance Speeches: Ralph Ellison, Winner of the 1953 Fiction Award for Invisible Man." National Book Foundation website. http://www.nationalbook.org/nbaacceptspeech_rellison.html.

Fox, Margalit. "Gregory Rabassa, Noted Spanish Translator, Dies at 94." *New York Times*, June 16, 2016.

Stamp, Jimmy. "When F. Scott Fitzgerald Judged Gatsby by Its Cover." Smithsonian.com, May 14, 2013. https://www.smithsonianmag.com/arts-culture/when-f-scott-fitzgerald-judged-gatsby-by-its-cover-61925763.

Alter, Alexandra. "Paul Bacon, 91, Whose Book Jackets Drew Readers and Admirers, Is Dead." *New York Times*, June 11, 2015.

Wolfe, Tom. "The "Me" Decade and the Third Great Awakening." *New York*, August 23, 1976.

"Bench by the Road Project." Toni Morrison Society website. Accessed December 10, 2017. http://www.tonimorrisonsociety.org/bench.html.

Literary Hub. "Interview with a Bookstore: Powell's Books in Portland." *Guardian*, April 4, 2016. https://www.theguardian.com/books/2016/apr/04/interview-with-a-bookstore-portland-powells-books.

Smith, Zadie. "This is how it feels to me." *Guardian*, October 13, 2001.

Howard, Kait. "20th anniversary edition of *Infinite Jest* features fan-designed cover." Melville House blog, January 4, 2016. https://www.mhpbooks.com/20th-anniversary-edition-of-infinite-jest-features-fan-designed-cover.

Murakami, Haruki. "Jazz Messenger." *New York Times*, July 8, 2007. http://www.nytimes.com/2007/07/08/books/review/Murakami-t.html.

Alter, Alexandra. "The House the 'Wimpy Kid' Built." *New York Times*, May 24, 2015.

Neary, Lynn. "Classic Novel '1984' Sales Are Up in the Era of 'Alternative Facts'." NPR: *The Two-Way*, January 25, 2017.

Díaz, Junot. Interview with Adriana Lopez. "Nerdsmith." *Guernica*, July 7, 2009. https://www.guernicamag.com/nerdsmith.

Díaz, Junot. "The Mongoose and the Émigré." *New York Times Magazine*, May 17, 2017.

Morton, Megan. "Shelf life: novelist Hanya Yanagihara on living with 12,000 books." *Guardian*, August 12, 2017. https://www.theguardian.com/books/2017/aug/12/homes-author-hanya-yanagihara-new-york-12000-books.

MacFarquhar, Larissa. "The Dead Are Real: Hilary Mantel's imagination." *New Yorker*, October 15, 2012. https://www.newyorker.com/magazine/2012/10/15/the-dead-are-real.

Le Guin, Ursula. Interview with John Wray. "Ursula K. Le Guin, The Art of Fiction No. 221." *Paris Review*, Issue 206, Fall 2013.

Mitchell, David. Interview with David Barr Kirtley. "Episode 175: David Mitchell." *Geek's Guide to the Galaxy* podcast, November 2, 2015. https://geeksguideshow.com/2015/11/02/ggg175-david-mitchell.

Bond, Jenny, and Chris Sheedy. *Who the Hell Is Pansy O'Hara?* New York: Penguin Books, 2008.

Faulkner, William. Interview with Jean Stein. "William Faulkner, The Art of Fiction No. 12." *Paris Review*, Issue 12, Spring 1956.

Gladwell, Malcolm. "The Science of the Sleeper." *New Yorker*, October 4, 1999.

Rowell, Rainbow. Interview with Amanda Green. "The Rumpus Interview with Rainbow Rowell." *Rumpus*, October 17, 2014. http://therumpus.net/2014/10/the-rumpus-interview-with-rainbow-rowell.

Cobain, Kurt. Interview with Erica Ehm. "Kurt Cobain Talks About Literature and Life." *Much Music*, August 10, 1993. https://dangerousminds.net/comments/kurt_cobain_talks_about_literature_and_life.

"Bruce Springsteen." *New York Times: Sunday Book Review*, November 2, 2014.

Wilsey, Sean. "The Things They Buried." *New York Times*, June 18, 2006. http://www.nytimes.com/2006/06/18/books/review/18wilsey.html.

Bechdel, Alison. "OCD." YouTube video. Published April 18, 2006. https://www.youtube.com/watch?v=_CBdhxVFEGc.

Smith, Zadie. Interview with Terry Gross. "Novelist Zadie Smith on Historical Nostalgia and the Nature of Talent." NPR: *Fresh Air*, November 21, 2016.

Wu, Katie. "The Book Club Phenomena." *McSweeney's*, February 8, 2011. https://www.mcsweeneys.net/articles/the-book-club-phenomena.

Garner, Dwight. "Ex-Pat Paris as It Sizzled for One Literary Lioness." *New York Times*, April 19, 2010.

Handy, Bruce. "In a Bookstore in Paris." *Vanity Fair*, October 21, 2014.

Wadler, Joyce. "P.D. James." *People*, December 8, 1986.

Penzler, Otto. Interview with Dan Nosowitz. "How the Owner of the Greatest Mystery Bookstore Pulled the Genre Out of the Muck." *Atlas Obscura*, May 22, 2017. https://www.atlasobscura.com/articles/otto-penzler-mystery-bookstore.

King, Stephen. Interview with Andy Greene. "Stephen King: The Rolling Stone Interview." *Rolling Stone*, November 6, 2014.

Gaiman, Neil. "Gunpowder, treason and plot." Neil Gaiman (blog), November 5, 2004. http://journal.neilgaiman.com/2004/11/gunpowder-treason-and-plot.asp.

Gaiman, Neil. "Being alive. Mostly about Diana." Neil Gaiman (blog), March 27, 2011. http://journal.neilgaiman.com/2011/03/being-alive.html.

Stein, Sadie. "Once and Future." *Paris Review*, October 24, 2014. https://www.theparisreview.org/blog/2014/10/24/once-and-future.

Waldman, Katy. "A Conversation with Philip Pullman." *Slate*, November 5, 2015. http://www.slate.com/articles/arts/books/2015/11/philip_pullman_interview_the_golden_compass_author_on_young_adult_literature.html.

Lawless, John. "Revealed: the eight-year-old girl who saved Harry Potter." *Independent*, July 2, 2005. http://www.independent.co.uk/arts-entertainment/books/news/revealed-the-eight-year-old-girl-who-saved-harry-potter-296456.html.

de Freytas-Tamura, Kimiko. "George Orwell's '1984' Has a Sales Surge." *New York Times*, January 26, 2017.

Berlatsky, Noah. "NK Jemisin: the fantasy writer upending the 'racist and sexist status quo'." *Guardian*, July 27, 2015. https://www.theguardian.com/books/2015/jul/27/nk-jemisin-interview-fantasy-science-fiction-writing-racism-sexism.

Gibson, William. Interview with David Kushner. "Cyberspaceman: William Gibson on Life Inside and Outside the Internet." *Rolling Stone*, November 18, 2014. http://www.rollingstone.com/culture/features/william-gibson-on-life-inside-and-outside-the-internet-20141118.

Stephenson, Neal. Interview with Steve Paulson. "The People Who Survive, an interview with Neal Stephenson, author of Seveneves." *Electric Lit*, June 18, 2015. https://electricliterature.com/the-people-who-survive-an-interview-with-neal-stephenson-author-of-seveneves-4582140577cf.

Kunzru, Hari. "Dune, 50 years on: how a science fiction novel changed the world." *Guardian*, July 3, 2015. https://www.theguardian.com/books/2015/jul/03/dune-50-years-on-science-fiction-novel-world.

Okorafor, Nnedi. Interview with Michelle Monkou. "Must-read sci-fi: 'Binti' by Nnedi Okorafor (and interview!)." *USA Today: Happy Ever After*, October 4, 2015. http://happyeverafter.usatoday.com/2015/10/04/michelle-monkou-nnedi-okorafor-interview-binti.

Alter, Alexandra. "Science, Minus the Swearing." *New York Times*, February 25, 2017.

Ferris, Emil. Interview with Terry Gross. "In 'Monsters,' Graphic Novelist Emil Ferris Embraces the Darkness Within." NPR: *Fresh Air*, March 30, 2017.

Wolk, Douglas. "Masters of the Universe. The space story Saga is the comic world's big hit." *Time*, August 5, 2013.

Johnson, Ariell. Interview with Fabiola Cineas. "I Love My Job: Amalgam Comics & Coffeehouse Owner Ariell Johnson." *Philadelphia*, May 15, 2017. http://www.phillymag.com/business/2017/05/15/ariell-johnson-amalgam-comics-coffee-house-philadelphia.

Spencer, Josh. *Welcome to the Last Bookstore*. Directed by Chad Howitt. Chad Howitt website, 2016. http://www.chadhowitt.com/portfolio/the-last-bookstore.

Cocozza, Paula. "George Saunders: 'When I get praise, it helps me be a little bit more brave'." *Guardian*, October 18, 2017. https://www.theguardian.com/books/2017/oct/18/george-saunders-lincoln-in-the-bardo-when-i-get-praise-it-helps-me-get-a-little-bit-more-brave.

"About George Saunders." George Saunders website. http://www.georgesaundersbooks.com/about.

"Drift Away into the Not-Quite-Dreamy Logic Of 'Get in Trouble'." NPR: *All Things Considered*, February 3, 2015.

Lahiri, Jhumpa. Interview with John Burnham Schwartz. "How Jhumpa Lahiri Learned to Write Again." *Wall Street Journal*, January 20, 2016. https://www.wsj.com/articles/how-jhumpa-lahiri-learned-to-write-again-1453305609.

Octavia E. Butler." *Wikipedia: The Free Encyclopedia*. Wikimedia Foundation, Inc. Last modified December 6, 2017. https://en.wikipedia.org/wiki/Octavia_E._Butler.

"A Short History of City Lights." City Lights website. Accessed December 10, 2017. http://www.citylights.com/info/?fa=aboutus.

Kaplan, Fred. "How 'Howl' Changed the World." *Slate*, September 24, 2010. http://www.slate.com/articles/news_and_politics/life_and_art/2010/09/how_howl_changed_the_world.html.

Ingraham, Christopher. "Poetry is going extinct, government data show." *Washington Post*, April 24, 2015. https://www.washingtonpost.com/news/wonk/wp/2015/04/24/poetry-is-going-extinct-government-data-show.

Smith, Tracy K. Interview with Mike Wall. "'Life on Mars': Q&A with Pulitzer-Winning Poet Tracy K. Smith." Space.com, May 4, 2012. https://www.space.com/15538-life-mars-tracy-smith-pulitzer-interview.html.

Harris, Jessica B. "Dining with James Baldwin." *Saveur*, Issue 189, May 15, 2017.

Huxley, Aldous. *Collected Essays*. New York: Harper & Row, 1959.

"Mansplain." *Oxford Living Dictionary*. Accessed December 10, 2017. https://en.oxforddictionaries.com/definition/mansplain.

Gross, Terry. "David Sedaris on the Life-Altering and Mundane Pages of His Old Diaries." NPR: *Fresh Air*, May 31, 2017.

Achenbach, Joel. "Writing with the Master." *Princeton Alumni Weekly*. Accessed December 10, 2017. https://paw.princeton.edu/article/writing-master.

Hitchens, Christopher. Interview with Charlie Rose. *Charlie Rose*, PBS, WNET: August 13, 2010.

"The Hitch Has Landed." Dish.andrewsullivan.com, April 20, 2012. http://dish.andrewsullivan.com/2012/04/20/hitchs-service.

Berger, John. *About Looking*. New York: Vintage, 1992.

Montgomery, Sy. Interview with Simon Worrall. "Does an Octopus Have a Soul? This Author Thinks So." *National Geographic*, June 10, 2015. https://news.nationalgeographic.com/2015/06/150610-octopus-mollusk-marine-biology-aquarium-animal-behavior-ngbooktalk.

O'Connor, Flannery. *Mystery and Manners: Occasional Prose*. New York: Farrar, Straus and Giroux, 1970.

Kerouac, Jack. *Big Sur*. New York: Penguin, 1992.

Bryson, Bill. "Bill Bryson answers your questions." *Guardian*, March 10, 2005. https://www.theguardian.com/culture/2005/mar/10/awardsandprizes.scienceandnature.

Ackerman, Diane. Interview with Linda Richards. "At Play with Diane Ackerman." *January Magazine*, August 1999.

Mead, Rebecca. "Starman." *New Yorker*, February 17 & 24, 2014.

Yong, Ed. *I Contain Multitudes*. New York: Ecco, 2016.

Saro-Wiwa, Noo. *Looking for Transwonderland*. Berkeley, CA: Soft Skull Press, 2012.

Thuras, Dylan. Interview with Ari Shapiro. "'Atlas Obscura' Tour of Manhattan Finds Hidden Wonders in a Well-Trodden Place." NPR: *All Things Considered*, September 20, 2016.

McKenna, Shannon. "Octavia Books Bestsellers—And Why." Shelf Awareness, September 21, 2006. http://www.shelf-awareness.com/issue.html?issue=285#m1818.

Hemingway, Ernest. *Selected Letters 1917–1961*. New York: Scribner, 2003.

Heat-Moon, William Least. *Blue Highways*. New York: Back Bay Books, 1999.

Patrick, Colin. "The Highest Compliment Maurice Sendak Ever Received." *Mental Floss*, November 3, 2012. http://mentalfloss.com/article/12975/highest-compliment-maurice-sendak-ever-received.

Strayed, Cheryl. *Wild*. New York: Vintage, 2013.

Child, Julia, with Alex Prud'homme. *My Life in France*. New York: Anchor Books, 2007.

Child, Julia. "To Roast a Chicken." PBS, WGBH: *The French Chef*. Season 7, Episode 13, January 24, 1971.

The Curious Pear. "Meera Sodha Wants to Change the Way You Think About Indian Food." *Food52*, July 1, 2016. https://food52.com/blog/17324-meera-sodha-wants-to-change-the-way-you-think-about-indian-food.

Ryan, Valerie. "He's the modern Mr. Wizard." *Boston Globe*, October 20, 2015. https://www.bostonglobe.com/lifestyle/food-dining/2015/10/20/side-science/R9T2htbijbQ3pfaOovQejN/story.html.

Pelzel, Raquel. "Making the Cookbook: How to Cook Everything." Epicurious.com, April 13, 2015. https://www.epicurious.com/expert-advice/how-mark-bittman-created-how-to-cook-everything-better-article.

Asimov, Eric, and Kim Severson. "Edna Lewis, 89, Dies; Wrote Cookbooks That Revived Refined Southern Cuisine." *New York Times*, February 14, 2006. http://www.nytimes.com/2006/02/14/us/edna-lewis-89-dies-wrote-cookbooks-that-revived-refined-southern-cuisine.html.

Carlson, Cajsa. "London's Libreria Bookshop." Cool Hunting, February 29, 2016. http://www.coolhunting.com/culture/libreria-london-book-shop.

"7 Writers on Their Favorite Bookstores." *New York Times*, December 7, 2016. https://www.nytimes.com/interactive/2016/12/07/travel/7-authors-on-their-favorite-bookstores.html.

Voelker, Ryan. "Cooking and Living with Jami Curl." *Oregon Home*. Accessed December 10, 2017. http://www.oregonhomemagazine.com/profiles/item/1818-jami-curl.

"About Big Gay Ice Cream." Video. Big Gay Ice Cream website. Accessed December 10, 2017. https://www.biggayicecream.com/about.

Waters, Alice. Cover blurb for *The Art of Eating: 50th Anniversary Edition* by M. F. K. Fisher, edited by Joan Reardon. Boston: Houghton Mifflin Harcourt, 2004.

Fisher, M. F. K. *The Gastronomical Me*. London: Daunt Books, 2017.

"M. F. K. Fisher's Half-and-Half Cocktail." *Food52*, October 28, 2015. https://food52.com/recipes/38995-m-f-k-fisher-s-half-and-half-cocktail.

Gordinier, Jeff. "A Confidante in the Kitchen." *New York Times*, April 2, 2014.

Chamberlin, Jeremiah. "Inside Indie Bookstores: McNally Jackson Books in New York City." *Poets & Writers*, November/December 2010.

Hillenbrand, Laura. "Four Good Legs Between Us." Seabiscuit Online. Accessed December 10, 2017. http://www.seabiscuitonline.com/article.htm.

"Mission Statement." We Need Diverse Books website. Accessed October 15, 2017. http://weneeddiversebooks.org/mission-statement.

Turner, Kimberly. "One Year of Street Books: A Bike-Powered Library for the Homeless." *Lit Reactor*, June 5, 2012. https://litreactor.com/news/one-year-of-street-books-a-bike-powered-library-for-the-homeless.

"Reading Rainbow Theme." Composed by Steve Horelick, vocal by Chaka Khan. PBS: *Reading Rainbow*, 1983.

B., Arturo. Quoted in "Write Your Own Path Forward: 2015–16 Annual Report." 826 National website, 2016. https://826national.org/826NAT_AR%2015-16WebFinal.pdf.

"Good Night Bill of Rights." Pajama Program website. Accessed December 10, 2017. http://pajamaprogram.org/good-night-bill-of-rights.

Dunham, Lena. Foreword to *The Liars' Club*, by Mary Karr. New York: Penguin Classics, 2015.

Woodson, Jacqueline. Interview with Kat Chow. "Jacqueline Woodson on Being a 'Brown Girl' Who Dreams." NPR: *Morning Edition*, September 18, 2014.

Smith, Patti. Interview with Ian Fortnam. "Patti Smith: 'I'm like William Blake in the Industrial Revolution.'" TeamRock.com, November 26, 2014. http://teamrock.com/feature/2015-11-26/patti-smith-i-m-like-william-blake-in-the-industrial-revolution.

Moraga, Cherríe, and Gloria E. Anzaldúa, eds. *This Bridge Called My Back*. New York: Kitchen Table/Women of Color Press, 1983.

Gay, Roxane. *Bad Feminist*. New York: Harper Perennial, 2014.

Traister, Rebecca. *All the Single Ladies*. New York: Simon & Schuster, 2016.

Lee, Hermione. "Writers' rooms: Virginia Woolf." *Guardian*, June 13, 2008. https://www.theguardian.com/books/2008/jun/13/writers.rooms.virginia.woolf.

Woolf, Virginia. *A Room of One's Own*. Boston: Mariner Books, 1989.

Gaiman, Neil. Interview with Toby Litt. "Neil Gaiman: Libraries are cultural 'seed corn.'" *Guardian*, November 17, 2014. https://www.theguardian.com/books/2014/nov/17/neil-gaiman-libraries-are-cultural-seed-corn.

Rankine, Claudia. *Citizen*. Minneapolis: Graywolf Press, 2014.

Hamid, Mohsin. Interview with Tochi Onyebuchi. "All Writing Is Political: A Conversation with Mohsin Hamid." *Rumpus*, May 17, 2017. http://therumpus.net/2017/05/all-writing-is-political-a-conversation-with-mohsin-hamid.

Hamid, Mohsin. "Mohsin Hamid on the dangers of nostalgia: we need to imagine a brighter future." *Guardian*, February 25, 2017. https://www.theguardian.com/books/2017/feb/25/mohsin-hamid-danger-nostalgia-brighter-future.

"'And Tango Makes Three' waddles its way back to the number one slot as America's most frequently challenged book." Press release. American Library Association, April 11, 2011. https://web.archive.org/web/20110414234446/http://ala.org/ala/newspresscenter/news/pr.cfm?id=6874.

"The History of Little Free Library." Little Free Library website. Accessed December 10, 2017. https://littlefreelibrary.org/ourhistory.

Mann, Charles C. *1491*. New York: Vintage Books, 2006.

Tuchman, Barbara W. *Practicing History*. New York: Random House, 1992.

Wolfe, Tom. Interview with Tom Brokaw. "Wolfe on Researching 'The Right Stuff'." *NBC Today Show*, November 5, 1979.

Sanchez, Jonathan. "The owner of Blue Bicycle Books looks back at 20 years in the literary biz." *Charleston City Paper*, September 16, 2015. https://www.charlestoncitypaper.com/charleston/the-owner-of-blue-bicycle-books-looks-back-at-20-years-in-the-literary-biz/Content?oid=5453644.

"History of Tattered Cover." Tattered Cover website. Accessed December 10, 2017. http://www.tatteredcover.com/detailed-history-tattered-cover.

"The Things They Carried." *Wikipedia: The Free Encyclopedia*. Wikimedia Foundation, Inc. Last modified November 13, 2017. https://en.wikipedia.org/wiki/The_Things_They_Carried.

O'Brien, Tim. *The Things They Carried*. Boston: Houghton Mifflin, 1990.

Finkel, David. *Thank You for Your Service*. New York: Picador, 2014.

Sacks, Oliver. *Gratitude*. New York: Knopf, 2015.

Sanghani, Radhika. "Dr Lucy Kalanithi: 'Two years on, the sting of losing Paul is finally fading'." *Telegraph*, April 23, 2017. http://www.telegraph.co.uk/women/life/dr-lucy-kalanithi-two-years-sting-losing-paul-finally-fading.

Gawande, Atul. *Being Mortal*. New York: Picador, 2017.

Prince-Ramus, Joshua. "Behind the design of Seattle's library." Lecture, TED2006, February 2006. https://www.ted.com/talks/joshua_prince_ramus_on_seattle_s_library.

McKnight, Jenna. "Bing Thom combines curves and points with library in British Columbia." *Dezeen*, May 18, 2016. https://www.dezeen.com/2016/05/18/bing-thom-architects-surrey-library-vancouver-canada-concrete.

Frankl, Viktor. *Man's Search for Meaning*. Boston: Beacon Press, 2006.

Brown, Brené. *Rising Strong*. New York: Random House, 2017.

Kurtz, Adam J. Interview with Katie Olson. "Adam J. Kurtz's 'Pick Me Up: a Pep Talk for Now and Later." *Cool Hunting*, September 26, 2016. http://www.coolhunting.com/culture/adam-j-kurtz-pick-me-up-book.

Sincero, Jen. Interview with Carolyn Kellogg. "'You Are a Badass': Author Jen Sincero explains how to kick butt." *Los Angeles Times*, May 6, 2013. http://articles.latimes.com/2013/may/06/entertainment/la-et-jc-jen-sincero-you-are-a-badass-20130506.

Saramago, José. Interview with Anna Metcalfe. "Small Talk: José Saramago." *Financial Times*, December 4, 2009. https://www.ft.com/content/bfaf51ba-e05a-11de-8494-00144feab49a.

Vonnegut, Kurt. "Kurt Vonnegut: In His Own Words." *Times*, April 12 2007. https://www.thetimes.co.uk/article/kurt-vonnegut-in-his-own-words-mccg7v0g8cg.

King, Stephen. *On Writing*. New York: Scribner, 2000.

Lamott, Anne. *Bird by Bird*. New York: Pantheon Books, 1994.

Nabokov, Vladimir. *Speak, Memory*. New York: Vintage, 1989.

Guillebeau, Chris. *The Happiness of Pursuit*. New York: Harmony, 2016.

Gilbert, Elizabeth. "Your elusive creative genius." Lecture, TED2009, February 2009. https://www.ted.com/talks/elizabeth_gilbert_on_genius.

Gilbert, Elizabeth. *Big Magic*. New York: Riverhead Books, 2016.

Shahn, Ben. *The Shape of Content*. Boston: Harvard University Press, 1957.

Wallace, David Foster. "Roger Federer as Religious Experience." *New York Times: Play Magazine*, August 20, 2006.

Nyad, Diana. "By the Book: Diana Nyad." *New York Times: Sunday Book Review*, October 11, 2015.

Kupper, Mike. "Bowie Kuhn, 80; baseball's commissioner in stormy era." *Los Angeles Times*, March 16, 2007. http://articles.latimes.com/2007/mar/16/local/me-kuhn16.

Epstein, Dan. "Ball Four, You're Out: How a Classic Baseball Book Became a Failed Baseball Sitcom." *Vice Sports*, September 22, 2016. https://sports.vice.com/en_us/article/78nx5z/ball-four-youre-out-how-a-classic-baseball-book-became-a-failed-baseball-sitcom.

Scott, Kim. *Radical Candor*. New York: St. Martin's Press, 2017.

Knight, Phil. *Shoe Dog*. New York: Scribner, 2016.

Knight, Phil. "My Fill-in Father." *New York Times*, June 18, 2016.

Adigard, Eric. Panel Discussion with Chee Pearlman. "A Conversation about the Good, the Bad, and the Ugly." *Wired*, January 1, 2001. https://www.wired.com/2001/01/forum.

"PowerPoint Does Rocket Science—and Better Techniques for Technical Reports." Edward Tufte website. Accessed December 10, 2017. https://www.edwardtufte.com/bboard/q-and-a-fetch-msg?msg_id=0001yB&topic_id=1.

Hische, Jessica. *In Progress*. San Francisco: Chronicle Books, 2015.

Popova, Maria. "Bruno Munari on Design as a Bridge Between Art and Life." BrainPickings. Accessed December 10, 2017. https://www.brainpickings.org/2012/11/22/bruno-munari-design-as-art.

Sagmeister, Stefan. *Things I Have Learned in My Life So Far*. New York: Harry N. Abrams, 2008.

Muhlke, Christine. "Profile in Style: Ilse Crawford." *New York Times: T Magazine*, September 25, 2008.

Bailey, Ian. "Owner of Munro's Books in Victoria hands over shop to employees." *Globe and Mail*, July 9, 2014. https://www.theglobeandmail.com/arts/books-and-media/owner-of-munros-books-in-victoria-handing-over-shop-to-employees/article19530442.

Carroll, Lewis. *Alice's Adventures in Wonderland*. London: Puffin, 2015.

Kalman, Maria. "The Illustrated Woman." Lecture, TED2007, March 2007. https://www.ted.com/talks/maira_kalman_the_illustrated_woman.